Encounters: essays on literature and the visual arts

ENCOUNTERS

Essays on literature and the visual arts

Edited by John Dixon Hunt

W · W · Norton & Company · Inc ·
New York

© this collection Studio Vista Publishers 1971
Published in Great Britain by Studio Vista Publishers
Blue Star House, Highgate Hill, London N.19
Set in Times New Roman 10 on 11 pt
Printed in Great Britain by R. J. Acford Ltd., Industrial Estate, Chichester, Sussex
SBN 289 70026 4

Contents

Preface

John Dixon Hunt

> From long bigotted deference to the old maxim that poetry is painting in speech, and painting dumb poetry, the two sisters, marked with features so different by nature, and the great masters of composition, her oracles, have been constantly confounded with each other by the herds of mediocrity and thoughtless imitation.

Thus Fuseli in the *Analytical Review* of 1794, exultant over the tarnished glories of the doctrine of *ut pictura poesis* and the meagre fruits that doctrine had borne during the eighteenth century. And in the same piece he goes on to welcome the attack, twenty-eight years earlier, by Gotthold Ephraim Lessing on this long-treasured item of aesthetic ideology: 'The futility of such mutual inroads of poetry and painting on each other has been shown by a late German writer of great acuteness and some taste.' That Lessing's *Laocoön* is generally neglected these days is perhaps adequate testimony to the thoroughness with which he disposed of the traditional assumptions about the sisterhood of the arts.* Yet despite the weighty confirmation given to that dismissal by modern literary criticism from Coleridge onwards as well as by more recent patterns in the visual arts, there still survives a firm commitment, shared by the seven contributors to this volume, to explore the encounters between literature and the visual arts.

Modern literary criticism and formal discussion of the visual arts have proceeded along separate paths and there often appears little scope for a *rapprochement*. They can join forces most easily in the study of the history of ideas,† but such inquiries do not readily insist upon the crucial differences that exist between figurative and verbal expression, with the consequence that the individual work of art is neglected, its special and unique properties lost amid the ideal entities. Yet, alert to that liability, the joint encounter of literary and visual criticism in exploring historical parallels or continuities of idea may still yield important insights. For the student of literature, often fast bound to his close scrutiny of texts, ignores at great risk the historical context of what he studies so myopically. It may seem a cliché even to that student, but it is only too frequently a necessity to insist, with Whitehead, that 'In each period there is a general form of the forms of thought; and,

* The long tradition of the doctrine of *ut pictura poesis* and some of its manifestations in decline have been treated by Jean H. Hagstrum, *The Sister Arts. The Tradition of Literary Pictorialism and English Poetry from Dryden to Gray* (Chicago 1958).

† For example, Erwin Panofsky's *Meaning in the Visual Arts* (New York 1955 and London 1970) and *Studies in Iconography* (New York and London 1962); E. Wind, *Pagan Mysteries in the Renaissance* (London 1967); or Fritz Saxl, *A Heritage of Images. A Selection of Lectures* (London 1970).

like the air we breathe, such a form is so translucent, and so pervading, and so seemingly necessary, that only by extreme effort can we become aware of it.'* Yet the awareness is vital. In an endeavour to promote it one may sometimes invoke a discipline other than one's own to provide freshly angled recognitions of this historical 'form'.

But here another difficulty emerges. The strange phenomenon of (and my phrase is advisedly paradoxical) *visual illiteracy*. The student of words rarely knows how to look at images; worse still he seldom acknowledges this blindness. Pierre Francastel writes: 'Je connais des hommes qui admettent ne pas entendre la musique; j'en connais bien peu qui admettent ne pas voir . . .'† The habit and art of reading figurative images is as difficult as that of studying verbal structures. So that the student of literature, who is to be introduced to visual materials to enlarge his historical sensibility, has yet to be instructed in the reading of them. An apt analogy with another literary source can often be thrown lightly in his path; the visual parallel will need more careful presentation.

This collection of essays offers no programme for the exploration of such parallels. Indeed, the fortunes of *ut pictura poesis* must warn against all doctrinaire procedures. There is a curious insecurity about the few attempts made so far to trace extensive parallels between literature and the visual arts according to some controlling principle. Two writers in particular, Mario Praz and Wylie Sypher, have promoted specific inquiries based upon a general thesis.‡ Praz offers an intriguing formulation:

> Each epoch has its peculiar handwriting or handwritings, which, if one could interpret them, would reveal a character, even a physical appearance, as from the fragment of a fossil palaeontologists can reconstruct the entire animal . . . And what else is handwriting but the concentrated expression of the personality of an individual? Of all the sciences or pseudo-sciences which presume to interpret the character and destiny of man from signs, graphology is surely the one which has the soundest foundation. Handwriting is taught, and certain of its characteristics belong to the general style of the period, but the personality of the writer, if it is at all relevant, does not fail to pierce through. The same happens with art.

Sypher's principle is the more tricky and problematic one of style:

> A style is a vocabulary. It may well be the most sensitive and explicit vocabulary of any society. If style is a vocabulary, it is also syntax; and syntax expresses the way in which a society feels, responds, thinks, communicates, dreams, escapes . . .

and elsewhere he quotes Arnold Hauser to the effect that style is 'like a musical theme of which only variations are known'. Our assent to each of these controlling theses is, I imagine, ready enough. It is the awkwardness

* From *Adventures of Ideas*, quoted by Wylie Sypher *Rococo to Cubism in Art and Literature* (New York 1960), p. xvii.

† Pierre Francastel, *La Réalité Figurative* (Paris 1965), p. 13. Together with Francastel's *Etudes de Sociologie de l'Art* (Paris 1970), *La Réalité Figurative* deserves much wider recognition in Britain and the United States for its speculations and explorations of the interdisciplinary territory between art, history and sociology.

‡ Mario Praz, *Mnemosyne. The Parallel Between Literature and the Visual Arts* (Princeton 1970); Wylie Sypher, *Four Stages of Renaissance Style. Transformations in Art and Literature 1400–1700* (New York 1955) and *Rococo to Cubism in Art and Literature* (see above).

of some of the encounters between specific literary and visual works that these formulae promote that revives scepticism. At their best they allow exciting new perspectives to be opened upon moments of literary history, as the other discipline disturbs our comfortable assumptions about a period and sharpens our reading of a text. But at their least successful there emerges a rather arbitrary series of *correspondences*, almost a parlour game of analogies in which the two art forms are shuffled for more intriguing juxtapositions. Both our consent to and our disengagement from such activity is focused in the witty example, cited by Mario Praz, of James Laver's *Style in Costume*. Laver, arguing that 'clothes are nothing less than the furniture of the mind made visible, the very mirror of an epoch's soul', matches the drapery of the *Charioteer of Delphi* with an ionic column, a trunk hose with an Elizabethan table leg. Marvellously apt, but how many crucial questions does it beg!

Such large 'graphological' identifications are not really the aim of these essays, at least in the first instance. Nor do we want to offer any ideas about critical methods that do not emerge from and survive in actual example. There are important reasons for trying to be pragmatic and empirical. Each comparativist problem will require its own special solution, which we have tried to demonstrate in our choice of seven moments of literary history —as well as of a variety of literary forms—where the shape and scope of the critical inquiry has been determined by the intellectual climate of the age in which the author writes and the forms in which he expresses himself. Even the most rudimentary principle that informs certain of our comparativist approaches—the idea of the *Zeitgeist*—will (it is self-evident) vary according to the period. Burckhardt's is a useful formulation of the assumption and its variable: writing to Kinkel who had proposed a study of the arts of the Netherlands he advised: 'Conceive your task as follows—How does the spirit of the fifteenth century express itself in painting? Then everything becomes simple'.* That period of Netherlands society necessarily promoted a spirit that may perhaps be traced in parallels and connections between the arts that could not possibly provide a pattern for critical inquiries into, say, eighteenth-century England.

These are, doubtless, obvious truths, but they are rarely honoured in the criticism that, eager to identify parallels between the arts, only too often proceeds upon the assumption that connections will always be the same and of the same variety at any stage of the historical continuum. By asking various scholars to discuss encounters between literature and the visual arts in the period where they are most at home we may perhaps escape the dangerous awkwardnesses of such *a priori* assumptions, the palpable offspring of the decadence of *ut pictura poesis*. This means that at least two essays, on sixteenth- and seventeenth-century parallels, *do* treat of that doctrine, for it is an essential enterprise in those periods to understand the meaning and energy of *ut pictura poesis;* but at other times there will be other more exact and relevant approaches.

Each essay, then, determines its own method and comparativist criteria, and only through assessing the procedures and results of such case histories can the critical possibilities of any larger scheme of relationships between art and literature begin to emerge. What these essays have in common is

* Quoted by E. H. Gombrich, *In Search of Cultural History* (Oxford 1969), a most stimulating exegesis of some aspects of the comparativist's activities.

the concern to provide literary texts with visual analogues that illuminate their creative or cultural origins and meanings. Each writer here respects the differences between a verbal and a visual or figurative syntax; without neglecting them, without blurring various modes of expression at any one epoch, we are all concerned to recover fresh insights into literary experience by considering the relationship of verbal creation to the visions common to a whole society at a given period.

There is one further area of common interest—those occasions on which writers have been decisively influenced by visual material. This volume offers several examples of this other mode of critical activity for the comparativist. The dangers here are no less real for being obvious; yet just because it is difficult to isolate clearly how a writer has used structures learnt from the visual arts or how words may be deployed in place of images it seems no reason to shirk what can be for several literary works and events a crucial encounter with the visual arts. It should also be evident from the subjects handled in these essays that far from thinking these various methods should be saved for use only as a panacea in the criticism of minor cultural phenomena we insist that even major literary figures and events may well need approaching in this way.

What Fuseli called the 'mutual inroads of poetry and painting' may often have been futile, and they have just as frequently elicited a futility of critical response. Yet the incursions of writers into worlds of visual images and visual modes of imagination have sometimes borne fruit in their writings; the contiguities of the arts in any age have shaped their individual forms in ways that a comparativist approach may reveal; the age itself can be studied through its various manifestations and these then allowed to condition our reading of a text. It is not, then, out of some 'long bigotted deference' to the old maxim of *ut pictura poesis* that this volume seeks to elucidate some of those encounters.

Piers Plowman and the visual arts

Elizabeth Salter

Compared with the poetry of Chaucer, which is lavishly provided with references to the visual arts, Langland's *Piers Plowman* is economical enough; if we relied upon encouragement from the poet to persuade us that his work is deeply indebted to painting and sculpture for its imagery or for its larger descriptive conventions, we should be badly off. It is typical of Langland, scrupulously concerned to make beauty present its credentials in a world of moral values, that he should have his dreamer condemned for long dealings with 'coueytse-of-eyghes', that 'foule lust of the ey3en' which traditionally featured in medieval attacks on the arts as stimulants of 'veyne ioye and glorie'.[1] The dreamer is beguiled from true vision by *concupiscentia oculorum*, a handmaid of Fortune:

> . . . Coueytise-of-eyes . conforted me ofte,
> And seyde, 'haue no conscience . how thow come to gode . . .'[2]

(. . . lust-of-the-eyes often comforted me, and said 'Don't let your conscience trouble you about your methods of making money . . .)

To this austere view, patronage of the arts must, indeed, be a proving-ground for conscience; wall-paintings and stained-glass windows become, understandably, part of a shady 'spiritual' transaction between a friar-confessor and the devious, expensive Lady Meed, whose offer to

> . . . 3owre cloystre do maken,
> Wowes do whiten . and wyndowes glasen,
> Do peynten and purtraye . and paye for the makynge . . .
>
> (B.III.60–2)

(. . . build you a cloister, whitewash your walls, glaze your windows, have paintings and statues made, and pay for the making . . .)

is repudiated as 'superbia vitae'[3] (pride of life)

> . . . On auenture pruyde be peynted there . and pompe of the worlde . . .
>
> (B.III.66)

(. . . lest pride and worldly pomp be (all) that is painted there . . .)

Even the exquisite calligraphic skills of the Middle Ages Langland only dares to mention, admiringly, in connexion with the Ten Commandments and their commentary:

> . . . This was the tixte trewly . I toke ful gode ʒeme;
> The glose was gloriousely writen . with a gilte penne . . .

(B.XVII.12–13)

(. . . this was the full text—I read it carefully: the commentary was splendidly inscribed, in gold lettering . . .)

It is not, therefore, surprising that when he does seem to acknowledge a direct link with a contemporary art-form, it is with the illustrations to manuals of religious instruction; his allegorical trees, buildings, garments and documents are naturally related to this art of 'clear visual representation', which intended 'that the reader in the midst of a complicated world of abstractions might see and grasp the essentials'.[4]

But the rather modest claims made by the poet himself have not deterred the critics from going to far more elaborate areas of mediaeval painting in order to elucidate and define some of the characteristics of his poetry. The sequential dream-structure of *Piers Plowman*—not one, but many dreams—has been generally described as 'Gothic': he 'breaks up the poem, in Gothic fashion, into a series of dreams . . .'[5] The spatial concepts which support, or *fail* to support the movement of the poem, have been likened to the 'empty' backgrounds of gold in sophisticated works such as the *Wilton Diptych* or the *Avignon Piéta*.[6] The 'paradoxical space',[7] in which the poem exists, has been compared with that of contemporary Italian fresco and panel painting: 'a strained, disharmonious unity of plane and space, line and mass, colour and shape.'[8]

Clearly, there is some kind of dilemma here. The poem itself sanctions attention to a very limited field of the visual arts: the readers of the poem are drawn to wider and more exciting terrain, as they try to express, for themselves and for others, their actual experience of Langland's dream-allegory. On the one hand, we are bound to act responsibly towards the text of *Piers Plowman*, pursuing our investigations with the same vigour that the poet himself uses in his own pursuit of truth: on the other hand, we are bound to take note of the fact that the poem sometimes appears to keep more distinguished company in the visual arts than its author is pre-pared, or able, to admit. Both courses of action are open to criticism: both promise discoveries and disappointments: both are necessary and, indeed, interdependent exercises.

The problem with analogy-making as opposed to source-hunting is only partly that of securing general agreement, for there is also the danger that agreement may be won by the striking nature of analogies rather than by their fitness. So, the suggestion that the un-localized settings of episodes in *Piers Plowman* can be likened to gold backgrounds in mediaeval manuscript and panel paintings is attractive. But this cannot be approved entirely, for the suggestion is based on the idea that both in the paintings and in the poetry, backgrounds are 'empty'.[9] While this may easily be true of Langland's presentation of his central narratives, it is far from true of the relationship of the gold 'backdrop' in the *Wilton Diptych* to its varied foreground subjects. The effect of gold-leaf, or gold paint, whether plain, diapered or tooled in ornate designs, is hardly ever that of 'emptiness'; when it is not present simply to provide a substantial, glittering screen, against which foreground events may be seen to greater advantage, it functions as a spiritual comment, enveloping the particular moment—Deposition, or Resurrection—in a haze of significant light. It is almost the reverse of 'emptiness'. Only one episode

in *Piers Plowman* could legitimately call to mind the use of gold-leaf in manuscript illumination—the Harrowing of Hell.[10] Here Langland deliberately introduces the theme of blinding light: Christ approaches Hell as a spirit clothed in splendour—

> . . . And now I se where a soule . cometh hiderward seyllynge
> With glorie and with grete liȝte . god it is, I wote wel . . .
>
> <div align="right">(B.XVIII.304–5)</div>

> (. . . And now I can see a soul sailing towards us, in glory and blazing light; it is God, I am certain.)

The whole of the drama is envisaged as the confrontation of light and the 'dukes of this dym place'; whatever the precise source of Langland's imaging, the impression given by this whole section of his poem is not falsely conveyed in terms of those miniatures of the Harrowing of Hell and the Resurrection which float the triumphant Christ in a concentrate of gold light to the walls of Hell, or out of the confines of the tomb[11] (ill. 1). But for most of the time, the 'emptiness' of Langland's backgrounds is better represented in visual terms by the plain, empty space of the manuscript page, as it appears behind and through the line-drawings of humbler mediaeval book-illustrators, who are similarly concerned with the essential shape of an act, or an episode, rather than with all of its supporting and corroborative detail. In this respect, we would come nearer to some of Langland's attitudes and procedures by studying a work such as the fourteenth-century *Holkham Bible Picture Book*:[12] here the contrast between the vigorous, dramatic rendering of Biblical scenes from Creation to Last Judgement, in strokes equivalent for their energy and decisiveness to Langland's strong language—

> . . . '*Consummatum est*,' quod Cryst . and comsed forto swowe
> Pitousliche and pale . as a prisoun that deyeth;
> The lorde of lyf and of liȝte . tho leyed his eyen togideres.
> The daye for drede with-drowe . and derke bicam the sonne . . .
>
> <div align="right">(B.XVIII.57–60)</div>

> (. . . 'It is finished,' said Christ, and began to lose consciousness, pathetic and pale, like a dying prisoner; the Lord of Life and of Light then closed his eyes. The daylight faded, for fear, and the sun darkened . . .)

and the bare unsubstantiated background to those scenes (ill. 2) is reminiscent of the way in which *Piers Plowman* holds parts of the Biblical narrative in solution, as it were, taken out of their particular historical context, and exhibited to the eye of faith alone.

The *Holkham Bible Picture Book* is too simple a production to be of more than momentary interest to the reader of *Piers Plowman*. Its limited material means that it can have limited usefulness as a comment on the organizational problems presented to Langland by his all-embracing visions of life, death and salvation as they are revealed in religious history and moral allegory. And it is the complex and shifting nature of the 'spatial environments'[13] in *Piers Plowman* which has prompted comparison with some major Italian painting of the mid- and later fourteenth century. Frescoes which depict the violent and contrarious sensations of a country afflicted by bubonic plague, guilt, fear and anguished spirituality, are said to share with the English poem 'paradoxical space, a rejection of perspective, and a tension between the natural and the unnatural, the physical and the

abstract'.[14] But no Italian fresco adequately represents the variety of Langland's dealings with space and location. Traini's *Triumph of Death*, in the Campo Santo, Pisa,[15] with a theme similar to that of Passus xx of *Piers Plowman*—

> . . . Deth cam dryuende after . and al to doust passhed
> Kynges and kny3tes . kayseres and popes;
> . . .
> Many a louely lady . and lemmanes of knyghtes
> Swouned and swelted . for sorwe of Dethes dyntes . . .
>
> (B.XX.99–100, 103–4)

> (. . . Death came driving after [them], and smashed into dust kings and knights, emperors and popes . . . many a lovely lady, and many a knight's mistress sank into mortal swoon with the pain of death's blows . . .)

has something of that 'inconsequence of spatial relations' observed in the poem: groups of people, each oblivious of the other, are disposed over the picture-area, engaged in separate activities—ladies seated in a grove, knights riding in cavalcade, hermits praying and meditating in rustic seclusion. Their existence in a common picture-space is rather summarily indicated; the relationship between grove, rocky countryside and open meadow is not explored realistically. A sense of tragic isolation pervades, which only death will, ironically, dissolve. The fresco is, however, far simpler to grasp than the equivalent section of *Piers Plowman*: there is some structural logic to its 'broken terrain' landscape, as there is also some logic to its time-scheme. Its events are embedded in space and time at the same depth. In *Piers Plowman* there are no such certainties. The attack of Death takes place within a dream, and, further, within the context of the coming of Anti-Christ. The boundaries of present and future are continuously blurred, as we move from contemporary reference—the accommodating Friars, the terrors of the Black Death—to apocalyptic forecast; we are left, designedly, uncertain whether Anti-Christ already reigns, in the fourteenth century, or whether the dreamer is being admitted to a vision of the Last Days. The battles that rage, between Anti-Christ and Conscience, between Death and Humanity, between Sin and Virtue, have not one, but many grounds of action; they take place about the 'barn of Unity', the historical Church of post-apostolic and mediaeval times, in the Westminster of Langland's day, in the labyrinths of man's interior world.[16] The transitions are unremarked; they are hardly difficult to make, for no substantial, vizualizable, setting is provided, either in terms of allegory or literal realism. The 'broken terrain' of Langland's composition, we might say, is that of the mind; the locus of action is as changeable, as unlimited as the growing capacity of the dreamer's vision to 'wander through eternity', or to interpret the images in the troubled 'mirror of middle-earth'.[17] The only control exercised over the choice, disposition and relating of materials is spiritual; it is not so much an 'insecurity of . . . structure'[18] that we find in *Piers Plowman* as a deliberate attempt to work on a principle familiarly expressed by Langland's contemporary, the author of *The Cloud of Unknowing*:

> 'Wher then', seist thou, 'schal I be? Nowhere bi thi tale!' Now trewly thou seist wel: for there wolde I have thee . For whi nowhere bodely is everywhere goostly . . .[19]

('Where then', you say, 'am I to be? Nowhere, according to you!' Now, indeed, you're on the right track . . . for to be nowhere in the body is to be everywhere in the spirit . . .)

Langland's reluctance to show his reader, or his dreamer, any sympathy for that irritable question—'Where, then . . . am I to be? Nowhere, according to you!'—is crudely understood as an admission that stability and security are lost. Rather, it is a direction towards a new stability—a coherence to be discovered only fragmentarily in history or fiction, regarded as sequential narratives, but most fully in the great spiritual themes that inform them.

The search for similar statements, similar procedures is rewarded more positively by the art of the earlier mediaeval period than by that of Langland's own day. The Carolingian *Utrecht Psalter*,[20] made near Rheims in the ninth century, is not only remarkable for the literal nature of some of its pictorial commentary on the psalms, verse by verse. Its most significant features relate to concepts of space and time. For here, in a single picture-space, disparate subjects are irrationally, but unquestioningly juxtaposed: the light, impressionistic backgrounds of late-antique landscape painting are used to suggest, but never to define, some common ground inhabited by all created beings. They are, however, metaphors rather than representations of space—as English artists, copying the *Psalter* in the twelfth century, recognized.[21] Their later versions of the manuscript go one stage further in the translation of landscape into pure calligraphy: their figures, dancing, fighting, praying, lamenting in isolable groups, are presented in a context which is, simultaneously, as shallow as the manuscript page, and as deep as the total, realizable meaning of the Psalmist's text—'nowhere bodely is everywhere goostly . . .'. For here, seeming irrationality can only ever be resolved by the words of the psalms in their literal and figural senses; a picture which contains, within a single frame, and in a single space, episodes from Old and New Testament history, from contemporary life, and from religious legend clearly asks to be 'read' not as a continuous and self-sufficient narrative, but as an exploration of deeper harmonizing truths.

So, the logic of a scene which could otherwise appear meaningless, or at best enigmatic, is found in the text inspiring it, and in the range of meanings offered by that text. Space and time are flexible concepts, accommodating the phenomena of the material world to the larger realities of a spiritual universe. The abrupt proximity of unrelated actions and events in an illustration of Psalm LXXXV[22]—ploughing and reaping, the Visitation, the Virgin and Child, men protected by angels—is 'explained' by the text of the psalm:

terra nostra dabit fructum suum (v. 12).

(Our land shall give her increase).

misericordia, et veritas obviaverunt
sibi: justitia et pax osculatae sunt (v. 10).

(Mercy and Truth are met together: Righteousness and Peace have kissed each other.)

veritas de terra orta est: et justitia
de caelo prospexit (v. 11).

(Truth shall spring out of the earth; and Righteousness shall look down from heaven.)

ostende nobis, Domine, misericordiam
tuam: et salutare tuum da nobis (v. 7)

(Show us thy mercy, O Lord, and grant us thy salvation.)

But the picture achieves its proper unity at a deep level of significance:
the Psalm and its illustration, allegory, history, and genre realism, are
synthesized in a timeless and untramelled process of prophecy and fulfilment.
It is the benignity of God—'Etenim Dominus dabit benignitatem' (v. 12)
(Yea, the Lord shall give that which is good)—witnessed in the life and
words of the Psalmist himself, in the fact of the Incarnation and in the yearly
rewards of man's labour on earth, which provides true sustaining continuity.

Similarly, the choice and arrangement of subjects for Psalm XVI[23] (ill. 3)—
Christ raising Adam and Eve out of Hell, the three Maries at the tomb, a
company of Saints, Christ praised by angels and human beings asleep—
result, superficially, in an inconsequence not only spatial. The very process,
however, of interpreting

> . . . non derelinques animam meam in inferno:
> nec dabis sanctum tuum videre corruptionem . . .
>
> (v. 10)

> (. . . Thou wilt not leave my soul in hell; neither wilt thou suffer thine
> Holy One to see corruption . . .)

as the Harrowing of Hell and the Resurrection, argues for an underlying
view of space and time in which text and illustration are of vital, linked
consequence; the Psalmist's premonition of truth was confirmed by pro-
vidential Christian history. To such a view the range of reference, from
ordinary human life to the life of Christ, from the Saints on earth to the
angels rejoicing in Heaven, is not unacceptably wide, nor are the forms taken
by such reference particularly surprising. Man's intuition is instructed of
divine purpose, in sleep—'usque ad noctem increpuerunt renes mei' (v. 7)—
(and in the night my inmost self instructs me . . .) as his waking under-
standing is instructed by Scripture and legend and holy example.

In Langland's *Piers Plowman* the dreamer arbitrates between the poet, the
reader and the materials of vision; he is involved, commenting upon the
variety, pace, and often unexpected quality of the action—the sudden
disappearances:

> . . . And whanne he hadde worded thus . wiste no man after,
> Where Peers Plouhman by-cam . so priueliche he wente . . .
>
> (C.XVI.149–50)

> (. . . And when he had spoken thus, he disappeared so suddenly that
> no-one had any idea what had become of Piers the Ploughman . . .)

—the sudden transformations:

> . . . And thanne called I Conscience . to kenne me the sothe.
> 'Is this Iesus the Iuster?' quod I . 'that Iuwes did to deth?
> Or it is Pieres the Plowman! . who paynted hym so rede?'
>
> (B.XIX.9–11)

> (. . . And then I asked Conscience to tell me the truth—'Is this Jesus,
> the jousting knight, whom the Jews put to death, or is it Piers the
> Ploughman? Who stained him so red?' . . .)

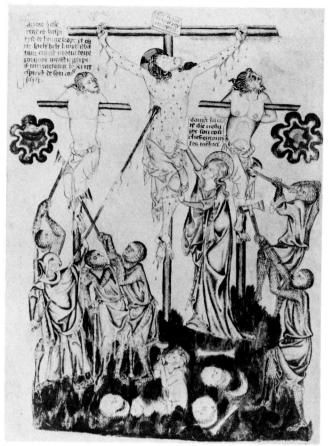

2 *The Holkham Bible Picture Book* British Museum MS. Additional 47682, f. 32b

3 *The Canterbury Psalter* Trinity College, Cambridge, MS.R.17.1, f. 24

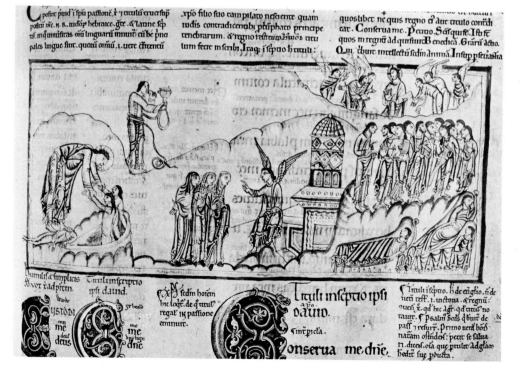

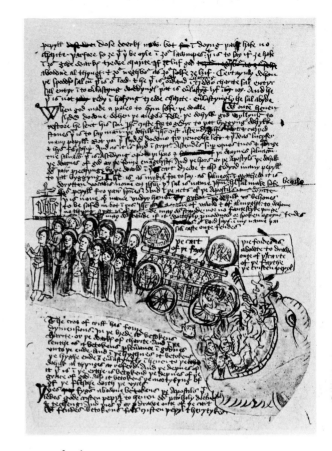

4 'The Cart of the Faith' British Museum MS.37049, f. 83a

5 'The Tree of Life' British Museum MS.37049, f. 19b

6 'The Tree of Love' British Museum MS. Additional 37049, f. 25a

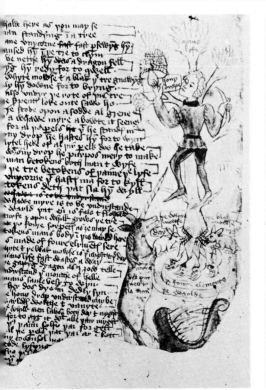

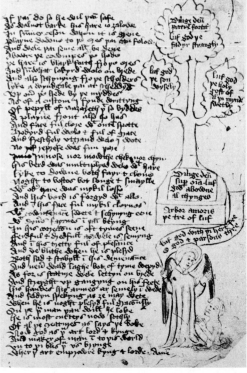

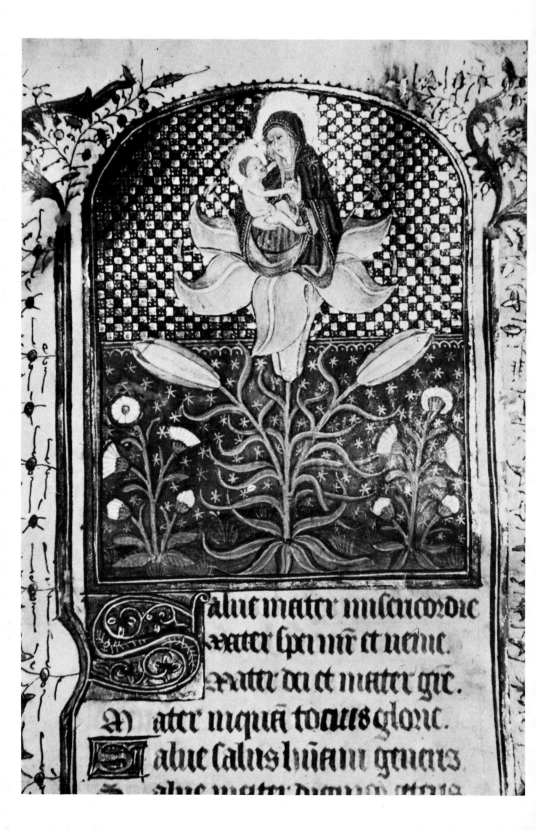

And so, too, in the Psalter illustrations, the Psalmist is constantly present as an onlooker, a participant, an eye upon events or an actor in one episode of the drama; this agile figure, trampling upon the unjust, supplicating God, threatening and praising, is hardly a unifying agent, in a strict sense. But he does, like the dreamer of *Piers Plowman*, provide a focus of attention in a world of diverse and, if only initially, perplexing forms.

The art of the *Utrecht Psalter* and its copies can have nothing but associative value for studies of Langland's art: a more specific indebtedness could never be in question. It does, however, usefully remind us, when we are tempted to compare his structures adversely with the 'strong geometry [or geography]'[24] of the *Divine Comedy* and the *Canterbury Tales* that surface irrationality may not indicate confusion of outlook, but rather a different mediaeval attitude to the ways in which the poet and artist can express the relationship of phenomenal and spiritual truth. In this case, a method of Biblical illustration throws light, from afar, upon Langland's methods: in other cases, using simpler art-forms within his probable reach, we might expect to be rewarded more exactly and, indeed, more richly. The confidence which recent writers have shown in going to treatise-illustration for the sources of Langland's imagery is well-founded; his own phrasing is clearly directive—to a Tree of the Vices:[25]

> . . . Ac whiche be the braunches . that bryngeth men to sleuthe? . . .
> <div align="right">(C.VIII.70)</div>

> (. . . But which are the branches that entangle man in slothfulness? . . .)

—to a Wheel of the Virtues:[26]

> . . . take Pacience,
> And bere hit in thy bosom . abowte wher thou wendest,
> In the corner of a cart-whel . . .
> <div align="right">(C.XVI.160–2)</div>

> (. . . adopt Patience, and carry it in your heart wherever you go, as part of a 'wheel' of virtues . . .)

Manuscripts best described as 'spiritual encyclopaedias', which provided for all levels of the later mediaeval devout reading public poems and prose-pieces accompanied by drawings, could have given him exemplars.[27] Turning their pages, we are confronted by many of the raw materials of Langland's allegory: king, knight and bishop, their hearts touched with death's spear:[28] Christ leading 'the cart of the fayth', packed with believers, and threatened by devils, to his heavenly harvest[29] (ill. 4):

> . . . And whan this dede was done . Grace deuised
> A carte, hy3te Cristendome . to carye Pieres sheues;
> And gaf hym caples to his carte . Contricioun and Confessioun . . .
> <div align="right">(B.XIX.326–8)</div>

> (. . . And when this had been done, Grace provided a cart, called Christendom, to carry Piers' sheaves, and gave him Contrition and Confession as cart-horses . . .)

trees of life, attacked at the roots by time and death, trees of the vices, rooted in pride[30]

> . . . Pruyde hit aspide,
> And gadered hym a gret ost . greuen he thenketh
> Conscience, and alle Cristene . and cardinale uertues,
> To blowen hem doun and breken hem . and bite a-two the rotes . . .
>
> (C.XXII.337–340)

(. . . Pride noticed this, and collected a great army, intending to attack Conscience, and all Christians, and the cardinal virtues, to blow them over, and smash them, and gnaw at their roots . . .)

lamps of good-works, fed with the oil of charity—[31]

> . . . For-thi chastite with-oute charite . worth cheyned in helle;
> It is as lewed as a laumpe . that no liȝte is inne . . .
>
> (B.I.186–7)

(. . . For chastity without charity should be fettered in hell: it is as useless as an unlit lamp . . .)

Concerned only with clarity of exposition, this is a world in which the grotesque or the bizarre has no place;[32] when Langland comes to his central allegory of the Tree of Charity, he has his guide-figure, Piere, shake humanity from the branches, like apples, and the devil gather them up, like an orchard-thief:

> . . . For euere as thei dropped adown . the deuel was redy,
> And gadred hem alle togideres . bothe grete and smale . . .
>
> (B.XVI.79–80)

(. . . And as fast as they dropped, the devil was ready, and gathered them all up, whether large or small . . .)

And when the manuscript artists present us with the Tree of Life, man is the ripening fruit for whom time, death, and damnation greedily watch[33] (ill. 5).

But we should be mistaken if we imagined that by such detailed comparisons we could do more than indicate how knowledge of certain pictorial formats may have worked in the poet's imagination. This is most clearly proved by the section of the poem in which the dreamer's desire to understand 'what charite is to mene' (B.XVI.3) is answered by exposition and visionary experience of a Tree of Charity. Here, in a very important sense, Langland tells us that source-hunting is not enough—although his warnings have not been properly heeded by the critics, who persist in trying to elucidate the passage in terms of particular kinds of mediaeval tree-models.[34] For while any of the manuscripts already mentioned, and a wide variety of others similar, could have given Langland his exemplar for the tree as it is first described to the dreamer (B.XVI.4–16), brief and plain, like a simple line-drawing, no manuscript illustration and no religious treatise could account for his translation of picture into active drama. It is as if the poet impatiently turned from the manuscript page, with its three-fold trees of love[35] (ill. 6), its loaded trees of life, its burgeoning hearts of contemplation,[36] and substituted experience of love and life in a visionary re-creation of the story of the Fall, and the Redemption. What, in the cold words of the first expositor, Anima, is nothing but a formula, becomes a living substance in the words and movements of the second guide, Piers Plowman, for he takes the dreamer down to a deeper level of spiritual consciousness (B.XVI.19–20) and makes

the tree-allegory *work*. The intervention of the dreamer, by his continued
questioning of the tree's structure—

> . . . 'Pieres', quod I, 'I preye the . whi stonde thise piles here?' . . .
>
> (B.XVI.24)

(. . . 'Piers', I said, 'pray [tell me] why these props stand here?' . . .)

and of Piers, by his decisive action against the apple-robber—

> . . . And Pieres for pure tene . that o pile he lauȝte,
> And hitte after hym . happe how it myȝte . . .
>
> (B.XVI.86–7)

(. . . And Piers, in swift anger, snatched up that particular prop, and hit
out at him, regardless of the outcome . . .)

leaves pictorial allegory far behind, as the tree is metamorphosed into
Christian history, and love becomes incarnate:

> . . . And thanne spakke *Spiritus Santus* . in Gabrieles mouthe,
> To a mayde that hiȝte Marye . a meke thinge with-alle . . .
>
> (B.XVI.90–1)

(. . . And then the Holy Spirit spoke, through the voice of Gabriel,
to a maiden called Mary, a most meek creature . . .)

In fact, whether we look to the rich art of the Middle Ages, or to its poorer
relations for help with understanding *Piers Plowman*, the usefulness of our
studies must nearly always stop short of Langland's poetry. So, a single
manuscript painting may elucidate some of the processes which went to the
making of his famous metaphor of love as the 'plant of peace':

> . . . Loue is the plonte of pees . and most preciouse of vertues;
> For heuene holde hit ne myȝte . so heuy hit semede,
> Til hit hadde on erthe . ȝoten hym-selue[37] . . .
>
> (C.II.149–151)

(. . . Love is the plant of peace, and the rarest of virtues. For heaven
could not hold it, so heavy it was—until it had begotten itself upon an
earthly body . . .)

In a fifteenth century prayer-book, decorated sumptuously for the Talbot-
Beauchamp family[38] (ill. 7), the Virgin and Child, ringed with bright gold,
are supported in the bell of a slender lily which rises from a green mound.
Langland's words are brought to mind by the strange growth of body out of
plant, woman and child out of symbolic purity: by the paradox of heavenly
symbol rooted in earth, and humanity lifted to heaven. But nothing in the
painting can suggest that further imaginative act of the poetry which
transmutes plant, flesh and blood into shivering leaf and into needle-point,
so that we may be left with a sense of the mystery of the Incarnation and
not simply with a picture of its beauty:

> . . . Was neuere lef vp-on lynde . lyghter ther-after,
> As whanne hit hadde of the folde . flesch and blod ytake;
> Tho was it portatyf and pershaunt . as the poynt of a nelde,
> May non armure hit lette . nother hye walles . . .
>
> (C.II.152–5)

(. . . Never leaf upon linden-tree was lighter than when it had taken on earthly flesh and blood: then was it as subtle and piercing as the point of a needle—no armour, no high wall could keep it out . . .)

For like the greatest religious painter of Northern Europe in the next century, Hieronymus Bosch, Langland was always more preoccupied with power than with beauty of concept. Far-fetched as the comparison may at first seem, it is Bosch alone, among later mediaeval artists, who matches the range and some of the special quality of Langland's invention. The relevance of Bosch's *Haywain*[39] triptych to the opening of *Piers Plowman* is very clear: in both picture and poem man's life, in its sensual confusion, is poised between Heaven and Hell. Langland's description of his 'field full of folk',[40] with its tumbling crowds of beggars, merchants, churchmen and labourers is rapid and impressionistic: in this it differs from Bosch's presentation of his fallen world, which is observed with acute, almost photographic precision. But the informing vision is common to both: 'all the wealth of this world, and also the misery',[41] the headlong rush of man, once destined for greatness, into the 'deep dale' of hell, where nothing but death awaits him—

> . . . deth, as ich lyuede,
> Wonede in tho wones . and wyckede spiritus . . .
>
> <div align="right">(C.I.17–18)</div>

(. . . death, I believed, dwelt in those places, and wicked spirits . . .)

And only the hideous procession of the central panel of *The Haywain*, where demon trudges shoulder to shoulder with doomed man, can properly remind us of Langland's Deadly Sins, mingling as friends with all classes of society:

> . . . I, Wrath, rest neuere . that I ne moste folwe
> This wikked folke . for suche is my grace . . .
>
> <div align="right">(B.V.151–2)</div>

(. . . I, Wrath, never rest from shadowing these wicked folk, for that is my vocation . . .)

The paintings of Bosch can offer us explicit, arresting statements of themes which in *Piers Plowman* are developed in a more leisurely, discursive manner. The egg-monster in the Hell volet of *The Garden of Delights* triptych[42] reveals an ale-house, within its cracked body; Langland's Glutton is beguiled into a tavern on his way to confession.[43] In Bosch's picture no hope is held out to the revellers, who can only climb in and out of the dark waters of Hell: Langland's sinners are eventually allowed the knowledge that

> . . . goddes mercye is more . than alle hise other werkes . . .
>
> <div align="right">(B.V.289)</div>

(. . . God's mercy is the greatest of all his works . . .)

But behind both scenes lies the controlling idea of conviviality blind to damnation; both artists work energetically and ironically to demonstrate the truth that sin is already hell, and that hours in the ale-house are snatched from salvation.

Most important is the way in which both Bosch and Langland move boldly to question and disturb accepted boundaries of the ordinary and the

extraordinary. Bosch's studies of saints in prayer or meditation surround the dreaming or semi-conscious man with landscapes fashioned strangely from inner and outer reality: the phantasmagoria of the spiritual world, shapes of good and evil, invade that 'mighty world of eye and ear' with life and substance.[44] So, in Langland's poem, the dreamer is admitted, in a solitary dream, to a land which accommodates, without apology, the sights and sounds of contemporary England, the events of Biblical history and the allegories of man's moral existence. Neither poet nor painter allows sharp distinction to be made between waking and dreaming. What the waking senses might receive as customary, becomes, in the dream, material for wonder:

> . . . I seigh the sonne and the see . and the sonde after,
> And where that bryddes and bestes . by here makes thei ȝeden,
> Wylde wormes in wodes . and wonderful foules,
> With flekked fetheres . and of fele coloures . . .
>
> (B.XI.318–321)

(. . . I saw the sun, and the sea, and then the sea-shores, and birds and beasts going-forth with their mates, wild snakes in the woods, and marvellous birds whose feathers were flecked with many a colour . . .)

Conversely, the material of vision is often adjusted to everyday reality, as when Langland's dreamer questions Abraham about his meeting with the Trinity:

> . . . 'Havest thow seyen this?' ich seide . 'alle thre, and o god?'
> 'In a somer ich seyh hym', quath he . 'as ich sat in my porche,
> Where god cam goynge a-thre . ryght by my gate . . .'
>
> (C.XIX.241–3)

(. . . 'Have you seen this', I said, 'all three in one God?' 'One summer I saw him', he said, 'as I was sitting in my porch—God in three persons came walking down my path . . .')

The variousness of the phenomena presented to the reader or the viewer is never less than challenging, and is often bewildering. Access to understanding lies only through the dreamer or the saint, in whose experience the poem or painting lives. The eye constantly retreats from Bosch's paradoxical landscapes, crowded with diabolic and heavenly symbolism, to the holy figures who, in their hours of trial and trance, call up, suffer, and finally resolve the confusion. So, too, it is only by resting upon the efforts of Langland's dreamer, who by turns invites, resists and accepts the evidence of his vision, that wilderness and paradise can be seen, even temporarily, in meaningful harmony.

Notes

1 *The Mirrour of the Blessed Lyf of Jesu Christ*, ed. L. F. Powell (Oxford 1908), p. 70.
2 *The Vision of William Concerning Piers the Plowman*, ed. W. W. Skeat (Oxford, repr. 1954), B.XI.51–2.
3 I John II, 16.
4 A. Katzenellenbogen, *Allegories of the Virtues and Vices in Mediaeval Art* 2nd ed., tr. A. J. P. Crick (New York 1964), p. 63.
5 Morton Bloomfield, *Piers Plowman as a Fourteenth Century Apocalypse* (New Jersey 1963), p. 19.
6 Ibid., pp. 41–2.
7 Charles Muscatine, 'Locus of Action in Mediaeval Narrative', *Romance Philology*, XVII, no. 1 (1963), p. 122.
8 Millard Meiss, *Painting in Florence and Siena after the Black Death* (Princeton 1951), p. 165.
9 Bloomfield, loc. cit.
10 *Piers Plowman*, B.XVIII.137 foll.
11 See in particular, f.103ᵇ of the *Paduan Psalter*, Fitzwilliam Museum ms. 36/1950, f. 96 of the *Peterborough Psalter*, Corpus Christi College, Cambridge ms.53.
12 British Museum ms. Additional 47682. (Facsimile edition by W. O. Hassall, London 1954).
13 Muscatine, op. cit., p. 120.
14 Muscatine, op. cit., p. 122.
15 Reproduced by Meiss, op. cit., pl. 85.
16 B.XX.72 foll., 132 foll.
17 B.XI.8.
18 Muscatine, loc. cit.
19 *The Cloud of Unknowing*, ed. P. Hodgson, (EETS, OS 218, 1944, repr. 1958) ch. 68, p. 121.
20 Utrecht University library, Cod. 32; facsimile ed. by E. T. De Wald, *The Illustrations of the Utrecht Psalter* (Princeton 1932).
21 See C. R. Dodwell, *The Canterbury School of Illumination* (Cambridge 1954) ch. IV.
22 *The Canterbury Psalter* Trinity College, Cambridge, ms. R.17.1, f. 150ᵇ. Facsimile ed. M. R. James (London 1935).
23 Ibid., f. 24.
24 Muscatine, op. cit., p. 120.

25 See E. Salter and D. Pearsall, *Piers Plowman: the C Text* (York Mediaeval Texts 1967), p. 15.

26 See R. E. Kaske, '*Ex vi transicionis* and Its Passage in *Piers Plowman*', *Style and Symbolism in Piers Plowman*, ed. R. J. Blanch (Tennessee 1969), pp. 258 foll.

27 Such compilations as are found in British Museum mss Arundel 507, and Additional 37049, for instance, and, in a more learned context, an Apocalypse picture-book in the Wellcome Museum, London.

28 Additional ms. 37049, f. 36a: cf. *P. Plowman*, B.XX.99–100, quoted above.

29 Ibid., f. 83a.

30 Ibid., f. 19b and 48a.

31 Ibid., f. 82b 'the oyle in the lawmpes betokens charyte . . .'.

32 A point completely misunderstood by some readers: see D. Mills, 'The Role of the Dreamer in *Piers Plowman*', in *Piers Plowman: Critical Approaches*, ed. S. S. Hussey (London 1969), pp. 200–4.

33 British Museum Additional ms. 37049, f. 19b. See also the Tree of the Vices, with 'human fruit', threatened by death, in an English psalter of the fourteenth century, Walters Library, Baltimore.

34 See for instance, the account of earlier work and the new suggestions in Ben H. Smith, *Traditional Imagery of Charity in Piers Plowman*, (The Hague 1966), ch. III.

35 British Museum Additional ms. 37049, f. 25a, Compare *Piers Plowman*, B.XVI.23, 63.

36 British Museum Cotton Faustina ms. B.vi. pt. II, f. 22b.

37 'Till it had begotten itself upon an earthly body.'

38 The *Talbot Hours*, Fitzwilliam Museum, Cambridge, ms. 40/1950, f. 73.

39 *L'Opera Completa di Bosch*, ed. D. Buzzati and M. Cinotti (Milan 1966), Tav. XVI–XVII.

40 B.ptrol. 17, C.I. 19.

41 C.I.10.

42 *Hieronymus Bosch: The Garden of Delights*, ed. W. Hirsch (London 1954), plate facing p. 42.

43 B.V. 304 foll.

44 See in particular, *St John the Baptist in Meditation*, *Opera Completa*, Tav. XLI.

'A speaking picture':
some ways of proceeding in literature and the fine arts in the late-sixteenth and early-seventeenth centuries

Douglas Chambers

The late-sixteenth and early-seventeenth centuries have long been recognized as the golden age of English literature. The lyricists of Elizabethan England were revived and cherished by the Victorians, and from the latter part of that century onwards metaphysical poetry and drama were again in the ascendant. Until very recently, however, the other arts, and painting in particular, have suffered from a neglect similar to that of Shakespeare in the late-seventeenth century. In 1661 John Evelyn wrote in his *Diary*: 'I saw *Hamlet* Pr: of Denmark played: but now the old playe began to disgust this refined age'.[1] And in 1953 Ellis Waterhouse, writing about Elizabethan portraiture, remarked that 'the general level of work is of an even mediocrity, executed in the main, it would seem, by small factories rather than by painters with a more personal style of their own'.[2]

Waterhouse's judgement is fairer and less condescending than Evelyn's, but it too would now have to be modified in the light of the more recent work of Dr Roy Strong. What Dr Strong has demonstrated, both in his formidable catalogue, *Tudor and Jacobean Portraits*, for the National Portrait Gallery and in the more accessible *The English Icon* (both London 1969), is the importance of the work of individual artists such as Eworth and Scrots and the development throughout the period of certain styles and pre-occupations. Much of what he has said (and demonstrated most tellingly in *The Elizabethan Image* exhibition at the Tate Gallery, London) about the 'iconographic' mode in portraiture at large is an extension of what has long been recognized about the portraits of Queen Elizabeth herself—that is, that many of them, especially those painted in her old age, are not 'literal' renderings of the Queen as she was, but the idea of the Queen, the 'icon' of her that her subjects worshipped.[3]

The famous 'Armada Portrait' by George Gower at Woburn (ill. 9), for instance, is scarcely a 'true' representation of the Virgin Queen at fifty-five; rather it is an idealized and eternalized rendering of her who represented the spirit of Tilbury and Plymouth Hoe, that 'she' around whose presence as Gloriana the whole enterprise of late sixteenth-century England flourished.[4] It is this 'she' to whom Donne also pays tribute in 'The First Anniversarie' as 'shee which did inanimate and fill the world' or 'she, of whom th'Ancients seem'd to prophesie, when they call'd vertues by the name of *shee*' (11. 68–9, 175–6). She who was Belphoebe, Diana, Gloriana, Cynthia, Astraea, and a host besides, whose names were matched by her symbolic attributes—the Phoenix, the Rose, the Moon, and so forth—was also a real woman, but it was a daring artist who painted her so. We come upon the posthumous

portrait of the aged queen, sometimes attributed to Mark Gheeraerts the Elder,[5] with as great a shock as if we had found Queen Victoria painted in a dressing gown.

What we have here is as much typology as iconography. That is to say that what interested the English Renaissance mind was not the way in which a character differed from his predecessors but the way in which particular characters in particular situations conformed to traditional images of that role or station. This attitude was strengthened by the antiquarianism (sponsored in part by the Tudor propaganda machine), which flourished in the new Society of Antiquaries and in the work of such disparate scholars as Leland and Bacon. For the effect of this in the long run was to reinforce the sense of the historical continuum as one perpetual manifestation of the same eternal truths about morality, society and human nature.[6] The iconographical or typological mode became the way of seeing that under the apparent (and misleading) differences of species from their kind lay the essential sameness that was the substratum of the moral order.

It was the business of the painter or biographer not to be taken in by superficial or delusory exceptions but to elicit the fundamental design of ordering providence as applied to the role or station occupied by the 'sitter' within that providential framework. If Elizabeth differed from the notion of the virgin queen that all her names and attributes were meant to suggest, that was irrelevant to the ideal notion of her character that her biographers and portraitists attempted to convey. What was relevant was only so much of her *persona* as conformed to this ideal. Similarly, when Walton set out to write the 'Life of Donne' he was not primarily interested in the peculiarities of Donne's life but in the way in which that life conformed to the 'type' of converted saintliness that was Walton's model, that is, the life of St Augustine. And Earle and Overbury in their books of 'Characters' only present these same 'types' in a wider social spectrum. The material of Theophrastus has been added to the moral stuff of the 'commonplace' tradition—the wisdom of old age, the impracticality of philosophers, and so forth. And if we no longer believe in such figures as the melancholic man as 'types', it is nevertheless a measure of the strength of this tradition that the rashness of youth and the absent-mindedness of professors are still both familiar 'iconographical' counters of argument.

Such examples serve to remind us that 'iconography' or 'typology' or 'character-writing' is not necessarily moral or social predestination. Rather, it represents a way of making sense of the apparent eccentricity and flux of human character and of recognizing conventional models within conventional roles—virgin queen, melancholy courtier, heroic soldier or whatever. The individual is not unimportant, but his importance is measured in terms of conformity (or non-conformity) to the received type. At the lowest this conformity is merely comic stuff—the type of the political fool, for instance, in Jonson's Sir Politic Would-Be. At its highest it celebrates the ideal and is the very stuff of religious affirmation—Gloriana and the saints.

What we have come to be familiar with in the iconography of the Virgin Queen, however, is true of much of the portraiture and indeed artistic mentality of the age as a whole. For the queen's portraitists, to paraphrase Donne, painted the *idea* of the queen and not as she was. To confront the young poet Surrey in William Scrots's painting (ill. 8), leaning upon a decayed classical column, is to see transferred into paint that conceit of Petrarch's 'Rotta e l'alta colonna', which Surrey's friend Wyatt so movingly

translated (or transformed) in his 'The piller perisht is whereto I lent'. Now Wyatt's poem is often thought to be a very personal lament for the loss of his patron Thomas Cromwell, but it is nonetheless personal for appealing to a traditional sonnet for the materials of its complaint. We do not invent a new language each time we fall in love or confront the fact of death. The more intense the joy or grief, the less likely are new metaphors. There are, moreover, certain conventional ways of speaking (or singing) about love that are more telling than any new metaphors. Indeed, to a poet like Wyatt it would have been inconceivable that any really new way of talking about love or lamenting death could have been found.[7] If he laments the passing of Cromwell he does so in the same way as Petrarch lamented Laura and in a mode that is the verbal equivalent of that painterly conceit of the ruins of time—the broken column in Scrots's painting of Surrey. And, to extend the parallel, the paradox that Wyatt's poem can be written at all in the face of ostensibly crippling grief has its visual counterpart in the paradox of Surrey's magnificent costume, worn with what Sir Thomas Hoby calls 'Recklesnesse' (Castiglione's *sprezzatura*)[8] in the face of the decay and mutability of that 'glory of our blood and state'.

The paradox of man's estate, in which because death is the only certainty life must be the more festive and ceremonious, is also Sir Thomas Browne's theme in *Urne Buriall*.

> There is nothing strictly immortal, but immortality; Whatever hath no beginning may be confident of no end (all others have a dependent being, and within the reach of destruction); . . . But man is a noble Animal, splendid in ashes, and pompous in the grave, solemnizing Nativities and Deaths with equall lustre, nor omitting Ceremonies of bravery, in the infamy of his nature.[9]

This paradoxical admiration of death's dark solemnities had its visual counterpart in the fashion for melancholy that was not peculiar to Browne's time but enjoyed a greater vogue then.[10] Night is, after all, a time both for melancholics and for lovers, and the common pun on the verb 'to die' (meaning to have sexual intercourse) is one that such seventeenth-century dramatists as Webster and Tourneur translated literally on to the stage. When the revenger Vindice in Tourneur's *The Revenger's Tragedy* presents the besotted Duke with the skeleton of his (Vindice's) sister, disguised as a courtesan, with the lips of her skull poisoned, he arranges the liaison within a sepulchre. In so doing he transfers to the stage the familiar visual conceit that was present a century earlier in Niklaus Manuel Deutsch's *Death as a Soldier Embraces a Young Woman*.

Donne similarly made 'blasphemous' use of the themes of death, love, and resurrection in his poem 'The Canonization': 'We dye and rise the same, and prove mysterious by this love.'[11] But 'blasphemy' is too strong a word for a technique that Donne at least knew to be blasphemous—for what was, in fact, a deliberately ironic dramatic part, Jack Donne in the role of amatory blasphemer. For Donne seems always to have been playing at roles, as if there were no other way of speaking the truth than dramatically. The Lothian portrait (ill. 10) presents him as a literary melancholic with all the black trappings of fashionable melancholy about him and a wry face to keep them in their place. The text that forms an arch behind his head, 'Illumina Tenebras Nostras Domina', is, moreover, a parody of the third collect for Evensong.[12]

This sense of a personal but dramatized melancholy is present in 'Twicknam Garden' with its sense of an individual paradise lost through individual perversity: 'And that this place may thoroughly be thought True Paradise, I have the serpent brought.' But the humour (in both its senses) of the pose in the portrait indicates an ironic vein that is more characteristic of the amatory poems of the *Songs and Sonets*—of a poem such as 'Aire and Angels' for instance, where affirmation and willing disbelief are held in an ironic suspension by grammar and syntax. We do not look simply for the bio-graphical Donne in his poems, and the Lothian portrait, suspended between wry wit and black gloom, is a way of telling us why we must not.[13] The Lothian portrait is an 'icon' of Donne as a 'humorous' melancholy poet. We do not any more expect it to be a straightforward account of the facts of Donne's biography than the Armada portrait is of Queen Elizabeth's. It tells us what Jaques has already told us, that 'all the world's a stage and all the men and women merely players'.

This sense of the poet as actor carried over into Donne's ecclesiastical career. We see it in the portrait of him as an Old Testament prophet which is in the deanery at St Paul's; and it continued until the end of his life. When in his dying hours he came into the pulpit of St Paul's to preach 'Death's Duell', his last and (quite literally) most terrific sermon, the atmosphere, as Walton tells us, was of a dramatic event—congregation was transformed into audience. The valedictory of that sermon was as telling as Prospero's, and it too had its visual counterpart—that statue of the mortal Doctor in his winding sheet (now in the Choir of St Paul's) which Donne rose from his death-bed to pose for.[14]

T. S. Eliot has censured Donne's prose for its 'impure motive', by which, I take it, he means its dramatic sensationalism. But the Donne who knew the dramatic tricks of logical debate, and used them in his amatory poems knowing full well that they would be detected by that circle of wits who were his friends,[15] did not feel obliged to abandon the drama when he stepped into the pulpit. 'For our sight of God here,' he says in a sermon of 1628, 'our Theatre, the place where we sit and see him, is the whole world, the whole house and frame of nature, and our *medium*, our *glasse*, is the Booke of Creatures, and our light, by which we see him, is the light of Naturall Reason.'[16]

If we seem a long way from 'iconography' it is because we tend not to associate the playing of character roles for a moral purpose (the sort of thing we find in Jonson's city comedies) with the emblematic and morally traditional.[17] We tend also to forget how totally this way of thinking permeated the English Renaissance mind—that where we make a hard and fast discrimination between the 'scientifically' historical or clinically bio-graphical on the one hand and the received wisdoms of typology on the other, we make a distinction that that mind would not readily have recognized.

Exemplary of this is Hans Eworth's painting of Sir John Luttrell (ill. 11). In the background a galleon breaks up and plunges into a stormy sea, an obvious allusion to some historical incident in Luttrell's career, but in the foreground a resolute Sir John rises waist-high and Neptune-like above the waves to have his uplifted right arm rewarded by Peace who leans out from amongst a group of mythological deities in a bower of clouds to bestow the award. And, in case we have somehow missed the import of the scene, a rock in the foreground bears the legend: 'Mor [than] the rock amlodys [amidst] ye raging seas/The constat [constant] heart no dager [danger]

dreddys nor feyars [fears].'[18] Here the allegorical (or symbolical), the moral, and the clinically historical coexist within one work of art without any apparent uneasiness.

II

The theme of constancy *v*. mutability is a common one both in painting and poetry, and the ambiguous poise of the one tells us something about how to 'read' the other. In Shakespeare's Sonnet 53, for instance, the young man addressed is both a biographical subject and a painted or artistic object. The 'millions of strange shaddowes' that 'tend' on him are both 'historical' hangers-on of a somewhat sinister character and the *chiaroscuro* strokes of the portrait painter. And the ambiguity of the figures of historical beauty to which he is compared—Adonis and Helen—is reflected in the ambiguity of the syntax used to make this comparison. Adonis, after all, though he was the lover of Venus and the ideal of male beauty, was also killed by a boar wound that was generally interpreted to be a sign of the effects of lust. And Helen, *because* she was a great beauty, 'burnt the topless towers of Ilium'.

Shakespeare, however, is not content with these 'iconographical' ambiguities: are we to read Helen and Adonis 'in bono' or 'in malo', or both? He surrounds the painted hero-heroine with an ambiguous nimbus. 'Describe *Adonis*', he says 'and the counterfet is poorely immitated after you.' If the implication is that the 'counterfet' is a poor copy of Adonis, whereas the young man is a better copy, is he (the young man) then a better 'counterfet'? What is the force of 'counterfet' here? Similarly, if it is necessary to 'on *Hellens* cheeke all art of beautie set' before the young man 'in *Grecian* tires [is] painted new', is there not some irony in the fact that it is art (or indeed artifice) that makes the young man's beauty (also called into question by the deviousness of '*Grecian* tires') similar to Helen's?

I do not here wish to call into question the straightforward import of Eworth's painting—that Luttrell is quite unambiguously the 'constant heart' amid the 'raging seas' of mutable existence.[19] What I should like to claim, however, is that Shakespeare's portrait, because ambiguous (like Hilliard's *Man Aged Twenty-four in 1572*),[20] begins there but goes on to a state of far greater psychological complexity. The last couplet of the sonnet takes us to this complexity at once.

> In all externall grace you have some part,
> But you like none, none you for constant heart.

Is the 'externall grace' contrasted to the 'you' of 'constant heart' or to an internal grace of which we have no evidence? If it is contrasted to the 'you' of 'constant heart' we have first to know what that 'you' is like. The sonnet has given us only ambiguous evidence and the final line leaves us still unillumined. Are 'none' like the young man because he is better or because he is worse? What tone is the reader to use?

The poised ambiguity here is akin to the dubious balance of Donne's 'The Canonization', 'Aire and Angels', or 'The Relique'. Do the 'all' of 'The Canonization' 'approve [Donne and his mistress] *Canoniz'd* for Love' because they merit it or because the 'all' are merely ignorant of the facts? Is the gravedigger, coming upon the bones of Donne and his mistress and thinking 'that there a loving couple lies', deceived? Do they lie in another sense, or does he understand more than they—or the world?

Neither Donne nor Shakespeare could have seen Giorgone's painting

called *Tempesta* (probably the most elaborate of all the Renaissance treatments of the tension between constancy and change),[21] but Donne as a traveller on the continent must have seen much similar work, both in Maria de Medici's France and at the Imperial Court in Frankfurt. Moreover, both Donne's patron, Sir Robert Drury, and his lifelong friend, Sir Henry Wotton, were very familiar with the art of the Italian Renaissance. Drury made a tour of Italy in 1602 and Wotton, who was there frequently, became the artistic *doyen* of his age—later acting as adviser and agent in Charles I's acquisition of the Duke of Mantua's collection.

Although Shakespeare's acquaintance with great works of art must have been less than Donne's, he shows an obvious familiarity with the work of the miniaturists[22] and himself invented an *impresa*, to be painted by Burbage for the Duke of Rutland's tilt in 1613, that was so obscure as to be incomprehensible to the spectators.[23] For a tilt in the same year Sir Henry Wotton wore two *imprese*, 'the first a small exceeding white pearl, and the words, *sole candore valeo*. The other a sun casting this motto, *Splendente refulgat*.'[24] Both these *imprese* had something in common with that of Queen Elizabeth's champion, George Clifford, Earl of Cumberland, in a miniature painted by Isaac Oliver, now at Greenwich. There the earth is suspended between the sun and moon and the *impresa* bears the motto 'Hasta quen'.

The identification of art and literature with 'real life' is perhaps nowhere so obvious as in the Elizabethan tilts and tournaments for which these *imprese* were devised. Contemporary accounts of tilts sound more like the matter of mediaeval romance than straightforward reportage. Sir Robert Carey, for instance, came to the Coronation Day Tilt of 1593 disguised as 'the forsaken knight that vowed solitarinesse, but hearing of this great triumph thought to honour [his] mistresse with [his] best service, and then to retourne to pay [his] wonted mourninge.'[25] The cause of his appearing thus was the queen's displeasure with his marriage, but it is not improbable that the material of his disguise was suggested by the 'Forsaken Knight' of the third book of the 1590 *Arcadia* who appeared,

> attired in his owne liverie, as blacke, as sorrowe it selfe could see it selfe in the blackest glasse: his ornaments of the same hew, but formed in the figure of Ravens, which seemed to gape for carrion: onely his raynes were snakes, which finely wrapping themselves one within the other, their heads came together to the cheekes and bosses of the bit, where they might seeme to bite at the horse, and the horse (as he champte the bit) to bite at them; and that the white foame was ingendered by the poysonous furie of the combatt. His *Impresa* was a *Catoblepta* which so long lies dead, as the Moone (whereto it hath so naturall a sympathie) wants her light. The worde signified that *The Moon wanted not the light, but the poor beast wanted the Moones light.*[26]

There was a general taste for difficult wit in these *imprese* and Jonson spoke out of tune with his time when he said 'that Done himself for not being understood would perish',[27] for a teasing obscurity was the vogue. Samuel Daniel's treatise *The Worthy Tract of Paulus Iovius, Contayning a Discourse of Rare Inventions, both Militarie and Amorous Called Imprese* (London 1585), instructs that 'an *Imprese* may not exceede three words,[28] . . . that it be not altogether manifest nor too obscure, neither yet triviall or common, . . . [and] that the figure without the mot [motto] or the mot without the figure signifie nothing'.[29]

Many of these *imprese* are reminiscent of contemporary poetical conceits and affirmative of Jonson's belief that 'In small proportions, we just beautie see: and in short measures, life may perfect bee'.[30] The *impresa* is a microcosm of wit and a testimony to the common seventeenth-century belief that great truths may be as well (or better) understood in small things as in large. In the May Day tournament of 1571, for instance, Thomas Coningsby represented his passion for Frances Howard with the device of a white lion devouring a coney and the motto 'Call you this love'.[31] This conceit was, of course, a traditional one, and it finds its expression poetically in Spenser's *Amoretti* 56:

> Fayre ye be sure, but cruell and unkind,
> As is a Tygre that with greedinesse
> hunts after bloud, when he by chance doth find
> a feeble beast, doth felly him oppresse.

More common is the Petrarchan love conceit that, as Sidney renders it, 'in blackest winter night [the poet feels] the flames of hottest sommer day' (*Astrophil and Stella* 89). And it is this ambiguous tension between a black melancholic despair and the torturing fires of love that Hilliard renders in the famous *Unknown Youth against a Background of Flames* (c. 1595, ill. 12). But Wyatt gets Petrarch's contrast more exactly when he says 'I burne and freise like yse'[32] and Isaac Oliver gives us an 'icon' of this in his miniature of a young man, also in flames (c. 1600) with the motto 'Alget qui non ardet' (He freezes who does not burn). And again it is Spenser who handles ironic ambiguities of this conceit most extensively in his *Amoretti* 30.

> My love is lyke to yse, and I to fyre;
> how comes it then that this her cold so great
> is not dissolv'd through my so hot desyre,
> but harder growes the more I her intreat?
> Or how comes it that my exceeding heat
> is not delayd by her hart frosen cold:
> but that I burne much more in boyling sweat,
> and feele my flames augmented manifold?
> What more miraculous thing may be told
> that fire which all thing melts, should harden yse:
> and yse which is congeald with sencelesse cold,
> should kindle fyre by wonderfull devyse?
> Such is the powre of love in gentle mind,
> that it can alter all the course of kynd.

Ben Jonson, who complained of obscurity in Donne, was not himself free from a taste for 'dark conceits', mythological symbol, and arcane chivalric lore.[33] For although his poems are models of Horatian clarity, his masques are elaborate constructions of classical allusion, often quite obscure. Indeed, to look at the margins of the texts of these masques in the Herford and Simpson edition is to see at once, in Jonson's extensive footnotes and references, that one is in a world where, as in the tilts, the delight of the spectator is in discovering the significance of these 'more removed mysteries'. This is the world of Browne's *quincunx* or Bacon's *De Sapientia Veterum*, where the great design of the virtuous and orderly universe is hidden under the simple appearances of things and the tales of classical mythology are charged with deeper truths than history or philosophy.

III

Here again, as with Sidney's *Arcadia*, the distinction between art and life is a difficult one to make. The figure of Chivalry in a cave at the opening of Jonson's *Prince Henry's Barriers* is paralysed or rendered inactive in a way that is not only similar to Spenser's Guyon at the Cave of Mammon but also reminiscent of any number of tilt combatants—of the appearance of Sir John Parrott, for instance, as 'the frozen knight' at the tilt of 22 January 1581.[34] But of course *Prince Henry's Barriers*, though a conscious antiquarian exercise, *was* a tilt. The Prince fought against fifty-six defendants. Nor is it surprising that the Prince, whose painting by Gheeraerts elicits just these qualities of chivalric valour,[35] should be characterized as 'Meliadus, Lord of the Isles' with a shield capable of reviving Chivalry in its ruined house. For Jonson, the creator of the piece, the bricklayer become classical poet, had himself played the role of classical *miles* in 'real life' when 'in his servuce in the Low Countries, he had jn the face of both the Campes Killed ane Enimie & taken opima spolia from him'.[36]

It is this sort of classicism—the mixture of chivalric and antique—that is reflected in Inigo Jones's designs both for a *Squire or Knight Bearing an Impresa Shield* (*c.* 1610) and for the setting of the *Barriers* in St George's Portico—a somewhat bizarre mixture of the classical and gothic modes not unlike Jones's later designs for St Paul's. Indeed, it was this 'festival gothic' that came to be enshrined in the stones of Longford Castle, Ruperra, and especially Bolsover[37]—making Jonson's final fling against Jones (as Iniquo Vitruvius) in the masque *Loves Welcome at Bolsover* (1634) doubly gratuitous.

Jonson was, however, more a classicist than a mediaevalist in his masques, and it is not surprising that Jones's designs reflect the influence of the Italian baroque tradition, both in the theatre and the fine arts. In *Love Freed From Ignorance and Folly* the masquers in the cloud[38] are reminiscent of countless *intermedii* but also of the etchings of engravings of Parmigianino whose work featured in the great collections of the Duke of Arundel and Charles I.

Jonson required of his audience a familiarity with classical literature and mythology, not only in his masques but in his poems and plays as well. Even in the *Conversations With Drummond*, often supposed to have been conducted when Jonson was drunk, his 'characters' of Drayton, Du Bartas, Lucan, and Ovid are all translations from judgements on other poets in Quintilian's *Institutio Oratoria*.[39] Similarly, Jonson's poem 'The Voyage', like Bellini's painting *The Feast of the Gods* (ill. 13), or *Love's Labour's Lost* or *Midsummer Night's Dream*, for that matter, depends for its burlesque effect upon a ready familiarity with and sympathy for the literature of classical antiquity. Jonson was no less demanding of his reader than Isabella d'Este of her painters; the learned style of either 'would not tolerate an unlettered caprice'.[40]

There is a delicate ambiguity in both 'The Voyage' and *The Feast of the Gods*, and each tells us something about how to 'read' the other. Jonson's poem is both an exposé of base moderns who claim (and receive) epic attention for mean actions[41] and a much more gentle satire (addressed to such literati as the members of his 'tribe') on the stuff of classical epic. So too Bellini's painting is both an amused aside on classical mythology (in the manner of Lucian) and at the same time a bemused depiction of the arcane fooleries of the d'Este 'court'. Simply to 'read' either the painting

or the poem one way or the other is to reduce these ambiguities and in that sense to misunderstand the work.

This ready interchange of life with classical art is most obvious in the masque because it so delicately contained the contemporary within the framework of a classical literary spectacle. And the masque, for which Jonson wrote and Jones designed, became transformed into the material of its architectural setting. For the great monument to Jones's Palladianism is not the palatial set for *Oberon* but its successor and legatee, the Banqueting House at Whitehall in which the masques were performed. Once again life imitates art. Summerson says of the Banqueting House that it is 'almost like realising a stage set in permanent materials'.[42] And in his *Apotheosis of James I* on the ceiling of the Banqueting House Rubens celebrated in painting that ascent of the virtues into the clouds that was so often Jonson's subject in the masques. The substance of divine right that is exemplified in the queen turned goddess in a masque is eternalized in Rubens's canvas in a way that echoes not only the majestic triumph of the pagan gods but the assertive majesty of the New Testament tapestries woven in the Mortlake factory.

IV

It is necessary to stress how important 'PICTURE and SCULPTURE', the two 'principal *Gentlewomen*'[43] to architecture were to the shadowing forth of the magnificence of the crown in its buildings. One can no more divorce the plaster panels, derived from Peacham's moral emblem book *Minerva Britanna* (1612),[44] from their architectural setting in the ceilings of Blickling Hall and Boston Manor than the dance from the music or the words in Jonson's masques. And that the effect was intended as total and homogeneous is evidenced in Jones's designs for Wilton where his drawing for a 'baroque' ceiling was carried to its logical artistic conclusion in the painting of an illusory dome done for the Double Cube Room by Emmanuel de Critz.

The work of de Critz at Wilton reminds us once again of the interaction of art, literature and life. For the 'Rubensian' panels done by him for the Single Cube Room are of scenes from the *Arcadia*—a work written not only within the circle of Sidney's sister, the Countess of Pembroke (whose seat Wilton was) but named for her as *The Countess of Pembroke's Arcadia*. And Aubrey remarks, moreover, that not only was Wilton in her time an 'Arcadian seat' but that she laid out the grounds of her house at Ampthill on the basis of the description of Basilius's house or 'lodge' in the *Arcadia*.

> The Lodge is of a yellow stone, built in the forme of a starre; having round about a garden framed into like points: and beyond the gardein, ridings cut out, each aunswering the Angles of the Lodge: at the end of one of them is the other smaller Lodge, but of like fashion; where the gratious *Pamela* liveth: so that the Lodge seemeth not unlike a faire *Comete*, whose taile stretcheth it selfe to a starre of lesse greatnes.[45]

The garden in the *Arcadia* is a traditional moral emblem. Not only is Pamela the star of virtue, like the 'Stella' of Sidney's *Astrophil and Stella*, but the five-angled lodge with its gardens is a living 'sign' of the avenues (the five senses) by which that virtue may be assailed. Nor is this merely a pastoral conceit. The moral combats of the *Arcadia* are externalizations of the inner

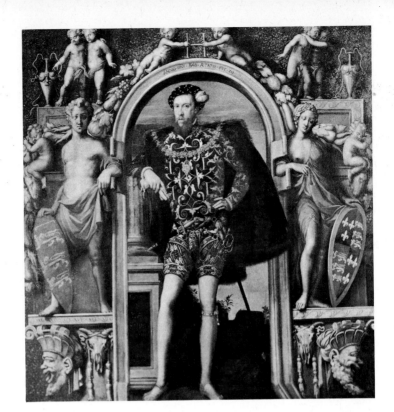

William Scrots *Henry Howard, Earl of Surrey,* *c.* 1550 oil on canvas 87½ × 86½ in. (222 × 219.5 cm.) Collection the Duke of Norfolk, Sussex. Reproduced by kind permission of the Duke of Norfolk

George Gower *Queen Elizabeth I, c.* 1588 oil on panel 41½ × 52½ in. (105.5 × 133.5 cm.) From the Woburn Abbey Collection, Bedfordshire. Reproduced by kind permission of the Duke of Bedford

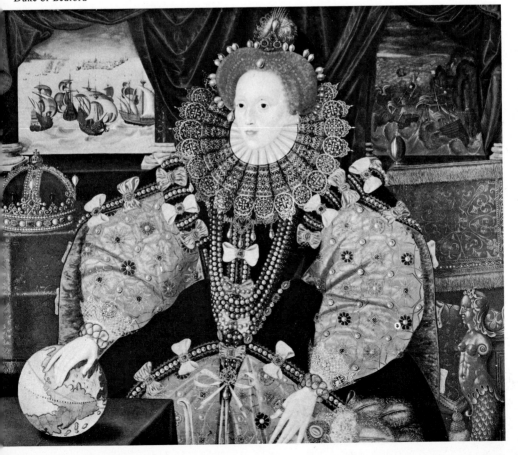

10 Unknown artist *John Donne, c.* 1595 oil on panel 29½ × 24 in. (75 × 61 cm.)
Collection the Marquess of Lothian, Derby. Reproduced by kind permission of the
Marquess of Lothian

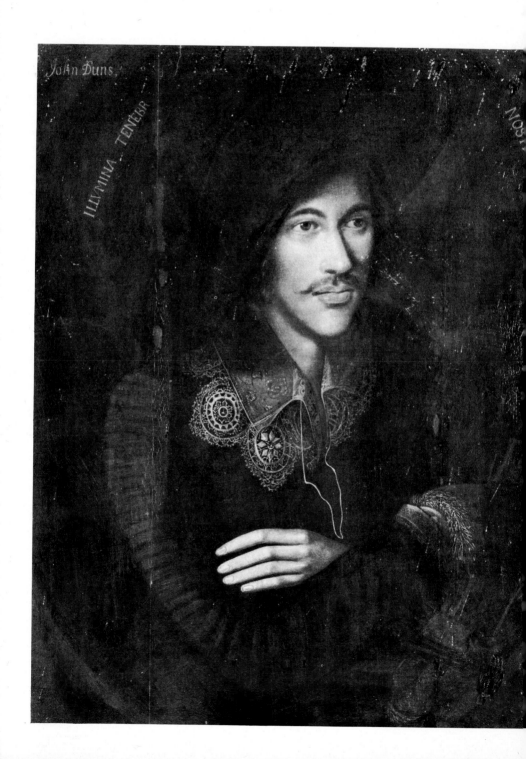

Hans Eworth *Sir John Luttrell* 1550 oil on panel 43½ × 33 in. (110.5 × 84 cm.)
The Courtauld Institute of Art, London

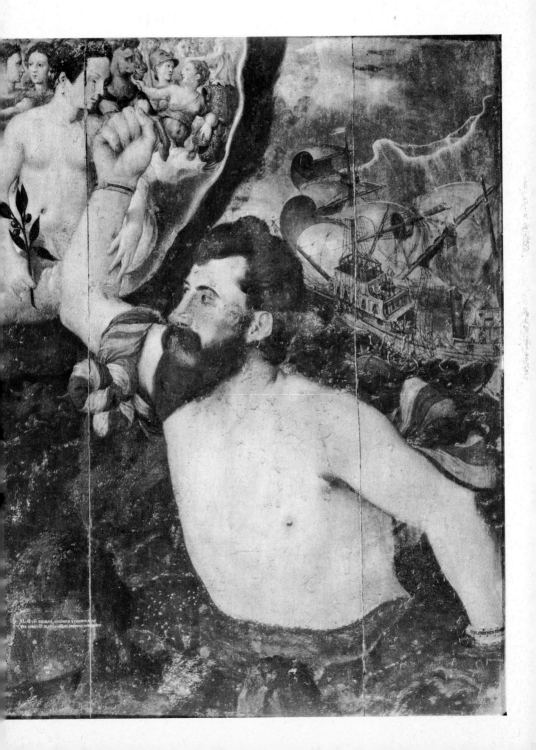

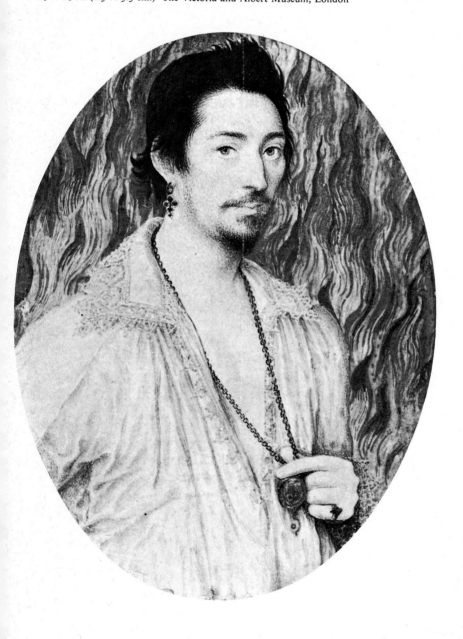

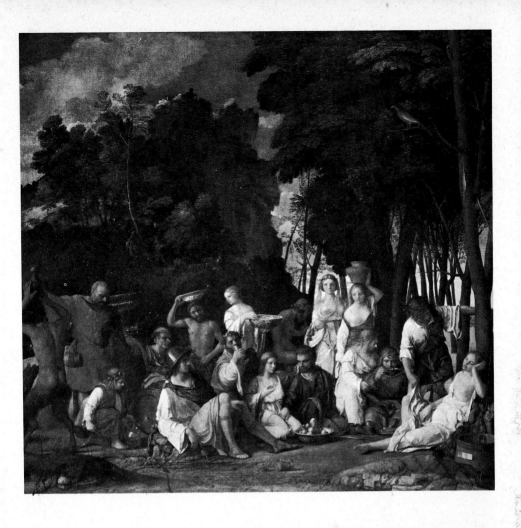

Grav'd by Sim. Gribelin from the Painting of P.P. RUBENS on the Ceiling
in the Banqueting house at WHITE HALL on the Year ...

15 Simon Gribelin, engraving (1720) of Rubens's painting on Banqueting House ceiling.
Painting 1622 oil on canvas, total dimensions 110 × 55 ft (33.5 × 16.75 m.)

16 Correggio *The Mystic Marriage of St Catherine, c.* 1514 wood 52⅛ × 48⅜ in.
(134.5 × 123 cm.) Detroit Institute of Arts, Detroit

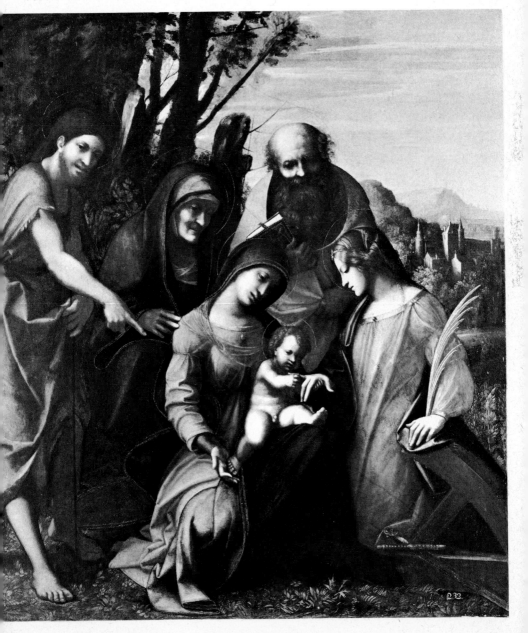

17 Nicolas Poussin *The Testament of Eudamidas*, c. 1655 oil on canvas 43½ × 54⅜ in. (110.5 × 138 cm.) The Royal Museum of Fine Arts, Copenhagen

18 Nicolas Poussin *Extreme Unction*, c. 1644 oil on canvas 46⅛ × 70⅛ in. (117 × 178 cm.) Collection the Duke of Sutherland, on loan to the National Gallery of Scotland, Edinburgh

19 Pietro da Cortona *Tancredi wounded after the duel with Argante, c.* 1640–5 oil on canvas
35½ × 48½ in. (90 × 123 cm.) Collection Professor Briganti, Rome

20 Nicolas Poussin *The Israelites Gathering the Manna, c.* 1637–9 oil on canvas
58⅜ × 78 in. (149 × 198 cm.) Musée du Louvre, Paris

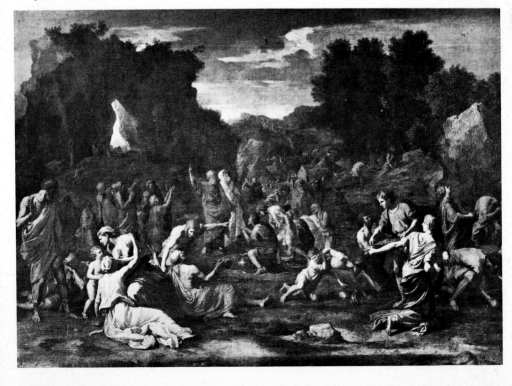

21 Nicolas Poussin *Landscape with a Man Killed by a Snake* 1648 oil on canvas
47 × 88¼ in. (119.5 × 224 cm.) National Gallery, London

22 Nicolas Poussin *Landscape with the Body of Phocion Carried out of Athens* 1648
oil on canvas 44⅝ × 68⅞ in. (114 × 175 cm.) Collection the Earl of Plymouth, Shropshire

23 Nicolas Poussin *The Ashes of Phocion Collected by his Widow* 1648 oil on canvas
45⅝ × 69¼ in. (116 × 176 cm.) Collection the Earl of Derby, Lancashire

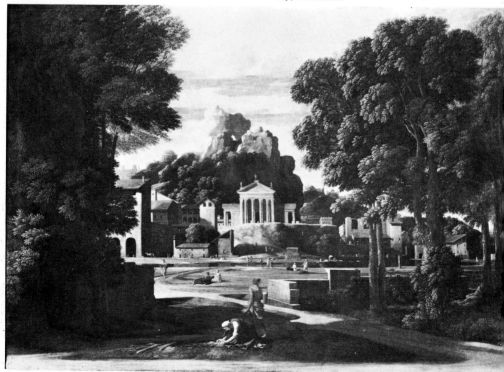

moral struggle of the main story. Their emblem is a felicitous combination of Gawain's pentangle and Milton's garden, and the ambiguous tension between luxuriance and restraint that is the preoccupation of Milton's 'blest pair' (and of the Lady in *Comus*) is further exemplified in Marvell's 'skilful gardener' (Is he God or Fairfax, or both?) in 'Upon Appleton House' where the five-pointed figure also reappears.

> From that blest Bed the Heroe came,
> Whom *France* and *Poland* yet does fame:
> Who, when retired here to Peace,
> His warlike Studies could not cease;
> But laid these Gardens out in sport
> In the just Figure of a Fort;
> And with five bastions it did fence,
> As aiming one for ev'ry Sense.
>
> (St.36, 11.281-6)

What is true of the interaction between heroical virtue and its landscape or architectural setting, however, is even truer of the 'magnificence' that is Spenser's theme in *The Faerie Queene* and James I's intention in the Banqueting House at Whitehall. Indeed, we might take Spenser's text and apply it to the King's enterprise: 'I meane glory in my general intention'.[46] But this was not any glory, but the manifestation of the greatness of the Stuart state and the resolution of all discords into the chaste harmonies of an architectural monument.[47] The 'spiritual geometry' of the *Arcadia* with its elaborate pattern of balanced parts and complementary divisions had its architectural complement in the geometrical perfection of the Single and Double Cube Rooms at Wilton, as the plan of Longford Castle, with its three towers and connecting passages, reaffirmed in stone the mystery of the Trinity.[48] But James's design (or Jones's) went beyond the piety of Longford or even the elaborate mediaeval devotionalism lavished by Sir Thomas Tresham on his three-sided lodge at Rushton or his cruciform house at Lyveden. The Banqueting House was to be nothing less than the palace of the New Jerusalem,[49] that 'Sabeoth Sight' for which Spenser had asked at the end of *The Faerie Queene*, realized in stone.

In the hall the raised dais with the Chair of State on which the King was both spectator and actor (as divine presence) in the masques, was also the centre of the great occasions of state—the reception of ambassadors, signing of treaties, etc.—that were the ceremonious stuff of Stuart statecraft. And Jones's use of light as a 'glory' above and behind this chair was learned as much from the masques as from books of architecture.

The early descriptions of the Banqueting House speak of a 'greate Neech' (niche) at the south end in which the Chair of State stood.[50] It was of about the same dimensions as the window above it, a symbolic foil for the King, done in 'gilded fretwork against a dusky green-blue background'.[51] It seems to have had something in common with Jones's proposed setting for the judgement seat of James, the British Solomon, in the new Court of Star Chamber,[52] and of course was echoed by the niche behind the King in Rubens's final apotheosis painting immediately above the dais. And both in their turn have affinities with Bacon's description of the Banqueting Hall of the Tirsan (or father of the family) in 'Salamon's House' in the *New Atlantis*.

> On the feast-day, the Father or Tirsan cometh forth after divine service into a large room where the feast is celebrated; which room hath a half-pace at the upper end. Against the wall, in the middle of the half-pace, is a chair placed for him, with a table and carpet before it. Over the chair is a state [canopy], made round or oval, and it is of ivy. . . . And the state is curiously wrought with silver and silk of divers colours, broiding or binding in the ivy. . . .[53]

Now in that work (*New Atlantis*) Bacon makes it very plain that the enterprise of 'Salamon's House' is derived from the Solomon of the Old Testament. And it is more than a little tempting to see this description (written about 1617) as an account of what Bacon expected, philosophically and architecturally, of his learned king in the enterprise of Whitehall.[54] And Bacon, as Privy Councillor co-opted to James's commission on the rebuilding of the Banqueting House, could scarcely have been unaware of the significance of his description of just such a hall and its ceremonious importance. Both 'Salamon's House' and the British Solomon claim the same ancestor, and the manifestation of this is a delicate balance of politics, religion, philosophy and art.

The chaste orders and gilded fretwork of the Banqueting House are the manifestations of *realpolitik* on the one hand and of philosophical idealism and divinity on the other; they may help us to understand the 'political' weight of something as fragile as *Oberon* or *The Masque of Augurs* (that were performed beneath them). For the transformation of imaginative setting (be it Bacon's description or Jones's sets) into stone was an attempt to realize in the world of the everyday the visionary and the eternal. The masque is the vehicle by which the ideal descends (literally, in the sense of the cloud machines) into the temporal, as 'divine philosophy' is a stage on the ascent from the 'real' world to the realm of grace. So too the Banqueting House, both in Jones's construction and Rubens's great ceiling (ill. 15), is a testament to that tension between the solid matter of temporal stuff and the signs and emblems of eternity that it contains, for it is towards that eternity that the struggling figures of Rubens's paintings aspire.

> O *London*, blessed M^rs of this happy Brittaine, build new thy Gates, ther's *peace* entering at them . . . Let *White-Hall* (fit embleme for her purity) be her chiefe Pallace, and let it say, *Ades alma salus* [Let here be the mother of prosperity, or salvation].[55]

Again, it is Spenser's lines that come to mind when we attempt to describe the visionary accomplishments of this Jacobean enterprise—Redcrosse's vision of Cleopolis:

> . . . The Citie of the great king hight it well,
> Wherein eternall peace and happinesse doth dwell.
>
> <div align="right">(Faerie Queene I.X.55)</div>

It was the creating of that 'eternall peace' that was James I's avowed intention and it is the consummation of that intention that the ceiling of the Banqueting House celebrates. In this, poetry as well as the other arts is the means both of exhorting and celebrating the ability to 'grow in effect into another nature'. Our proper haven, says Donne, is heavenly Jerusalem, but we have our models here: 'Peace in thy house, peace in thy heart, is a faire Modell, and a lovely designe even of the heavenly Jerusalem which is *Visio pacis*, where there is no object but peace'.[56]

V

Jonson's world, like Jones's, is also the world of Spenser and Shakespeare, where the real and the ideal consort easily with one another in a world of art that is a pattern of their resolution. The world of grace, as *The Tempest* or *The Winter's Tale* reminds us, infuses the world of nature by means of graciousness. Giulio Romano's 'statue' of Hermione is a living thing that 'beguile[s] Nature of her custom', and, resurrected with music like Eurydice, is grace's instrument within the court. Her flesh, like that of Rubens's deities, is not put away but is 'a mark of Grace'. For Spenser, as for Jonson, there was a tension between the world of nature, the *realpolitik* of the court, and the world of grace that gathered up the mythological ideal into the divine, but that tension was one of differences not contradictories. 'Heavenly Love' is not the same as 'Love' for Spenser, but its difference is in the sense that it is a greater truth and subsumes the other as the love of Christ, manifested at Easter, subsumes and transforms Spenser's amatory passion in *Amoretti* 68.

In Spenser, and in *The Faerie Queene* in particular, the rigid distinctions that we tend to enforce between the 'real' or historical, the scriptural, the mythological, and the emblematic or allegorical drop away, and in a way that is curiously similar to many of the masques.[57] The Sir Scudamour of book IV of *The Faerie Queene* is modelled on that gallant pattern of Elizabethan chivalry, Sir James Scudamore, who accompanied Essex on the Cadiz expedition, but he is also the type of the natural virtuous knight, and his failings, such as they are, are the failings of fragile nature. We 'read' him as we 'read' Eworth's Luttrell, as a historical man who 'incarnates' in a particular historical situation the ideal which is also his quest. The tender interchange in Eworth's painting between the real world of raging seas and the ideal world of gracious deities reminds us that the relation between Scudamour's undoubted prowess and his need for assistance from Britomart is one that admits of many intermediate stages as nature moves with the assistance of gracious fortitude towards grace. Indeed, the ideal world of the Temple of Venus that Scudamour describes in the tenth canto of book IV is reminiscent of the 'Hymne of Love' (also published in 1596) in the easy familiarity with which the allegorical, the mythological, the historical, and the Scriptural figures consort one with another. Delay and Doubt rub shoulders with Janus, and Damon and Pythias find themselves in the company of Jonathan and David. But all this would be readily understood by Spenser's audience whose tastes in the fine arts tell us as much as Christine de Pisan does about Spenser's mode.

The ceiling of Boston Manor (1622) with its mixture of the three theological virtues, the four elements, the five senses, and Peace, Plenty and War—all complemented by an overmantel in the same room of Abraham and Isaac—is a good beginning, but closer to Spenser's (or Scudamour's) description is the great screen in the hall at Burton Agnes (ill. 14), probably erected between 1600 and 1610. There a row of figures consisting of the twelve tribes of Israel, the nine Sibyls, and moral figures like Nobility and Liberality is surmounted first by a tier of the four evangelists and then by the twelve apostles. The top row of the screen proper[58] contains in the centre panel a knight in armour with a cross on his breastplate and shield, and flanking this figure are panels with angels standing before a heavenly city, the angel on the left leading by the hand another knight. The meaning of this tier

of the screen is obscure, but tradition has it that the kneeling knight, like the knight setting out on a quest in the middle panel of the tier below, is Sir Henry Griffith, the builder of the house. More interestingly, the central figure of the top tier wears the armour of a crusader and may be either St George or, as is not improbable, Redcrosse himself.

It matters less, however, whether this figure be Redcrosse or St George than that the various sorts of figures within the screen (allegorical, scriptural, etc.) have an easy commerce with one another in their subservience to a total heroic and virtuous design. The real Sir Henry, like Eworth's Sir John, finds nothing odd in setting out from a real city, which is also the terrestrial Jerusalem of the apostles who surround him, nor in arriving at the Sabeoth Sight of the New Jerusalem. For it is the business of such art, as it is the business of poetic invention, to deal with the world of brazen nature as it moves towards the realm of the golden. In that sense both poetry and art are instruments of grace and both tell us something about the frame of mind in which we read the other.

Spenser's description of Venus's reconciliation between Love and Hatred, issuing in Concord, Peace and Friendship (*Faerie Queene* IV.X.32–4) is not a programme for Rubens's Banqueting House ceiling, but it indicates to us how, to the audience of both, the ideal world might be both the directive and the reward of the real. And it is in this sense that Sidney translated the word *mimesis* as a 'speaking picture' to celebrate the fecund power of imaginative genius untrammelled by the tyranny of mere natural 'reality'.

> Only the poet, disdaining to be tied to any such subjection, lifted up with the vigour of his own invention, doth grow in effect into another nature, in making things either better than Nature bringeth forth, or, quite anew Her world is brazen, the poets only deliver a golden.[59]

It is the celebration of that difficult and magnificent delivery that is the subject of so much poetry and art of stature in the English Renaissance.

Notes

1 John Evelyn, *Diary*, ed. E. S. de Beer (Oxford 1955), III, p. 304.
2 Ellis Waterhouse, *Painting in Britain, 1530–1790* (London 1953), p. 19.
3 *v.* Roy Strong, *Portraits of Queen Elizabeth I* (Oxford 1963).
4 *v.* Erna Auerbach, 'Portraits of Elizabeth', *Burlington Magazine* (1953), where she refers to 'the superb expression of an almost heraldic monument of the Queen', p. 205. Cf. Bellini's portrait of Doge Leonardo Loredan (*c.* 1501) in which the Doge's ceremonial robes transform him into an image of the Venetian state.
5 Strong, op. cit., p. 153.
6 Similarly Hooker's concern 'that posterity may know we have not loosely through silence permitted things to pass away as in a dream', which forms the apology for his writing *The Laws of Ecclesiastical Polity* echoes Herodotus's reason for publishing his researches—'that the actions of men may not be effaced by time, nor the great and wondrous deeds displayed both by Greeks and barbarians [foreigners] deprived of renown'.
7 Sidney only *appears* to think so in *Astrophil and Stella* 1. His very appeal, 'look in thy heart and write', is derived from Petrarch. Milton makes the desire for novelty a prerogative of Satan's legions in *Paradise Lost*.
8 Cf. Wind's treatment of this 'gallant touch of encomium' in his analysis of Giorgone's *Three Philosophers* in *Giorgone's Tempesta* (Oxford 1969), p. 28, n. 33.
9 Thomas Browne, *Works*, ed. G. Keynes (London 1929), I, p. 169. It is also similar to the conceit in Nicholas Hilliard's portrait of a man (1583), now in the National Museum in Stockholm, in which the portrait, contained in an elaborate casket with a crucifixion on the back, is inscribed 'Non poco de Che se Medissimo dona' (He who gives himself gives no small thing).
10 Burton's *Anatomy of Melancholy* and Dowland's *Lachrymae* are two other popular examples of this vogue.
11 The 'blasphemy' here is analogous to Wyatt's use of Christ's warning to Mary Magdalen, 'Noli me tangere' (Touch me not), as a way of giving an ironic dimension to his sonnet (ostensibly on Anne Boleyn) 'Whoso list to hunt'.
12 I am indebted for this observation to John Sparrow, *Visible Words* (Cambridge 1969), p. 84. Sparrow remarks further that 'Donne is here playing the part of the melancholy lover'.

13 The ambiguous mode of the portrait, its dramatic tension, is apparent also in several of Hilliard's miniatures. The portrait of Lady Elizabeth Stanley (in the collection of Lord Bearsted) has 'in the sky the common emblem of love, a heart transfixed by an arrow, and is inscribed on the face, 'facies mutabilis/sed amor stabilis/semel missa semp fixa', while at the back there is the more private record in ink 'Demitte nichi Deus/ parce Deus'. G. Reynolds, 'The Painter Plays the Spider', *Apollo* 79 (1964), p. 283. Reynolds also suggests that Hilliard's *Man Aged Twenty-four in 1572* (in the Victoria and Albert Museum) wears a green thistle to symbolize love and joy (a difficult love?) and a black suit to signify grief and constancy. Certainly this 'traditional suffering but faithful lover' would be recognized at once by readers of Sidney or Donne.

14 The frontispiece to 'Death's Duell' is taken from this statue.

15 It is worth noting here that the Lothian portrait was left by Donne to his friend Sir Robert Ker and that Donne's circle was under the patronage of the Countess of Bedford who not only possessed the Armada portrait but was a frequent participant in the elaborately symbolic court masques of Ben Jonson which Queen Anne (of Denmark) made so popular at the court of James I.

16 John Donne, *The Sermons*, ed. G. R. Potter and E. M. Simpson (Berkeley, California, 1956), VIII, p. 220.

17 *v.* J. D. Redwine, 'Beyond Psychology', ELH 28 (1961), pp. 316–34.

18 For a discussion of this painting *v.* Frances Yates, 'The Allegorical Portraits of Sir John Luttrell', *Essays in the History of Art Presented to Rudolf Wittkower* (London 1967), pp. 149–60. The allegorical use of peace is also present in the anonymous portrait of Sir Edward Hoby at the Tate Gallery. A similar, though less complex, use of this theme is in Lawrence Hilliard's miniature of Margaret Russell, Countess of Cumberland, in which the clouds behind her head are inscribed with the motto 'Constant in the midst of inconstancey'. The mixing of two apparently dissimilar genres in Renaissance painting is not uncommon. Titian's painting *The Vendromin Family Adoring a Reliquary* is both a religious subject and a touchingly familiar family portrait.

19 Cf. Hilliard's miniature of a young man clasping a hand from a cloud who is surrounded by the motto 'Attici amoris ergo'. Here is a rejection of earthly for intellectual or heavenly love in Spenserian terms, though the 'Attici' may be as ambiguous as Shakespeare's 'Grecian tires'.

20 *v.* note 13 sup.

21 *v.* E. Wind, *Giorgone's Tempesta*, p. 3. What is also of interest to us in Giorgone is the way in which the contemporary and the allegorical sit happily together in his work. As Wind points out, 'in many respects Giorgone's way of combining idealized figures, drawn from legend, with vernacular figures in contemporary costume prepares for the Venetian grand style of composite allegory in which Veronese was later to excel', p. 14. This 'composite allegory' is also evident in Rubens's *Life of Maria de Medici* and in the Banqueting House ceiling at Whitehall *v.* pp. 50 foll.

22 *The Winter's Tale* I.ii.356; *Twelfth Night* III.iv.228; *Henry VIII* II.ii.32.

23 What this *impresa* looked like is unfortunately not known, but its obscurity was not peculiar in its time. This fashion for obscure *imprese* is not dissimilar to the earlier fashion (which continued into Shakespeare's time) for rebuses—a hat and a tun for Hatton, and so forth. Cf. Bacon's

praise of 'strangeness' in these things in his account of jousts, tourneys, and barriers in his essay 'Of Masques and Triumphs'.

24 *The Life and Letters of Sir Henry Wotton*, ed. L. P. Smith (Oxford 1907), II, p. 17.

25 *Memoirs of the Life of Sir Robert Carey* (Edinburgh 1759), p. 68.

26 Philip Sidney, *Works*, ed. H. Feuillerat (Cambridge 1912), I, p. 455. Frances Yates deals at greater length with the biographical elements in the Arcadia in her article, 'Elizabethan Chivalry: The Romance of the Accession Day Tilts', JWCI 20 (1957), pp. 4–25.

27 Ben Jonson, *Conversations With Drummond of Hawthornden*, *Works*, ed. C. H. Herford and P. Simpson (Oxford 1925), I, p. 138.

28 The Luttrell portrait in its two mottos fulfils this condition: 'Nec flexit lucrum' (Neither swayed by gain), 'Nec friget discrimen' (Nor deterred by danger). *v.* F. Yates, n. 18 supra.

29 Samuel Daniel 'To the Reader', sigs. [A₆ᵛ–A₇]. Cf. the cautions against the motto or 'word' being too plain given both by Jonson's master Camden in his *Remains Concerning Britain* (London 1674), pp. 447–8, and by Bruno in his *De gli Heroici Furori*, ed. Francesco Flora (Turin 1928), p. 99. Bruno's hermetical interests were, of course, very similar to the occult numerology espoused by Sir Thomas Browne. *v.* also J. Meagher, *Method and Meaning in Jonson's Masques* (Notre Dame, Indiana, 1966).

30 Jonson, 'To the Immortal Memorie, and Friendship of that Noble Paire, Sir Lucius Cary and Sir H. Morrison', *Works*, VIII, p. 245. Cf. Donne in 'The Storme': 'a hand, or eye by *Hilliard* drawne, is worth an history, by a worse painter made'.

31 Strong, 'Elizabethan Jousting Cheques in the Possession of the College of Arms', *The Coat of Arms* 5 (1958), p. 92.

32 The sonnet, 'I fynde no peace and all my warr is done'.

33 In the *Conversations*, for instance, Jonson deplored 'that Panagyrist who wrott Panagyriques in acrostics [and] Windowes crosses' (*Works*, I, 144), and yet in *For the Honour of Wales* he managed to twist 'Charles Iames Stuart' into 'Claimes Arthurs seat'. Drummond's claim that he wrote an account for Jonson of a bedcover worked with *imprese* by Mary Queen of Scots during her captivity also indicates a taste for such things. For an account of this *v.* E. M. W. Talbert, 'The Interpretation of Jonson's Courtly Spectacles', PMLA 61 (1946), pp. 454–73, and D. T. Starnes and E. M. W. Talbert, *Classical Myth and Legend in Renaissance Dictionaries* (Chapel Hill, NC, 1955).

34 Strong, 'Elizabethan Jousting Cheques', p. 8. Strong also points out that the tilt costume worn by the Earl of Cumberland in Oliver's miniature (*v.* supra, p. 12) is very similar to Jones's later designs for the masques—'Inigo Jones and the Revival of Chivalry', *Apollo* 86 (1967), pp. 102–7. This Jacobean interaction of life and art has as its apogee that absurd conjunction of pastoral romance and *realpolitik* in which Charles I (as Prince of Wales) and the Duke of Buckingham set out for Spain disguised as shepherds in 'Arcadian' costumes costing tens of thousands of pounds. Charles's attachment to the *Arcadia* and the world of pastoral, mythological and political idealism that it represented is evidenced in Milton's attack on him (in *Eikonoklastes*) for having used Pamela's 'pagan' prayer from the *Arcadia* on the night before his execution.

35 This connexion is strengthened by the fact that the influence of Gheeraerts on Jones was 'considerable' (*v.* Strong, 'Inigo Jones and the Revival of Chivalry').

36 Jonson, *Conversations With Drummond, Works,* I, p. 139. Similarly Sidney, whose action in refusing the cup of water at Zutphen became the famous example of a chivalric ideal, did no more than imitate the story of Arrian about Alexander the Great's refusing, before all his men, a cup of water in the Baluchistan desert.

37 *v.* F. Yates, 'Elizabethan Chivalry: The Romance of the Accession Day Tilts', JWCI 20 (1957), pp. 4–25.

38 Cf. Peace and the other deities—Venus and Mars, the three Graces, and Friendship—in the Luttrell painting by Eworth, supra, ill. 11.

39 *v.* Jonson, *Conversations,* ed. K. F. Patterson (London 1923), pp. xxxv and xxxvi.

40 E. Wind, *The Feast of the Gods* (Cambridge, Mass., 1948), p. 3. This Mantuan taste for classical mythology as an ironic comment on present occasions and persons extends to Monteverdi's *Ballo dell'ingrate* where the ladies of the Mantuan court (under the guise of classical *personae*) are comically sentenced to a hell of silence.

41 Cf. Milton's treatment of Satan and his 'moderns' in *Paradise Lost* I and II.

42 J. Summerson, *Architecture in Britain, 1530–1830* (London 1953), p. 71.

43 Sir Henry Wotton, 'The Elements of Architecture', *Reliquae Wottoniae* (London 1672), p. 49.

44 Peacham's emblems were in turn derived from James I's book of political philosophy, *Basilikon Doron.* For a larger account of the influence of emblem books *v.* R. Freeman, *English Emblem Books* (London 1948).

45 Sidney, *Works,* ed. Feuillerat, I, p. 91.

46 Spenser, 'The Letter to Ralegh', *The Faerie Queene.* For an account of the intention and building of the Banqueting House *v.* Per Palme, *Triumph of Peace: A Study of the Whitehall Banqueting House* (London 1957), to which I am much indebted in the following pages. Palme notes that even 'the order of a procession was in itself a work of art, a form expressive of the most lofty social values, those of honour and glory' (p. 58), and that the Banqueting House was 'built as a stage for the display of royal might and glory' (p. 120). Jonson's *Entries* designed for the first entry of James I into London are important forerunners of this sort of classical magnificence.

47 Cf. Jonson's *Newes From the New World, Discovered in the Moone* in which the King's person, better than 'Designe & Picture' was the model of all 'pure *harmonie*', *Works* VII, 513 foll.

48 Sir Thomas Gorges, the fanciful Elizabethan who built Longford Castle to vie with the splendours of Mary Sidney's Wilton, was the uncle of Spenser's friend Arthur Gorges. He had an equally arcane tomb erected in Salisbury Cathedral in 1635, where a globe made of pentangles, whose emblematic geometry is reminiscent of Browne's *quincunx* and the five-angled lodge of the *Arcadia,* surmounts an urn at the pinnacle of the monument. And the message of Browne's *Urne Buriall* is evident in the inscription on the urn, 'ab urna ad aetherem'.

49 Countless early seventeenth-century sermons are a testament to James as the British Solomon, and one of Rubens's three panels depicts him

thus, reconciling the rival claims of England and Scotland in one crown. A common notion, moreover, was that the harmonic pattern of Greek and Roman architecture was derived from the temple of the Biblical Solomon. *v.* G. B. Villapando, *In Ezechielem Explanationes* (Rome 1596–1605) and R. Wittkower, *Architectural Principles in the Age of Humanism* (London 1949), pp. 106 foll. Cf. also James's court preacher, Lancelot Andrewes: 'The *Rabbins*, in their *Speculative Divinitie*, doe much busy themselves to shew, that, in the *Temple*, there was a modell of the whole world, and that all the *Sphaeres* in heaven, and all the *Elements* in earth were recapitulate in it.' *XCVI Sermons* (London 1629), sig. [Xx$_4$v].

50 Jones's preliminary plan also shows this niche.

51 Palme, op. cit., p. 198.

52 Palme describes this, op. cit., p. 188, as 'the key to Inigo's conception of the hall'.

53 Francis Bacon, *Works*, ed. J. Spedding and R. L. Ellis (London 1857), III, 148. The use of the ivy is also similar to the Chair of States for the French King in Dorat's masque, *Magnificentissima spectaculi . . . a regina . . . descriptio* (Paris 1573).

54 Bacon must have been disappointed that the king's only academy was the miserable and abortive college for theological disputations founded at Chelsea in 1609. His description of the ceremonial in the hall of the Tirsan is too similar to the Jacobean ceremonial for the Feast of the Garter or the reception of ambassadors to avoid the implications of statecraft as well as philosophy in his work. The importance of architecture to statecraft is made explicit (again in terms of the Old Testament) in his essay 'Of Building' published in 1625.

55 *The Peace Maker: or Great Brittaines Blessing* (London 1619), sig. [A$_4$v], probably chiefly by Lancelot Andrewes.

56 Donne, 'A Sermon Preached at Whitehall, March 8, 1621 [1622]' *Sermons*, ed. Potter and Simpson, IV, 49.

57 This identification of different 'levels' of significance is also basic to Donne's mode in *The First Anniversarie*.

58 Perched on top of the screen itself are the seven virtues.

59 Sidney, *An Apology for Poetry*, ed. G. Shepherd (London 1965), p. 100.

Ut pictura poesis:
Dryden, Poussin and the parallel of poetry and painting in the seventeenth century

Dean Tolle Mace

Since the publication of Lessing's *Laocoön* in 1766 the famous sisterhood of poetry and painting which flourished in theory and in fact from the middle of the sixteenth to the middle of the eighteenth century has not been much praised or even understood. This has been unfortunate for the seventeenth century, a period in which Horace's maxim *ut pictura poesis*, although productive of some vain learning and some bad art, was a living idea which nourished some great painterly imaginations. Without the doctrine we should not have many of the notable works of Nicolas Poussin, who shares place with Rubens at the head of seventeenth century painting. And without some understanding of the doctrine we are unable to see many of Poussin's pictures as they were seen by his patrons and contemporaries. For this reason alone (and there are others) the venerable parallel of the arts is worth further discussion, particularly since Lessing's disapproval of the sisterhood among the arts has continued to influence art historians and critics of our own time as they have reviewed the seventeenth century.[1]

How did the parallel of poetry and painting come into being? Why was the seventeenth century so obsessed with the sisterhood of the two arts as to have been thought to have confused them? Professor Lee suggests that *ut pictura poesis* was the result of an Italian need—felt by painters since the time of Leonardo da Vinci—to elevate painting into the lofty company of the liberal arts. To do this painters had to have a body of theory and philosophy; and since there were no treatises on painting left from antiquity they had to turn to the great ancient theorists of poetry, Aristotle and Horace, both of whom had made enough incidental commentary on painting to invite the attention of theorists. But, alas, the Italian and later the French theorists, carried away by their admiration for antiquity, were unable to confine themselves to the few and incidental parallels suggested by these passages, and unwisely took over the general Aristotelian-Horation theory of poetry for application to painting. The theory of painting that results, continues Professor Lee, could not fail 'to show much that was pedantic and absurd if it was not absolutely false, for imposing on painting what was merely a reconditioned theory of poetry, the enthusiastic critics did not stop to ask whether an art with a different medium could reasonably submit to a borrowed aesthetic'.[2]

Dryden's 'Parallel of Poetry and Painting' which he prefixed to his translation of Du Fresnoy's *De Arte Graphica* (1695) very elaborately gives to painting the borrowed aesthetic to which Professor Lee objects, and in doing so sums up the parallel of the arts as it was developed in France and exported to

England. Dryden is here and there absurd, as in his singular opinion that warts and moles in portraits resemble flaws in tragic heroes. But he is never pedantic. He shows plainly to any sympathetic reader that the parallel of the arts was *not* manufactured to give more impressive credentials to painting; but that it grew out of his conviction and the conviction of the age that all great art must treat great human subjects. This being so, all great art must thus be parallel in some way to poetry, the art which had been perfected through the ages to deal with great human subjects. Lessing's notion that the aim of any art is merely to represent 'beauty' would have baffled Dryden as it would have baffled any other seventeenth-century critic.

Dryden's 'Parallel' although one of the best statements of the idea as it was developed in the century, is not one of Dryden's best critical essays. It is a hasty and careless piece of writing. By his own account he did not wish to interrupt his translation of Virgil to undertake the essay. Moreover he was intelligently aware that England was not rich in pictures for his own study. Most of the great collection of Charles I had been sold by the Puritans, and the other notable collections such as those of the Duke of Buckingham and the Earl of Arundel had been dispersed. He mentions 'some pieces of Raphael, Titian, Correggio, Michael Angelo and others' with which England was furnished, but he is mysteriously silent as to what he had actually seen.

Dryden's 'Parallel' had a long life and was much discussed in the eighteenth century, being re-published in 1718 along with Pope's *Epistle to Jervis* and again in 1783 by Mason.[3] Pope spoke highly of the piece, but after his time the essay was not so greatly admired. It had no relevance to the eighteenth-century craze to relate landscape painting and poetry. Modern critics have either ignored or scorned Dryden's occasional wisdom, while sometimes falsely imagining that Lessing's views are applicable to the seventeenth century.

Dryden opens his 'Parallel' with some quotations from Bellori's *Idea of a Painter* whose first paragraph informs us that the painter and sculptor imitate God by forming 'to themselves, as well as they are able, a model of the superior beauties; and reflecting on them, endeavour to correct and amend the common nature, and to represent it as it was first created, without fault, either in colour, or in lineament'.[4] Bellori's most instructive point to Dryden was probably not his Neo-Platonic commonplace but the highly un-Platonic revelation that 'beauty' in painting did not consist of some set of ideal and unalterable 'proportions' but rather the perfect representation of each thing according to its kind. 'The idea of . . . beauty,' says Bellori, 'is indeed various, according to the several forms which the painter or sculptor would describe. . . .' These 'forms' are human qualities, states of temperament and soul. Dryden is interested in a similar point as it was made by Philostratus, whom he claims to translate 'almost word for word': 'He who will rightly govern the art of painting, ought of necessity first to understand human nature. He ought likewise to be endued with a genius to express the signs of their passions, whom he represents.' The painter 'will exquisitely represent the action of every particular person, if it happen that he be either mad or angry, melancholic or cheerful, . . . in one word, he will be able to paint whatsoever is proportionable to any one'.[5]

Beauty in the visual arts has become detached from a Platonic idea of perfection, from mystical Pythagorean ratios, even from the empirical proportions of Leonardo and Dürer, and has become identified with the expression of human actions and passions.[6] Dryden sees the parallel between

the arts, therefore, as founded on their common treatment of human action and passion.

> The subject of a poet, either in Tragedy or in an Epic Poem, is a great action of some illustrious hero. It is the same in painting; not every action, nor every person, is considerable enough to enter into the cloth. It must be the anger of an Achilles, the piety of an Æneas, the sacrifice of an Iphigenia, for heroines as well as heroes are comprehended in the rule; but the parallel is more complete in tragedy, than in an epic poem. For as a tragedy may be made out of many particular episodes of Homer or of Virgil, so may a noble picture be designed out of this or that particular story in either author.[7]

Poussin, no less than Dryden, believed that painting should, like poetry, be an 'imitation of human action'. Poussin copied this phrase from Tasso's *Discorso del poema eroico*, merely substituting 'pittura' for 'poesia'. Elsewhere he says the subject of a painting 'should be something lofty, such as battles, heroic actions, religious themes'.[8]

Dryden also explains that history is a proper source for the 'great action' to both tragic poet and painter.

> Curtius throwing himself into a gulph, and the two Decii sacrificing themselves for the safety of their country, are subjects for tragedy and picture. Such is Scipio restoring the Spanish bride, whom he either loved, or may be supposed to love; by which he gained the hearts of a great nation to interest themselves for Rome against Carthage. These are all but particular pieces in Livy's History; and yet are full complete subjects for the pen and pencil.[9]

Some of these subjects are known in both literary and painterly versions from the seventeenth century, one of Poussin's famous 'Stoic' drawings being that of Scipio returning the Spanish bride.

In representing the passions and the manners ('Manners' was the seventeenth century term for what later criticism would call character) Dryden sees painting to have a great formal advantage, even over tragedy, owing to the painter's better opportunity to observe the unity of action and of time.

> The action, the passion, and the manners of so many persons as are contained in a picture are to be discerned at once, in the twinkling of an eye; at least they would be so, if the sight could travel over so many different objects all at once, or the mind could digest them all at the same instant, or point of time. Thus, in the famous picture of Poussin, which represents the *Institution of the Blessed Sacrament*, you see our Saviour and his twelve disciples, all concurring in the same action, after different manners, and in different postures; only the manners of Judas are distinguished from the rest. Here is but one indivisible point of time observed; but one action performed by so many persons, in one room, and at the same table; yet the eye cannot comprehend at once the whole object, nor the mind follow it so fast; 'tis considered at leisure, and seen by intervals; Such are the subjects of noble pictures; and such are only to be undertaken by noble hands.[10]

That picture or poem which best imitates nature, Dryden tells us, will be the best of its kind. And a true imitation is of the 'best nature', of that which is 'wrought up to an nobler pitch'.

Dryden's conception of the 'best nature' as the object of imitation (which he expounded as early as the 'Essay of Dramatick Poesy') is virtually identical to the theory of imitation set forth by Bellori which rejects both 'naturalistic' representation (for which, he tells us, Caravaggio was criticized) and a representation supposedly derived from an *a priori idea* in the mind of the artist—the central principle of mannerist theory. Poetry to Dryden and painting to Bellori were to strike a balance between imitating nature too closely and surpassing nature too greatly. Both naturalism and *maniera* were to be avoided in each art. The consonance between Dryden's 'poetic' and Bellori's 'painterly' imitation doubtless strengthened the validity of the parallel in Dryden's thought.

Dryden further develops the parallel of the two arts (following Du Fresnoy's example) in terms roughly equivalent to the *inventio, dispositio,* and *elecutio* of rhetoric. These ancient terms had long been assimilated to and intermixed with dramatic theory in France and England.

Invention is the groundwork of both arts, the matter on which poet and painter work. The power of invention is neither taught nor learned by rule; it comes only as a divine gift. Under the head of Invention is placed the 'disposition' of the work, the placing of 'all things in a beautiful order and harmony'. Next, the poet and painter must observe decorum.

> The compositions of the painter should be conformable to the text of ancient authors, to the customs, and the times. And this is exactly the same in Poetry; Homer and Virgil are to be our guides in the Epic; Sophocles and Euripides in Tragedy: in all things we are to imitate the customs and the times of those persons and things which we represent. . . .[11]

Nothing should go into a poem or picture which is not 'convenient to the subject'. 'A painter must reject all trifling ornaments; so must a poet refuse all tedious and unnecessary descriptions.'

Du Fresnoy made 'design' or 'drawing' the second part of painting, and Dryden rightly makes the postures and stances of the characters in the performance of certain actions the poetic parallel of 'design': 'as of Achilles, just in the act of killing Hector, or of Æneas, who has Turnus under him'. Design in seventeenth-century painting served both for revealing action and for expressing the passions of characters. Dryden understood this precisely: 'Both the poet and the painter vary the posture, according to the action or passion which they represent, of the same person; but all must be great and graceful in them.'[12]

Design also involves the arrangement of subsidiary figures in painting and is parallel to the ordering of the episodes in epic poetry. (This would seem to be a very doubtful correspondence to enemies of *ut pictura poesis* but we shall see that Poussin managed it.)

> As in a picture, besides the principal figures which compose it, and are placed in the midst of it, there are less groups or knots of figures disposed at proper distances, which are parts of the piece, and seem to carry on the same design in a more inferior manner; so in epic poetry there are episodes, and a chorus in tragedy, which are members of the action, as growing out of it, not inserted into it.[13]

The third part of poetry and painting, elocution or expression, demonstrates the parallel of the 'colours' in both arts. This is where the hostile critic looks

most closely, for it is this part of the parallel which would seem most clearly to betray its fundamental weakness. How can 'colour' belong both to visual art and to poetry? Is this not a true confusion of formal means in each art? Literary criticism has concluded so, for it has been convinced that 'colour' in Dryden's poetry is nothing but a sort of visual and decorative wash, carelessly applied. Mark van Doren writes:

> To be going hand in hand with Virgil and Titian, the supreme colorists, was a supreme privilege in [Dryden's] eyes. Yet he labored with a complacency that one does not expect in a conscientious painter. And his results are what one does not find in a conscientious poet. For the parallel he drew between diction in poetry and color in painting was superficial. He conceived color in painting as a kind of splendid wash applied after the drawing is done. It is decoration. So with elocution in poetry; . . . That is, diction in poetry is a splendid wash that is spread over the framework of the plot. Words have no more function than the painter's pigments; the imagination is nothing but camel's hair.[14]

Dryden often failed in metaphor, but not because he thought colour a mere decoration. As Dryden explained the colours, whether as figurative language or as the pigments of a painter, they were simply the appropriate means in each art whereby reality could be transformed into that 'heightened nature' in which lay the very force and power of all art. The colours performed a fundamental, not a superficial task. Dryden's preoccupation with colour in this sense goes back at least as far as the composition of *Annus Mirabilis* (1666), in the preface of which he first elaborates his view of Virgil as a master of description. Virgil's art was the creation of a 'nature' never seen by the eye:

> When action or persons are to be described, when any such image is to be set before us, how bold, how masterly, are the strokes of Virgil! We see the objects he presents us with in their native figures, in their proper motions; but so we see them, as our own eyes could never have beheld them so beautiful in themselves.[15]

In the imagination of the poet 'nature' and 'idea' were together to form an order of words from which is created a new world, a new reality—a reality which is based on nature but yet surpasses nature. To do this Virgil 'made frequent use of tropes, which you know change the nature of a known word, by applying it to some other signification; . . .'[16] How illuminating this statement is for the doctrine of the parallel in colours! The word is emancipated from its normal relation to 'things' so that it may create a new 'thing' never before seen by the eye. The object of this new creation is to move the reader, which a bare representation of nature could never do. This is the precise function of colour (which includes light and shade) in seventeenth-century painting: colour and light were freed from their essential Renaissance work of revealing and defining things, of maintaining consonance with shape and line derived from 'scientific' observations of nature, and were allowed to play independently for expressive effect. This was the essence of the 'painterly style' of the seventeenth century.

In the 'Parallel of Poetry and Painting' Dryden explains poetic colour with a passage from Virgil. He recalls the legendary scene in which Virgil, reading from the sixth book of the *Aeneid* in the presence of Augustus and Octavia, tells of Misenus, the trumpeter:

[*Misenum Aeolidem*] *quo non praestantior alter*
 Ære ciere viros, . . .

and [says Dryden] broke off in the hemistic, or midst of the verse; but in the very reading, seized as it were with a divine fury, he made up the latter part of the hemistic with these following words:
 . . . Martemque accendere cantu.

How warm, nay, how glowing a colouring is this! In the beginning of his verse, the word *aes*, or brass, was taken for a trumpet, because the instrument was made of that metal, which of itself was fine; but in the latter end, which was made *ex tempore*, you see three metaphors, *Martemque—accendere—cantu*. Good Heavens! How the plain sense is raised by the beauty of the words![17]

Colour here is obviously not conceived by Dryden as a mere decoration; it is a metaphor designed to raise 'the plain sense', to transform reality itself into images whose work is to arouse feeling. In the imagination, plain brass becomes a trumpet and Mars is kindled to fire by the power of song. By this we understand what Dryden means when he says that metaphors 'have the power to lessen or greaten anything'; and when he adds that 'strong and glowing colours are the just resemblances of bold metaphors . . .'.[18] For it was in the seventeenth century that colour, light, and shadow were *consciously* understood to be used for this specialized 'metaphorical' purpose. As Dryden distinguished 'plain sense' from 'heightened nature', seventeenth-century art theory distinguished two kinds of light: the plain light of nature or science, and the light of the imagination—which was the equivalent of the poetic colour. Roger de Piles, for example, defines this difference as existing between the 'incidence of light' and the 'claro-obscuro'. The former 'consists in knowing the shadow which a body, placed on a certain plane, and exposed to a given light, ought to make upon that plane; a knowledge easily attained from the books of perspective'. This is the light that literally imitates nature by following the laws of optics; it may be demonstrated 'by the lines which are supposed to be drawn from the source of that light to the body enlightened; . . .' The other light, the claro-obscuro, 'depends absolutely on the painter's imagination, who, as he invents the objects, may dispose them to receive such lights and shades as he proposes in his picture, and introduce such accidents and colours as are most for his advantage'.[19] This light is the equivalent of figurative language—as the light of nature is of the word which names directly.

Dryden mentions Correggio along with Titian as most famous for his colour. And Correggio, a 'linear' Renaissance painter, one who defines natural objects by lines, will do to illustrate the beginning of what came to be the seventeenth-century metaphorical use of light and colour. One may quote Wölfflin:

In [Correggio] we can clearly see the endeavour to conquer line as dominating element. He still works with lines—long flowing lines— yet for the most part he complicates their course in such a way that it is difficult for the eye to follow them, and into the shadows and lights there comes a flicker and dancing as though of their own power they were striving towards each other and wished to emancipate themselves from line.[20]

This passage applies perfectly to Correggio's *Mystic Marriage of St Catherine* (ill. 16) where line defines the physical reality of the figure but light, shade, and

colour 'express' the mysterious combination of joy and melancholy which this moment in the history of St Catherine embodies. Already here light anticipates a quality it will have in the seventeenth century: it has acquired 'independence and has emancipated itself from things'. In the middle of the seventeenth century one may see precisely this use of colour and light in Poussin's *Testament of Eudamidas* (*c.* 1655), one of his famous 'Stoic' pictures (ill. 17). In this picture the light, shadow, and colour are independent of 'nature'; that is, the visible sources of light could never have provided the strong accents on the body of the scribe, the head of the mother, the arm of the daughter, the pillow and the forehead of the dying man—while at the same time allowing the dark and shadowed area of the picture. The light and colour are used here to 'greaten' and 'lessen' things for purely affective reasons: the picture must arouse emotion attendant upon a noble death.

Again, the same 'metaphorical' light appears in the *Extreme Unction* of *c.* 1644 (ill. 18). From both its artificial and natural sources the light is used to intensify the drama of the subject. Neither the shield in the background nor the priest in the foreground could derive their degree of light from the sources visible in the picture. The calculated expression has—through light—raised nature 'above the life' as Dryden would say.

A careful reader will notice the important fact that the poetic 'colours' as they are described by seventeenth-century critics are not necessarily pictorial. It is only their work as expression that counts (as this is the work of colour and light in the two pictures of Poussin). 'Expression,' Dryden writes, 'and all that belongs to words, is that in a poem which colouring is in a picture. The colours well chosen in their proper places, together with the lights and shadows which belong to them, lighten the design, and make it pleasing to the eye.' And for poetry—dramatic and epic: 'The words, the expressions, the tropes and figures, the versification, and all the other elegancies of sound, as cadences, turns of words upon the thought, and many other things, which are all parts of expression, perform exactly the same office.'[21]

Dryden's own application of 'colour' in this expressive sense is often disastrous; but the reason is not that he was confusing the arts, as Van Doren says. The reason is that words, applied by this theory, are too little bound to things and too much bound to feelings. The poet does not keep his eye on objects but his mind on expressing the passions. Dryden's failures with this method can be illustrated with any one of hundreds of 'bold metaphors'. Consider, for example, the outburst of Almanzor in the *Conquest of Granada* just as he discovers that his beloved mistress is tied by vows to another suitor. The hero is naturally called upon to express a violent feeling.

> Good heaven, thy book of fate before me lay,
> But to tear out the journal of this day:
> Or, if the order of the world below
> Will not the gap of one whole day allow,
> Give me that minute when she made her vow!
> That minute, ev'n the happy from their bliss might give;
> And those, who live in grief, a shorter time would live.
> So small a link, if broke, the eternal chain
> Would, like divided waters, join again.—
> It wonnot be; the fugitive is gone,
> Pressed by the crowd of following minutes on:
> That precious moment's out of nature fled,

And in the heap of common rubbish laid,
Of things that once have been, and are decayed.[22]

This is language 'colour'd' for the passion of grief; it is also an object lesson in a particular kind of baroque excess: images are controlled by 'feeling'; 'things' are forgot.

It should now be clear that the supposed affinity between the colours of rhetoric and the colours of the painter is that both were devices—not, respectively, to name 'things' or to represent the external world—but to assault the feelings of the reader or beholder and make him *imagine*, under the pressure of feeling, that the world as it appears in the work of art is real. Such 'colour' in poetry does not make us see what is, but attempts to make us 'feel'. This was exactly understood by the Abbé du Bos in his *Réflexions critiques sur la poesie et sur la peinture*. 'We must . . .imagine', he writes,

> that we behold, as it were, the object we only hear described in verse. *Ut pictura poesis*, says Horace. Cleopatra would not so much engage our attention, were the poet to make her say in a prose style, to her brother's detestable ministers: 'Tremble, ye wretches! Caesar, the avenger of crimes, is approaching with his victorious army.' Her thought takes a much grander turn, and appears with a far greater degree of the sublime, when it is clad with poetic figures, and puts the instrument of Jove's vengeance into the hands of Caesar. The following verse,
>
> Tremblez, mechans, tremblez; voici venir la foudre.
>
> (Tremble, ye villains; here comes the thunder; tremble!)
>
> shews Caesar armed with thunderbolts, with which he pours out his vengeance against the murderers of Pompey.[23]

Despite the Abbé's claim, we by no means see Caesar with thunderbolts. We see, in fact, nothing at all. Cleopatra's 'figure' is not visual. It is, however, a 'colour' in seventeenth-century figurative language and could be compared to painting because it does the expressive work of colour: it is expressive of the 'grander turn' of Cleopatra's thought.

II

There is in all this the essential clue to the origin of *ut pictura poesis* as a living and influential theory of art in the seventeenth century. It came into being not because poetry and painting sought out one another's pictorial devices, but because both arts became equally concerned with developing powers of expression. The history of this concern can be followed in Italy. Lodovico Dolce in his *Aretino*, a dialogue on painting published in 1557, suggests that painters, lacking a real model, might turn to Ariosto's description of Alcina in the *Orlando Furioso*, a description which he is pleased to quote:

> Di persona era tanto ben formata,
> Quanto mai finger san pittori industri:
> con bionda chioma, lunga e annodata,
> Oro non è, che piu risplenda, e lustri,
> Spargeasi per la guancia delicata
> Mistro color di rose e di ligustri
> Di terso avorio era la fronte lieta,
> Che lo spazio finia con giusta meta.

Sotto due negri, e sottilissimi archi
Son due negri occhi, anzi due chiari soli,
Pietose à riguardar, à mover parchi,
Intorno à cui par ch'Amor scherzi, e voli,
E ch'indi tutta la faretra scarchi,
E che visibilemente i cori involi.
Quindi il nazo per mezo il viso scende
Che non trova l'invidia ove l'emende.[24]

(Her shape is of such perfect symmetry,
As best to feign the industrious painter knows,
With long and knotted tresses; to the eye
Not yellow gold with brighter lustre glows.
Upon her tender cheek the mingled dye
Is scattered, of the lily and the rose.
Like ivory smooth, the forehead gay and round
Fills up the space and forms a fitting bound.

Two black and slender arches rise above
Two clear black eyes, say suns of radiant light;
Which ever softly beam and slowly move;
Round these appears to sport in frolic flight,
Hence scattering all his shafts, the little Love,
And seems to plunder hearts in open sight.
Thence, through mid visage, does the nose descend,
Where Envy finds not blemish to amend.)

Lessing rightly called Ariosto's word picture 'no picture'. 'I see nothing,' he wrote, 'and feel with vexation how vain is my best effort to see what he is describing.' Yet Dolce based the sisterhood of the arts on their common pictorial powers.

A few years later Giovanni P. Lomazzo in his *Trattato dell'arte della pittura scultura ed architettura* holds the sisterhood of poetry and painting to rest on entirely different ground: their common power to represent the *moti* or *passioni dell' animo*.[25] The poetry he chooses for painterly imitation is often remarkably unvisual but always highly emotional. Instead of looking for poetic 'pictures' he chooses 'pathetic' passages from Ariosto, Tasso, and the ancient poets, all arranged under the heading of the passion they represent: *gaudio, dolore, paura, sdegno,* and so forth.[26] He includes, for example, Erminia's famous lament for Tancredi from the *Gerusalemme Liberata*. One hears her outburst—noticing the 'figures, the versification, . . . turns of words upon the thought, etc.',—and then wonders how a painter would see her. She is not visible in the poetry. The problem for a painter was not to represent pictorially a 'picture' from the poem but to find a visual 'equivalent' —an 'objective correlative'—for Erminia's violent expression.

Anima bella, se quinci entro gire,
S'odi il mio pianto, alle mie voglie audaci.
Perdona il furto e'l temerario ardire:
Delle pallide labbra i freddi baci,
Che più caldi sperai, vuò pur rapire;
Parte torrò di sue ragioni a morte,
Baciando queste labra esangui e smorte.

Pietosa bocca, che solevi in vita
Consolar il mio duol di tue parole,
Lecito sia ch'anzi la mia partita
D'alcun tuo caro bacio io mi console . . .
Lecito sia ch'ora ti stringa, e poi
Versi lo spirto mio fra i labbri tuoi.[27]

 (. . . yet if thou love,
Sweet soul, still in his breast, my follies bold
Ah, pardon, love's desires and stealths forgive;
Grant me from his pale mouth some kisses cold,
Since death doth love of just reward deprive;
And of thy spoils sad death afford me this,
Let me his mouth pale, cold, and bloodless kiss;

 O gentle mouth! with speeches kind and sweet
Thou didst relieve my grief, my woe, and pain,
Ere my weak soul from this frail body fleet,
Ah, comfort me with one dear kiss or twain . . . O vain
O feeble life, betwixt his lips out-flie;
O let me kiss thee first, then let me die!)

A visual equivalent for this could only be achieved with extreme effects—not only in design but especially in light and colour, as is shown in Pietro da Cortona's painting of the scene (ill. 19). He is not so much 'representing' an action as expressing its emotional content. The light on Erminia's face and throat is placed there to emphasize her passion; the darkness shading Tancredi's face is expressive of his desperate condition. Throughout the picture the working of light is independent of 'nature' and linked completely to feeling. 'Objects' have been subordinated to feelings about 'objects', just as in Tasso's poetry *res* are subordinated to *verba* in the 'colours'. Pietro da Cortona's picture reveals some of the qualities one finds in Almanzor's speech; the expression is too artificial and theatrical. It is a style which can easily go out of control.

Lomazzo anticipated Pietro da Cortona by insisting that poet and painter have the common task of giving 'a certain external expression and demonstration in the body of those things which the soul suffers inwardly.'[28] His theory accounts not only for the parallel between the 'colours' in painting and poetry; it prophesies the parallel which the seventeenth century found to exist between Poussin's pictures and the French drama. Why? Because the parallel was founded on the fact that both painters and dramatic poets saw it as their particular task to reveal the inner life of the soul by an outward 'demonstration in the body', the one by design, light and colour, the other by words.

It was in the *mouvemens d l'âme* that the seventeenth century located the source of human action and the drama of human life. Hence painters and poets had as their primary subject the passions of the soul. Action itself had to be subordinated to representations of the passions. No clearer statement was ever made of this fact than that of Sir William Davenant (who was as much at home in France as in England) in the 'Preface to Gondibert':

Wise poets think it more worthwhile to seek out truth in the passions than to record the truth of Actions, and practice to describe mankind just as we are persuaded or guided by instinct, not particular persons as they are lifted or levell'd by the force of Fate, it being nobler to contemplate

the general History of Nature than a selected diary of Fortune. And
Painters are no more than Historians, when they draw eminent persons,
though they terme that drawing to the life; but when by assembling
divers figures in a larger volum, they draw Passions, though they terme
it but story, then they increase in dignity and become Poets.[29]

In 1719 the Abbé du Bos identifies *Probability* itself—the very foundation
of neoclassical dramatic art—with representation of the passions both in
painting and poetry. There are, he tells us, two kinds of probability in
painting, 'mechanic' and 'poetic'. The former consists of 'what is possible,
according to the laws of motion, and of optics'. The latter 'consists in giving
the personages such passions as suit them best, according to their age, dignity,
and temperament, and to the interest they are supposed to have in the action'.[30]

III

Now the essential element in French dramatic form which made it parallel
to painting is (as Davenant makes clear) that the 'action' had to consist only
of events necessary to justify and make comprehensible the representation
of the passions of the soul. Leaving aside any consideration of painting
or the other arts, Saint Évremond found the primacy of the passions over the
action on the French stage evidence for the superiority of the moderns over
the ancients. The dramatists of antiquity knew how to conduct an action
but Corneille had conceived a superior principle: he diminished the action
and made it subject to the passions of his characters:

> Corneille thought it not enough to make his characters act; he has dived
> to the very bottom of their soul, to find out the Principle of their actions;
> he hath descended into their heart, to see how their passions are form'd
> there, and discover the most hidden springs of their motions. As for the
> ancient Tragedians, either they neglect the passions by applying them-
> selves to an exact representation of the Incidents; or else they make
> Speeches amidst the greatest perturbations, and amuse you with moral
> sentences, when you expect nothing but Confusion and Despair from
> them. Corneille takes notice of the principal Events, and exposes as much
> of the Action as decency can allow: but this is not all; he gives the
> Passions all the extent they require, and leads Nature, without constrain-
> ing or abandoning her too much to her self.[31]

Saint Évremond reveals very clearly the place of 'history' or external events
in this scheme; they are meaningless in themselves; they have significance
only as they are intelligibly related to the passions of the soul. The main
purpose of the famous 'rules' was, in fact, to subordinate the action to the
passions. The action, we are told, should be restricted only to those events
which illuminate and expose the inner drama of the soul. Hence, according to
the Abbé d'Aubignac, the need for the unity of action.

> It is necessary that the poet always make his action as simple as he can,
> because he will always be better master of the passions and other orna-
> ments of his work when he presents them only where he judges it necessary
> to make them appear, than when he finds them in the story—in which
> there will always be some circumstances which give him trouble and which
> will do violence to his design.[32]

'Pathetic discourse', continues the Abbé, '*sont les plus excellentes actions du
Théâtre*'. He saw that the 'action' exists chiefly in the imagination.

In the representation all of tragedy consists only of discourse; that is the whole work of the poet, and to which principally he employs his powers and his mind; and if he makes some action appear on his stage, it is to take from it occasion of making some agreeable discourse. Everything which he invents, is toward the end of a speech; he supposes many things so that they serve as material for agreeable narrations; he searches out all means to give voice to love, hate, sorrow, joy, and the rest of the human passions; likewise it is certain, that he makes very few actions appear on the stage; they are nearly all imagined, at least the most important, beyond the scene; and if he reserves something to be seen, it is only to take from it some occasion to give the action speech. Finally, if one wishes to examine this kind of poem carefully, one will find that the actions are only in the imagination of the spectator, which the poet, by his skill, causes to conceive them as though visible and meanwhile there is nothing for the senses but discourse.[33]

Dryden understood the French system perfectly well and sympathized with it. He was virtually alone among his English contemporaries in realizing that it was the French preoccupation with representing the *mouvemens de l'âme* which underlay the necessity of the unities of time and action.

By pursuing close one argument which is not cloyed with many turns, the French have gained more liberty for verse, in which they write; they have leisure to dwell on a subject which deserves it, and to represent the passions (which we have acknowledged to be the poet's work).[34]

It can surely be seen that the French dramatic 'form' which we have been examining clearly does not fulfil an exclusively 'literary' need. It provided 'formal' principles applicable to all the arts in which it was possible to make 'passions' the subject and to diminish the importance of 'action'. It could be used in the music drama as well as in painting, because the composer and the painter, like the poet, were able to develop means of contracting the action into few events and of making their principal concern the representation of the passions. The composer employed the aria to express the passions and generally limited the action to recitative. The painter concentrated the passions in the human face and figure. The great advantage of the dramatic 'form' to the painter was that he would not be troubled by the temporal problem of an action. The whole action lay in the 'passions and manners'.

Poussin's *The Israelites Gathering the Manna* (ill. 20) is a 'dramatic' picture in this sense. There are many others,[35] but this one is of particular interest because it was celebrated among members of the French Academy to whom it was exhibited, by whom it was discussed, admired, and criticized. In 1667 Charles le Brun lectured on the painting to the Academy and André Félibien recorded his observations and the conversations of the academicians in his *Entretiens sur les vies et sur les ouvrages des plus excellens Peintres*.[36] Le Brun saw the *Manna* as an example of dramatic structure applied to painting; as an action which was given its existence by the passions which were represented.

Poussin had a very clear notion that expression of the passions was his purpose. In a letter he spoke of the *Manna* as giving him an opportunity to paint the passions, to represent 'hunger, joy, admiration, respect; a crowd of women and children, people of different ages and temperaments—things, I believe, that will not displease those people who can read intelligently'.[37]

Indeed the picture must be 'read'. It is not to be seen in an instant, but to be regarded slowly and with care.

Le Brun recognizes this necessity for 'reading' as he provides a careful description of the picture. His vision of it is useful, for it shows us how closely we must look at it.

> The landscape is composed of mountains, groves, and rocks. In the foreground appears to one side a seated woman who gives her breast to an old woman, and who seems to caress a young child who is near her. The woman who gives suck is dressed in a blue robe and a purple cloak enriched with yellow; and the other is dressed in yellow. Very near a man standing covered by a red drapery; and a little further back is a sick man on the ground, who half raising himself, supports himself on a stick.
>
> An old man is seated near these two women of which I speak: he has a nude back, and the rest of the body covered by a shirt and a mantle of red and yellow. A young man holds him by the arms and helps him to rise.
>
> In the same line, and on the other side of the left of the picture, one sees a woman who turns her back and who holds a little child in her arms. She has one knee on the ground; her robe is yellow, and her coat blue. She makes a sign with her hand to a young man who holds a basket full of manna which he carries to the old man of which I speak.
>
> Near this woman there are two young boys: the larger pushes the other away so that he can hoard only for himself the manna which he sees fallen to earth. A little farther away are four figures; the two nearest representing a man and a woman who gather the manna; and of the two others, the one is a man who conveys something to his mouth, and the other a girl dressed in a robe mixed of blue and yellow. She looks and holds the front of her robe to receive that which falls from heaven.
>
> Near the young man who carries a basket is a man on his knees who joins his hands and raises his eyes to heaven.
>
> The two parts of this picture which are on the right and on the left form two groups of figures who leave the centre open and free to the sight in order better to discover Moses and Aaron who are further away. The robe of the former is of blue stuff and his cloak is red. For the latter he is dressed in white. They are accompanied by elders of the people disposed in several different attitudes.
>
> On the mountains and on the hills which are in the distance appear the tents, the lighted fires, and an infinity of people dispersed on one side and the other; that which represents well an encampment.
>
> The heaven is covered by clouds very thick in some places; and the light which diffuses itself on the figures appears a morning light which is not very clear, because the air is filled with vapours; and likewise to one side it is more obscure because of the fall of the Manna.[38]

Le Brun points out that the various groupings of figures (although each in itself constitutes a little dramatic episode) all serve the principal subject. 'One finds a judicious contrast in the different disposition of the figures in which the position and the attitudes conform to the story, giving rise to the unity of action and the beautiful harmony which one sees in this picture.' Poussin has followed the primary rule of the theatre.

It is in the realm of expression, however, that Poussin has managed his

greatest dramatic triumph. There is not one character whose 'action' does not accord perfectly with his 'thought' and his 'passion'. The whole episode of the woman giving her breast involves the display of several appropriate passions. The man witnessing this act of charity represents the passion of 'admiration' which Le Brun tells us can be discovered by the position of his arms and by the look from his eyes. Poussin made him old, because a person less grave (or one rustic or gross) would not have understood the significance of the act. 'The painter thereby affects us with the greatness of the action.' Le Brun also notes that the woman, by looking at her child instead of her mother, performs a double act of charity: while she gives nourishment to the starving old lady she sheds tears of pity for the child. This indicates that she is torn between duty and pity. (Such an inner conflict was always necessary in a serious drama.) The child, we are informed, does not express jealousy in his face as he would have if his mother were suckling a child of his own age. The old lady shows her love for her daughter by putting her hand on her shoulder. The sick man who watches is so surprised by the charitable act that he momentarily forgets his illness.

To the right of this group is another episode. The young man touching the shoulder of the old man expresses joy, but his stance indicates that he does not concern himself about the source of the manna. The 'more judicious older man' behind him expresses his thanks to God. Farther to the right one sees a less agreeable display of the passions. One of the youngsters pushes the other aside, representing the passions of hunger and greed. Beyond this group the charitable woman in yellow directs the man with the basket to the old man. On the extreme right another man 'wonders' how the manna tastes. In the centre of the picture Moses shows the kneeling man in front of him that the help is from heaven, and Aaron shows all how to give thanks. The woman with shaded eyes to the right wants to look to the very source of the miracle.

A critic objects that Poussin did not literally follow the Biblical narrative. He allows the manna to fall in sight of the Israelites in direct contradiction to scripture, which tells that they found it already fallen like dew. Moreover the critic cannot see why Poussin should have shown anyone in languishment and misery, since, after finding the manna, they should have all had their hunger satisfied. This criticism and the reply reveal how well Le Brun understood Poussin's willingness to alter 'history' in order to represent passions. For in painting no less than in drama the story was made clear only by the actors. 'It is not with painting as with history,' replies Le Brun.

An historian makes himself understood by an arrangement of words and an order of discourse which forms an image of things, and represents successively such action as he wishes; but the painter, having only an instant in which he is able to take the things he wishes to figure on a canvas, it is sometimes necessary that he join together many incidents which, having preceded, to the end of making the subject understood, without which those who view his work would not be better instructed about the action he represents than if the historian, in place of telling the whole subject of his history, contented himself to tell only the end. It is for this reason that Poussin, wishing to show how the Manna was sent to the Israelites, believed that it did not suffice to scatter it on earth and to represent men and women who collected it; but that it was necessary, to mark the greatness of the miracle, to cause it to be seen

at the same time the state they were in. For this he represented them in a desert place; some in languishment, others hurrying to gather this nourishment, others thanking God for these benefits; the different states and the diverse actions having for him place of discourse and words to make his thought known. . . .[39]

Félibien records the opinion of another academician who confirms Le Brun's distinction between history and painting as the same distinction often made in dramatic criticism. 'If by the rules of the theatre', he says, 'it is permitted to poets to join together several events from different times in order to make a single action, provided that there is nothing self-contradictory and that *vraisemblance* be precisely observed, it is even more just that painters take this license.' No one can 'accuse Poussin of having put in his picture a single thing which harms the unity of action and which is not *vrai-semblable*. . . . Although he does not follow perfectly the text of holy scripture, one cannot say that he was far from the truth of the history.'

What one derives from this argument is precisely what one derives from the Abbé d'Aubignac's theory of the drama: 'history' or external events can and must be changed to conform to the emotional states of the persons for whom the action exists. The ordering of the plot must follow character. The real subject of the *Manna* is the passions of the characters, and it is through these that one understands the meaning of the whole story: the distress and misery of the Israelites; the providence of God; the joy derived from his care; the moral strengths and weaknesses of humanity. According to Le Brun the various episodes within the picture comprise an action which includes a peripeteia—this being the visible change of the Israelites from a condition of extreme misery to a happy state. The painter has provided not only an illustration of the Cartesian theory of the passions, but a painterly counterpart of dramatic form. The *Manna*, then, represents an identification of the formal means of drama and painting at a time in the history of both arts when such an identification was possible aesthetically, because both the drama and painting were able to subordinate action to expression.

IV

It surely requires no extraordinary demand upon the eye or mind to accept the *Manna* as the painterly equivalent in seventeenth-century terms of a dramatic action. But what of the parallel which Dryden allows, however hesitantly, between painting and the epic poem. Was this parallel accomplished to any degree by a seventeenth-century painter? It had to be if painting were to achieve the highest accomplishment of art, for that age placed heroic poetry even above tragedy in the hierarchy of the arts. 'A heroic poem, truly such,' wrote Dryden, echoing both English and French opinion, 'is undoubtedly the greatest work which the soul of man is capable to perform.'[40]

I should be willing to suggest that Poussin attempted not only dramatic pictures—which are easy to identify—but also pictures which are the visual equivalents of the epic—or rather, of 'history' treated according to the spirit of the epic. I am willing to make this suggestion by recalling that to the seventeenth century the essential difference between drama and epic was not that the action in the one form was 'presented' and in the other narrated, but rather that the drama contracted the world to 'manners and passions', while the epic enlarged the world to a great setting for a great

heroic action. The drama shortened what Homer and Virgil had amplified. 'Tragedy is the miniature of human life,' wrote Dryden, but 'an epic poem is the draught at length.'[41] To seventeenth-century criticism in general there was an amplitude and grandeur in an heroic epic action which could not be reached by tragedy, with the smaller compass of its action, its limited capacity for moving episodes. The stage was confined to present the whole 'action' by speaking and gesturing persons. The epic, through narration and description, could bring forth a whole world as Virgil had brought forth a whole world in the *Aeneid*. It was this amplitude of the epic that Poussin was reaching for in his two Phocion pictures (ills. 22, 23)—the setting of a human action celebrating heroic virtue on the stage of a large world—an accomplishment which he could never achieve in a mere 'dramatic' piece like the *Manna*.

The story of Phocion, told by Plutarch, is a story of state as well as that of a virtuous hero. Phocion, an Athenian general and statesman, lived in the time of Philip and Alexander, a time of great danger and peril for the city. His military skill had saved the city in many a dreadful battle. Even more impressive was Phocion's wisdom in trying to protect the city from its usual tendency to wage incautious and stupid wars. He particularly loathed popular opinion which he saw, in good Stoic fashion, as the source of all civil evil. Ironically it was an assembly made up of slaves, disenfranchised citizens, and returned exiles who condemned him to death on a charge of treason after he had attempted to prevent further hostilities between Athens and her enemies. Like Socrates he nobly drank hemlock. Since he died as a traitor the law forbade his burial in the city and his body was carried to Megara where it was burnt. His faithful wife, whose Stoic dignity equalled his own, collected his ashes, returned them to Athens and buried them under his own hearth. Plutarch's life is long and full of detail. It was Poussin's problem to unify the action and at the same time to suggest the large meaning in the life of Phocion, a heroic figure whose virtuous actions were of universal moral interest, and whose story, embodying good and evil, reflected the very nature of things.

The difficulty of painting such a history is obvious: there would be too many events and too many characters. The painter would seem not to be able to contain it all. Yet Poussin solved the problem of doing so—not by trying to present a large number of human actions in a picture, but by enlarging the physical world in which the events took place. For this he used architecture and landscape. Poussin's 'epic' use of landscape in the Phocion pictures is one of the great original contributions to the art of the seventeenth century. For the first time landscape provides not simply a background or a mood for the human action;[42] it literally takes a part in the action—not in the old emblematical manner of the *paysage moralisé*, but in a new 'expressive' manner.

It has been suggested that the nobility and beauty of the landscape in the Phocion pictures derive from Poussin's use of the modes as he described them in his famous letter to his friend Chantelou.[43] Poussin explains how each of the ancient musical modes had its particular affective quality which must reign *throughout* any composition in which it was used. The Dorian mode, for example, is 'stable, grave and serene', and the ancients 'applied it to subjects which are grave, severe and full of wisdom'.[44] It would have been suitable to either Phocion picture if it were clear that Poussin thought each of these pictures should have a controlling *ethos* and that all its parts should

be devoted to expressing that same *ethos*. In the same letter, however, Poussin asks Chantelou to consider poetry and the art of Virgil:

> The good poets used great care and marvellous artifice in order to fit the words to the verses and to dispose the feet in accordance with the usage of speech, as Virgil did throughout his poem, where he fits the sound of the verse itself to all his three manners of speaking with such skill that he really seems to place the things of which he speaks before your eyes by means of the sound of the words, with the result that, in the portions where he speaks of love, one finds that he has skillfully chosen such words as are sweet, pleasant and very delightful to hear; whereas, if he sings of a feat of arms or describes a naval battle or a storm, he chooses hard, rasping words, so that when one hears or pronounces them, they produce a feeling of fear. Therefore, if I had made you a picture in which such a style were adhered to, you would imagine that I did not like you. . . .

Poussin is celebrating Virgil's famous 'propriety' in language—that quality in his verse which allowed him in every part of his poem to adapt the verse, even hard and rasping sounds, to the subject which they expressed. To the sixteenth and seventeenth centuries this was one of Virgil's most dazzling achievements, and it was endlessly discussed. In his Discourses on epic poetry Tasso remarks Virgil's power to adapt all three styles to his subject. Dryden spoke of his words having qualities 'connatural' with their subjects.

Does it not seem possible that it occurred to Poussin that the proper use of landscape was not simply to provide a 'beautiful' image of the natural world in one dominating 'mode', but to provide 'appropriate' images and various 'modes' for expressing a variety of 'meanings' which would emphasize the grandeur and express the complexity of the story itself? The Phocion story demanded propriety in the Virgilian sense.

Both Phocion landscapes appear to me to reflect something more complex than the mere beauty and harmony of nature. Just as the nobility of Phocion is balanced by the evil of those men who condemned him to death, the beauty of the landscapes is subtly crossed with suggestions that nature itself harbours imperfections. This, by the way, is not inconsistent with the Stoic idea which held that although this is the best of all possible worlds, it is still a world tragically flawed by inconstancy and unexpected and terrible strokes of fate. The fairest of pastoral landscapes (ill. 21) may hide a poisonous serpent.[45]

One is tempted to recall a passage of Tasso in which he likens the epic world of battles, racks of cities, seditions, discords, works of cruelty and generosity, and so on, to the variety of the natural creation itself—the *magistero di Dio*—which is replete with 'fountains, lakes, meadows, and plains, forests, mountains; . . . and here fruits and flowers, there ice and snow, here habitations and farms, there solitary places and horrors'.[46] This similitude between landscape and human action is not incidental; it represents Tasso's belief in the correspondence between the works of nature and the works of man in the unity of the world. Nature and man had both fallen; but they were both elements in an ultimately perfect harmony of things. One had to see partial evil in order to know the universal good.

With these things in mind I think the best approach to the *Landscape with the Body of Phocion Carried out of Athens* (ill. 22) is through Fénelon's famous dialogue in which Poussin and Parrashius, the ancient painter, are imagined to be discussing it.[47] As Fénelon leads us through the picture

he sees clearly that its various parts have different affective qualities and must be 'read' differently—much as le Brun 'read' the various human actions of the *Manna*.

Fénelon brings our eyes to rest first on the two men carrying the body of Phocion. Poussin is made to say:

> I have represented his body which two slaves are carrying out of the city of Athens. They both appear afflicted, and their two sorrows are totally different. The first of these slaves is old; he is dressed in carelessly arranged drapery. His arms are naked and his legs show a strong and wiry man. His flesh colour marks a body used to hard work. The other slave is young, dressed in a tunic whose pleats fall with some grace. The two attitudes are different in the same action; and the two airs of the head are strongly varied, even though they are both servile. . . .
>
> The dead man is hidden under a disordered cloth which is wrapped around him. This cloth is poor and carelessly arranged. In this funeral procession everything is capable of exciting pity and woe.

Every visual detail—from facial expression to the ordering of the drapery— is arranged to one purpose: representing the passions of pity and dolour. Fénelon invites closer attention to detail:

> One should not fail to notice under this confused drapery the form of the head and of the whole body. The legs are uncovered; one can see not only the faded colour of the dead flesh, but also the stiffness and heaviness of the sagging limbs.

So far the image, though pathetic, might have been presented before any kind of background in a *place théâtrale*. But at this point Fénelon looks away from the procession itself to the surroundings:

> These two slaves who carry this body along a wide road find to one side of the road great stones cut in squares, of which some are elevated over others so that one believes himself seeing the ruin of some majestic edifice. The road appears sandy and beaten.

At this point we suddenly realize that there is the closest connection between the image of the human actors and the images surrounding them. There is a purely visual connection between the *idea* of a majestic ruined edifice and the ruin of the majestic life of Phocion, now before us only as a destroyed and ruined body carried by two mourning slaves. Fénelon also points out that the green colour of the trees immediately in front of the stones is weak and that the trees have few leaves. The bark on the trunks is rough and gnarled. These details in imagery were, I believe, designed to underline the passions expressed by the human figures. Nature and art, in the great world, are not set apart from human life. The creation is a unity. The fading green of the trees 'loses itself in the sombre blue of the sky'. Is there not a visual equivalent here of Virgil's occasional need to use 'hard and rasping' words?

On the right side of the picture there is a rough terrain. One sees 'hollows under strong shadow and tops of rocks strongly illuminated'. There are also some savage thickets. A little above there is a road which leads to a sombre and dense wood. An extremely clear sky gives more force to the sombre greenery. The 'affective' character of nature in the whole foreground corresponds precisely to the sombreness of the human figures and to the meaning of the procession. All which meets the eye participates in a scene of desolation,

Behind this 'rude terrain', however, we discover a contrast in mood and image. Fénelon remarks the 'fresh and tender grass', and points out 'a shepherd leaning on his crook, occupied in watching his snow-white sheep. The shepherd's dog is lying asleep behind him. On this plain one sees another road over which passes a wagon pulled by oxen.' 'A man of rustic air is in front of the wagon: a woman walks behind, and she appears to be the faithful companion of this simple villager. Two other cloaked women are in the wagon.' This, of course, is what Roger de Piles described as the 'rural style' in landscape. Fénelon has Parrhasius comment on this part of the scene:

> Nothing produces a more delicate pleasure than these pastoral pictures. We owe them to the poets. They began to sing in their verses the naïve graces of simple and artless nature, and we have followed them. The ornaments of a countryside where nature is beautiful makes a more pleasant image than all the pomps which art has been able to invent.

Fénelon is seeing this area of the picture absolutely accurately: it is an image of the good, simple pastoral life as Virgil described it in the *Georgics*. This image has more than a formal relation to the imagery in the foreground: it reminds us of the contrast between the pastoral life of man and his life in political societies of men who are unstable, treacherous, and ungrateful. The pastoral landscape is a 'description' with meaning. It is an episode in the epic whole.

At the very back of the pastoral scene is a beautiful tomb 'd'architecture simple et noble'. 'It is without doubt', says Fénelon, 'the tomb of some citizen who died with perhaps less virtue but with more fortune than Phocion.' This thought, however fanciful, perfectly expresses what is visually suggested by the picture. The rich tomb is centred in the composition, directly above and directly behind the body of Phocion. One cannot miss the ironic contrast between the poor cloth thrown over Phocion's body and the elegant proportions of the beautiful marble tomb. The tomb 'expresses' a portion of the history of Athens: its art and its beauty—and also its moral failure: the central point of the Phocion story.

Fénelon then notices the serene sky above as well as the pure and clear water of the river Illisus which flows on both sides of the tomb. He speaks of the city itself in which Poussin has taken pains to avoid both 'confusion and symmetry'. There are two elegant temples (of anachronistic Roman architecture), a rectangular one on the right and a round one on the left surrounded by a sacred wood. In between these grand buildings are others, some of regular architecture, and others with something of a 'figure bizarre'. One sees crenellations, high walls, and small buildings of a simple and irregular appearance. Fénelon believes Poussin wished to mark divers epochs in Athenian history, from the early simplicities of 'republican' times to the heroic period of the present. This idea is in accord with the story represented in the picture, for the progress from rusticity to the heroic times also stands as a great irony. It is in sight of the heroic architectural achievements of Athens, representing the supreme art of antiquity, that the melancholy procession takes place. The progress, in moral terms, had been non-existent. Again, this is an image with 'meaning' for the story. Poussin emphasizes this irony by representing the fête in front of the temple of Jupiter. Poussin is made to say:

> This is a fête which I wished to represent following the truth of the history. While Phocion is being carried out of the city to the pyre, all

the people in joy and in pomp conduct a great celebration around the temple. . . . Although these people appear far in the distance, one sees without difficulty their celebration in honour of the Gods.

These were the very people who condemned Phocion. Once more there is an ironic contrast between the beauty and solemnity of the celebration and the terrible sentence passed on Phocion.

Fénelon then explains that the Acropolis may be seen on the summit of the mountains which dominate the hill. Behind Athens we have another view of nature: 'Montagnes escarpées et assez sauvages'. Fénelon notices that behind the beautiful temples and the cheerful pomp of the fête one sees a nude and horrible rock. He believes Poussin intended 'to make the area of the city cultivated and gracious, as it always is around large cities, but that he wishes to give a certain savage beauty to the distance, in order to conform to history, which speaks of Attica as a rude and sterile country'. Fénelon might have noted that nature in the remote distance appears unfriendly and menacing precisely as it does in the foreground near Phocion's body. The cultivated and gracious beauty of Athens appears as only a small part of the visible order of things in this picture. The effect of nature as a whole, however grand and however beautiful, suggests a mysterious menace as well as a mysterious beauty in the nature of things.

The similarities between the expressive techniques of the *Landscape with the Body of Phocion* and the *Ashes of Phocion Collected by his Widow* (ill. 23) are striking: the central human actors occupy the same place in the foreground and are framed on each side by looming, dark, and melancholy trees. The shadows emphasize the terrible and melancholy task of the faithful widow, whose nervously watchful and alert companion suggests by his stance the presence of danger. There appears to be a spy hidden in the trees to the right. In the middle distance we see a pastoral scene much like the one occupying the same area in the other picture. The city has the same varied architecture, irregular and small buildings contrasted to beautiful temples. The loveliest of the temples is centred above the bent figure of the widow, just as the elegant tomb is centred above the body of Phocion. The ironies in the second picture are exactly the same as those of the first. Above and behind the temple is another menacing and savage image of nature. The world is the same as that of the first Phocion picture: an apparently beautiful order of nature and humanity which, on close inspection, is seen to be flawed by the existence of disorder. If we are moved by the widow's noble action and recall the life of her husband, we are also reminded of the terrible circumstances of his death. The general effect of the landscape is to represent as inextricably intertwined great beauty and great evil.

Each of the two pictures has, by exploiting every possibility of the imagery, landscape, architecture, and human action, told a story—in purely visual terms—of such greatness as vastly to transcend the ostensible immediate subject. The final effect of each is to translate into a visual counterpart a great heroic action taking place in a world of very complex character, one which presents the paradoxical and contradictory character of existence itself. Phocion's life and death embody at once the supreme evil and the supreme human good: constancy and inconstancy. Nature and art in the picture represent precisely the same paradox. Tasso's vision of the achievement of the epic poem is realized pictorially: the great creation itself is seen as in a 'little world'.

The Phocion pictures are, I believe, unsurpassed examples of the seventeenth-century success in its own version of *ut pictura poesis*—a version which, of course, demanded the reversal of Horace's simile. Painting has achieved the ends of poetry by translating a moral narrative into purely visual forms.

Poussin's 'heroic' landscapes were something of a puzzle to the eighteenth century. Jonathan Richardson, the best English critic of the century until Reynolds superseded him, wrote it as his opinion in 1722 that the *Landscape with the Body of Phocion* and the *Landscape with a Snake* were pictures involving great error. The one, he saw, was a history, and the other an episode, but in both he believed there was no rapport between the human actors and the scenes. He thought the landscapes were too gay and cheerful for their sombre subjects; that a conflict existed between the sombre emotions aroused by the subjects and the emotions aroused by the beauty of the scene. The human events were too important, in fact, for the landscapes.[48]

This mistake in judgement stemmed partly from the traditional low place allowed to landscape by art theory, but mostly from a real loss of understanding of what Poussin appears to have intended in the great 'literary' landscapes of the late 1640s: a unified image of a great dramatic or epic action in which all the elements of the picture played their part—as all episodes, descriptions, ornaments, and so forth, were supposed in a literary work to assist the main design.

Every part of Dryden's 'Parallel' is illustrated by the Phocion pictures: heroic action presented in a 'unity'; a heightening of nature 'above the life'; 'episodes' (varying character of the landscapes) enforcing the main action; conformity to ancient texts—all to the end of moral instruction by affecting the passions. To see Poussin's great achievement in these pictures it is needful to return to the seventeenth-century critical terms and allow the eye to be guided by them.

No one, however suspicious of the seventeenth-century critical system, should fail to see that this system permitted painting to absorb the function of poetry without departing from the laws of a purely visual medium. There was no confusion of the arts, only a parallel. In its own terms painting became drama and epic. This was a peculiar seventeenth-century achievement, since it was only in that time that poetry and painting *seemed* to have the same formal means for doing the same things: for concentrating on the life of the soul; and for representing a great moral action in a great setting

Notes

1 See Rensselaer W. Lee, 'Ut Pictura Poesis: The Humanistic Theory of Painting', *The Art Bulletin*, XXII, no. 4 (December 1940), pp. 197–203. Also Irving Babbitt, *The New Laokoon, An essay on the Confusion of the Arts* (Boston 1910, chapters I–III. Gotthold E. Lessing, *Laocoön, or the Limits of Painting and Poetry*, trans. W. A. Steel (London 1949), p. 14.

2 Lee, op. cit., p. 201.

3 William Mason translated du Fresnoy himself, but retained Dryden's *Preface*, which, he says, is 'too superficial to stand the test of strict criticism, yet it will always give pleasure to readers of taste. . . .'

4 John Dryden, 'A Parallel of Poetry and Painting', in *Essays of John Dryden*, ed. Ker (Oxford 1926) II, p. 118.

5 Ibid., pp. 123–4.

6 Concerning the sixteenth-century decline of theories of proportion Panofsky has the following observation: 'This final development of the theory of proportion corresponds, however, to the general evolution of art itself. The artistic value and significance of a theory exclusively concerned with the objective dimensions of bodies . . . could not but depend on whether or not the representation of such objects was recognized as the essential goal of artistic activity. Its importance was bound to diminish in proportion as the artistic genius began to emphasize the subjective conception of the object in preference to the object itself.' 'The History of the Theory of Human Proportions as a Reflection of the History of Styles', in *Meaning in the Visual Arts* (New York 1955), p. 105.

7 Dryden, op. cit., p. 130.

8 Anthony Blunt, *Nicolas Poussin* (Bollingen Series XXXV, 7, New York 1967), p. 361; 363.

9 Dryden, op. cit., p. 130.

10 Ibid., pp. 131–2. See also 'Preface to Troilus and Cressida', in Ker, I, p. 213: 'The manners, in a poem, are understood to be those inclinations, whether natural or acquired, which move and carry us to actions, good, bad, or indifferent, in a play; . . .'

Dryden is probably referring to the first set of Poussin's *Sacraments*; in the second picture on this subject Judas is shown leaving the room, an action which Dryden would surely have commented on differently. Dryden could have known either picture only by engravings. The first was engraved by Jean Dughet; the second by Jean Pesne. See Wildenstein, 'Les Graveurs de Poussin au XVIIᵉ Siecle', in the *Gazette des Beaux Arts* (September–December 1955), p. 223 foll., p. 231 ff.

11 Dryden, op. cit., p. 139.

12 Ibid., p. 140.

13 Ibid., p. 143.

14 Mark van Doren, *John Dryden, A Study of his Poetry* (New York 1946), p. 53.

15 Dryden, 'Preface to Annus Mirabilis', in Ker, I, p. 16.

16 Ibid., p. 17.

17 Dryden, 'A Parallel of Poetry and Painting', pp. 150–1.

18 Ibid., p. 149.

19 Roger de Piles, 'The Principles of Painting' (1708), trans. 'by a painter' (London 1743). Quoted by Elisabeth G. Holt in *A Documentary History of Art* (New York 1958), II, p. 181.

20 Heinrich Wölfflin, *Principles of Art History*, trans. by M. D. Hottinger from the 7th German edition (New York, n.d.), p. 31.

21 Dryden, 'A Parallel of Poetry and Painting', p. 147.

22 Part I, act III, sc. I.

23 Abbé du Bos, *Critical Reflections on Poetry, Painting, and Music*, trans. by T. Nugent from the 5th edition (London 1748), I, pp. 231–2.

24 Lodovico Dolce, *Aretino oder Dialog über Malerei*, trans. by C. Cerri (Vienna 1871), canto VII, 11, 12.

25 G. P. Lomazzo, *Trattato dell' arte della Pittura*, etc. (Rome 1844), I, p. 186 foll.

26 Ibid., II, pp. 468–523 (chapter LXVI).

27 *La Gerusalemme Liberata*, canto XIX, 107–8, quoted by Lomazzo, op. cit., II, p. 482.

28 Lomazzo, op. cit., I, pp. 178–9.

29 Sir William Davenant, 'Preface to Gondibert', in *Critical Essays of the Seventeenth Century*, ed. J. E. Spingarn (Oxford 1908), II, pp. 3–4.

30 Abbé du Bos, op. cit., pp. 211–12.

31 Saint-Évremond, 'Upon Tragedies', *Mixed Essays* (London 1665), p. 156.

32 Francois Hédelin, Abbé d'Aubignac, *La Pratique du Théâtre* (Paris 1657), pp. 109–10.

33 Ibid., p. 371.

34 Dryden, *Essay of Dramatick Poesy*, Ker, I, p. 57.

35 For example: *The Judgement of Solomon* (1649) and *Healing The Blind of Jericho* (1650). It was such pictures, whose actions take place as though on a painted stage serving as a background, which caused Sir Joshua Reynolds to say that French painters 'appear to take their ideas, not only of grace and dignity, but of emotion and passion, from their theatrical heroes'. *The Literary Works of Sir Joshua Reynolds*, ed. H. W. Beechy (London 1855), II, p. 318.

36 Le Brun's lecture is embodied in the *Sixième Conférence* of the Royal Academy, 5 November 1667. See Félibien, *Conférences de l'academie de peinture et de sculpture* (Amsterdam 1706), VI, pp. 83–104.

37 Walter Friedlander, *Poussin, A New Approach* (New York, n.d.), p. 146. See also Félibien, *Entretiens . . . etc.* (Amsterdam 1706), IV, pp. 19–20.

38 Félibien, op. cit., pp. 81–3.

39 Ibid., p. 94. See *Sixième Conférence*, op. cit., pp. 101–2.

40 Dryden, 'Preface to the Æneas', Ker, II, p. 154.

41 Ibid., p. 157.

42 As in the *Healing the Blind of Jericho* or, to an extent, even in the *Manna*.

43 Blunt, op. cit., p. 296.

44 For the full text of the letter on the modes, see Blunt, op. cit., pp. 367–70.

45 Poussin was fascinated by serpents. One recalls not only the tiny but frightening serpent in the lovely *Landscape with Orpheus and Eurydice* (1650s), but also the great and terrible serpent in the *Landscape with a Snake*. In the seventeenth century this latter picture was known as *The Effects of Terror*, and it interested Poussin's contemporaries as a study of the passion of fear. The picture could also have been seen as a brilliant solution to the problem of the unity of time, for its presents a 'successive' dramatic action without violating the formal composition. One of the most extraordinary qualities of the picture is its paradoxical treatment of nature. The pastoral beauty of the scene is extremely moving; yet in that very scene is the horror of a terrible death which is also the result of nature. The lower left corner of the picture is a frightening image of nature as a source of terror. Yet that spring of water, whose head hides the fatal serpent, flows out into the beautiful lake behind the road. In the structure and mood of the landscape beauty and menace are indissolubly connected.

46 Tasso, *Discorsi dell' arte poetica*, ed. by A. Solerti (Torino 1901), pp. 47–48.

47 Fénelon, 'Parrhasius et Poussin', in *Dialogues des morts, Oeuvres* (Paris 1854), IV, pp. 513–19.

48 See Ellis K. Waterhouse, 'Poussin et L'Angleterre jusqu'en 1744', *Nicolas Poussin* (*Colloques Internationaux* directed by André Chastel, Paris 1960), p. 295.

Hogarth and the English garden:
visual and verbal structures

Ronald Paulson

A pair of truisms will serve as point of departure for these speculations on visual and verbal structures in eighteenth-century England. The first refers to the engravings of William Hogarth: 'His graphic representations are indeed books: they have the teeming, fruitful, suggestive meaning of *words*. Other pictures we look at—his prints we read.'[1] The second truism says: 'The English, whose genius is literary, had by 1745 . . . created the poetic garden'. My source goes on to say that if French gardens were characteristically geometrical and logical, English gardens of the eighteenth century were organized in a literary way.[2]

'Literary' England was a country that traditionally hewed to a religion and a world view that substituted for the image—religious or otherwise— the word; its greatest creative imaginations had belonged to writers like Shakespeare, while its painters, sculptors, and gardeners had been imported from abroad. In the eighteenth century the names we associate with gardening are of literary men—Temple, Addison, Pope, Shenstone, Lyttelton, Walpole, and that very literary politician the elder Pitt; a poet who planned a garden might naturally make it as like a poem as he could. The names we associate most often with Hogarth are not of painters but writers: Butler, Swift, and Fielding (who named the Hogarthian genre 'comic history painting'). An Englishman like Hogarth who wished to be both Englishman and history painter might well abstract those clauses of the classic art treatises that linked the highest kind of painting to poetry, the image to the word. Jonathan Richardson, in his *Theory of Painting* (1715), invited the viewer of the Raphael Cartoons, or of any history painting, to invent dialogue to accompany the pictured actions; and his elaborate verbal analyses of paintings helped to provide the climate for the 'readable' structures of Hogarth's works.[3]

From our quotations 'literary' appears to mean the artist's copying of literary effects, alluding to a written source, or dealing with subject matter that was originally literary. But it also refers to the 'meaning of *words*' and their degree of denotation; and 'read' would seem to imply the presence of a kind of syntax as well.

If the function of words is to denote (and incidentally to connote), then plastic and verbal art may come together in so far as both denote. So long as words can be attached to the objects or even the formal structure of a painting, so long as its visual content has the capacity for verbalization, the painting is connected closely with verbal structures, though itself a visual one. As it becomes more abstract, its relationships of colour, form, and

texture more emphatic, words fail: as is obvious if one turns from a Raphael Cartoon of the acts of St Paul to a Raphael Madonna and Child. Conversely, the higher the level of denotation, the more particular the objects represented (all the Hogarthian 'furniture' referred to by Horace Walpole),[4] the greater its potential for verbalization. When in *A Harlot's Progress* (1732) a group of particular people, known to the contemporary viewer by particular names, appears with a girl who is identified by a name (on a piece of paper and her coffin plate), and by a history in six successive plates, surrounded by very particular objects in particular London settings, we are dealing with a highly verbalizable structure.

Words themselves sometimes appear to increase denotation, as in the name 'M. Hackabout' on the coffin plate; and there are often titles, even verses, attached to the graphic designs: the ironic title *A Midnight Modern Conversation* contributes to the meaning of a picture of a drunken revel in which no one is conversing. Sometimes Hogarth's full meaning is only clear when an image is verbalized by the viewer, as in the rope's 'end' or the shoemaker's 'last' among the eschatological images of *The Tailpiece*.[5] As a magistrate creeps up on her, the Harlot's watch reads 11:45 and may be translated: 'Time is running out' (ill. 27).

A kind of denotation also informed the gardens developed by Bridgeman, Kent and Pope in the 1720s and 1730s. One area in the garden might be devoted to thoughts of love; the landscape architect, wrote William Shenstone, would begin with a beautiful spot, and 'somewhat strengthen its effect, . . . supporting its title by suitable appendages—For instance, the lover's walk may have assignation seats, with proper mottoes—Urns to faithfull Lovers—Trophies, Garlands, &c. by means of art'.[6] 'Strengthen its effect' means increasing the specificity of denotation or connotation in various ways. A river was accompanied by the statue of a river god, a dell by a wood nymph, and appropriate areas were dedicated to the memory of worthies by means of Roman portrait statues or columns. Along the garden path the visitor was provided with benches on which to sit, which faced a particular scene, usually mingling natural objects with man-made ones of high-level denotation (a statue: the Venus de Medici; a temple: the Pantheon; an urn with the story of Proserpina). The bench was also, however, often inscribed with lines enlarging upon the visual effect of the scene; and so were the columns and temples. The meaning in both gardens and the Hogarthian progress often depends on the combination of natural objects, familiar man-made objects, and words that was characteristic of emblem books, and it has the same riddling effect on the observer.

Walking through Stowe or Rousham or Stourhead today we may think of it as a wonderful pattern of colours, shapes and textures, of various trees, plants and grass, against water, sky and stone. But the planner's intention was to produce a meaning. Those flowers we enjoy today were significantly absent: the effect was monochromatic, avoiding the transience of the season's difference. As in the Poussiniste point of view in the quarrel of the formalists and colourists, the important consideration was the permanent meaning.

I

Hogarth's engravings were of course also monochromatic, and what I shall say about readable structures applies much less to his paintings (which

usually precede the prints) with their colours and textures. Specificity of denotation is related to the 'finish' of the representation, to the degree to which the viewer is aware of the imitation as well as the imitated object; of the paint which is used to evoke the table for the senses as well as the table itself. To the extent that it is there as paint or lines on paper, the paint or line is going 'beyond its mere local function, to become an autonomous form with its own relative significance'.[7] If words mediate between the poet and his subject, paint serves the same purpose for the artist. Colour is of course one element of specific denotation, but Hogarth (with much critical opinion behind him) believed that in a work of morality our interest would be distracted by colour and texture.

This assumption—not shared by a Goya, who marvellously disproved it—was the assumption of a man brought up on books. Verbal for Hogarth also included the typographical. He seems to have firmly grasped the fact that on the printed page both visual and verbal structures were visual; and that two qualities of the printed page could be reproduced graphically—its left-to-right linearity and its 'exactly repeatable pictorial statements' (Ivins's term) or homogeneity (McLuhan's term).[8] His shapes were expressed through the conventional patterns of parallel lines and cross-hatching—as conventional, and style-less, to his audience as half-tone plates to us. Unlike most other artist-etchers, he sought no more variation between impressions than would a printer; and like the printer he distinguished only between deluxe and ordinary qualities of paper. He was in a sense producing a graphic version of the page of a book, appealing to the growing reading public, exploiting the book's potential at the same time that he avoided many of its limitations.

The Hogarthian progress was structured by those rational, linear forms used to communicate meaning in prose narratives. Hogarth and his readers naturally read as they wrote, from left to right; and he arranged his prints for the left-to-right movement of the eye on a printed page—in each print as well as in the set of six or eight.[9] The plates could not be rearranged; they portray a series of successive moments and convey a pattern of temporal progression, of cause and effect or act and consequence, and of beginning, middle and end. The harlot comes to London, goes into keeping, is expelled, and declines from prostitution to prison, disease and death. Past, present and future also proceed from left to right across the plate (ill. 25): the harlot's arrival in London is implied by the York wagon on the left, in the immediate present she is listening attentively to the bawd Mother Needham in the centre, and her future is indicated by Colonel Charteris and his pimp waiting on the right.

We cannot omit mention of Lessing's criteria of space and time for distinguishing painting from poetry. Hogarth is very aware of time; he not only shows the harlot changing in time—in a series of successive, though widely separated moments—he also evokes time by surrounding a few stable elements (the protagonist herself, her noseless servant woman) with changes of scene, setting, clothing and associates; by often including sun dials or clocks with precise times, or papers with precise dates; and by representing objects that indicate time passing or the transience of things: broken mirrors, over-boiling pots, cracked walls, torn playing-cards, knots in curtains, or sprigs of flowers.

However, the space-time polarity in poetry and the plastic arts, though no longer as clear as it was to Lessing, contains the essential distinction between

Hogarth and a writer of narrative in a book. The latter presents 'nothing but progressive actions' and so portrays 'all bodies and individual things only on account of their relation to these actions': if he requires a ship at one point, it is only one trait—say its speed. The painter, however, can copy a narrative action only 'where history brings together' a multitude of bodies and traits, and he must copy all the traits that are visible, beyond the single one relevant to the narrator at a given moment.[10]

The artist of course uses all these prolix traits: they make the separate temporal steps of a narrative synchronous, producing a 'character'; they relate as parts to a whole, rather than as steps in a linear-chronological narrative. Being present in space as well as time, the clergyman, Mother Needham and Colonel Charteris also represent varying degrees of guilt in relation to the young girl from the country, and perhaps also indicate with their interrelations a microcosm of English society.

The simple linear sequence of left-to-right, of cause and effect, is complicated by the groupings of the people, by the parallels and contrasts within the plate, by the whole scene of which the initial linear pull toward the right is only a part. The plates are constructed on a tension between the linearity of the book and the simultaneity of the picture. The former Hogarth could have learned from Defoe or any contemporary writer of fiction. The latter is indigenous to a plastic work of art. In plate 1 of *A Harlot's Progress* (ill. 25) the limp goose's head resembles the girl's, attentively inclined toward the bawd's blandishments. The goose and girl are paralleled; the goose is at the same time a goose and a way of indicating a resemblance to the girl, who is a 'silly goose' (we have to verbalize here); the goose is also dead, and a proleptic meaning is involved. In plate 2 (ill. 26), the monkey's surprise parallels that of the harlot's cuckolded keeper, is verbalized in the realization that she is 'making a monkey of him', and indicates something about the animal part of him that is involved in the transaction with her. The sword under the retreating lover's arm also serves a second purpose: it seems to stab the cuckold in the back. This is a purely optical pun, with again a verbal translation implied: without 'stab in the back' the meaning is incomplete.

Although such juxtaposition or conflation was a part of the popular tradition of graphic satire, the sophistication of double and triple meanings, as well as the plausibility of the setting, is characteristically Augustan. I believe Hogarth owes these to the polysemous forms, the puns, zeugmas and juxtapositions of Butler, Dryden, Swift and Pope—to their habitual practice of seeing a thing in different ways at the same time. One need only compare the chalice and wafers that turn out to be a pope's head in Reformation satiric prints with the bed curtain which knotted becomes a screaming face in plate 3 of *Harlot* (ill. 27) or Dulness's yawn near the end of *The Dunciad*:

> More she had spoke, but yawn'd—All Nature nods:
> What Mortal can resist the Yawn of Gods?
> Churches and Chapels instantly it reach'd;
> . . . catch'd the Schools . . . spread o'er all the realm. . . .[11]

Besides the pun Hogarth shares with the Augustan satirists the ironic juxtaposition of separate elements: 'A hero perish, or a sparrow fall' or 'When Husbands or when Lap-dogs breathe their last',[12] or the placing of an affianced couple next to a pair of manacled dogs in *Marriage à la Mode*, plate 1. Pope's lines tell us as much about society's attitude toward heroes

and husbands as do Hogarth's about marriage. Such juxtapositions, often producing complex parallels and contrasts, extend from the smallest details to the conjunction of styles or of style and subject.

Allusion I take to be the most important of these devices for Hogarth. The Augustan employment of allusions to literary works (often the *Aeneid* or the Bible) was, as Maynard Mack has said, 'specifically evaluative, constructing its image by setting beside some present object or situation not so much another object or situation as another dimension, a different sphere'.[13] The works alluded to were usually from the heroic past, and the mock-heroic—the 'great pervasive metaphor of Augustan literature'[14]—was the particular form of juxtaposition allusion took.

In Hogarth the mock-heroic allusion may begin with the composition of the plates: the general relation of the figures to the picture space in *A Harlot's Progress* echoes not popular prints but sublime history paintings, or more specifically engravings of them; and plates 1 (ill. 25) and 3 (ill. 27) echo the compositions of a Visitation and an Annunciation. Portrayed, however, are not the Virgin Mary but Moll Hackabout, not the angel of the Annunciation but Justice Gonson about to clap her in jail. More often the mock-heroic echoes are conveyed through the pictures of Biblical and classical scenes on the walls. These paintings-within-the-painting are visually related to the conventional shape of the engraved plate. The repeated shape of the plates, placed side by side, is what calls for a sequence; and within a plate the shape of the picture on the wall is the same as that of the story— the plate itself—and so establishes a parallel between its story and the plate's. The allusion, so compartmentalized, bears the same relation to the whole scene as a gloss to a text or a simile to an epic narrative; but the two parts are as simultaneous as the mock-heroic reference to the person it engrosses:

> High on a gorgeous seat, that far out-shone
> Henley's gilt tub, or Fleckno's Irish throne,
> Or that where on her Curls the Public pours,
> All-bounteous, fragrant Grains and Golden show'rs,
> Great Cibber sate. . . .[15]

Cibber, were he to be portrayed by Hogarth, might have a picture of Milton's Council of Hell above his chair in a room of unexceptionable eighteenth-century décor. Hogarth uses these allusions in the same way as Pope: the figures beneath the pictures try to act up to them, as Cibber does to Dulness's image of him, and Belinda to Ariel's admonition, 'thy own Importance know'.

Hogarth's allusions, it is important to notice, are part of a realistic setting: they range from Old Master paintings, which were of just such subjects, down to penny prints, depending on the wealth or status of the owner. History paintings and portraits were urged by the Shaftesburys and Richardsons upon the 'great' as models, and so collecting was both a sign of social status (climbing) and a call to imitate the 'heroic' actions of the collected. My point is that the mock-heroic allusions are indigenous here in a way that they are not in a mock-epic poem.

While the pictures are Hogarth's visual equivalents of the Augustan mock-heroic structure, they are also part of all the significant, proleptic or antecedent detail—the everyday, commonplace objects—of the pictorial scene, and in this context they mark a stage in the transition from a narrative

to a descriptive mode, analogous to the process of nominalization described by linguists. The emphasis in Hogarth's prints is as much on nouns—pictures, tables, dresses—as on verbs or the narrative action itself. Although he imitates a narrative sequence (as he imitates the composition of a history painting, or Swift imitates a travel narrative), the result is less narrative in the sense of Defoe's contemporary fiction than a series of discrete scenes intended for meditation, like the stops along a garden path.

Hogarth's own analogy for his work was with the stage: 'my Picture was my Stage and men and women my actors who were by Mean[s] of certain Actions and express[ions] to Exhibit a dumb shew'.[16] The play characteristically presents a series of scenes, and in each lets the characters gradually reveal themselves—immediately by exposition, which tells us what has happened and is about to happen; ultimately by their own words and deeds exposed before us. The artist and the dramatist share this advantage over the writer: a single glance can catch the whole of the scene, and this is a preliminary step in the pictorial reading that is denied the poet or novelist. In the second stage of 'reading', the picture or scene is gradually revealed to (or explored by) the spectator in time.

A first impression of a Hogarth print conveys a particular image of intricacy and disorder, irrational human shapes within more-or-less containing architectural forms. In *A Midnight Modern Conversation* (ill. 28), for example, the effect is sheer contrast, between the out-of-control bodies and the geometrical panels and architectural lines of the room (analogous to the dignity of the mock-heroic title). The first plate of *A Harlot's Progress* (ill. 25) has the shapes of the buildings, straight and formal, like the protocol of the negotiations in which the girl finds herself with the bawd, in this strange London. These geometrical shapes are constrictive in so far as they suggest the opposite of the pliant-shaped humans and anticipate (in the light of the whole series) the gradual closing in of architectural space that ends in a coffin. Again, the analogy must be with the contemporary stage set and its Serlio-like horizontal-vertical grid. There, in the same rectangular frame as a Hogarth print, real people acted roles in front of scenery painted to appear three-dimensional; the stylized manners they acted out as human beings conformed in interesting ways to the painted lines of the set. This interplay of the real and the feigned or imposed, the natural and the geometrical, which extends to the pictures on the walls, is at the heart of Hogarth's world.

The large expressive structure is, however, soon lost sight of in the very chaos it represents. Once the initial impression has been made, the rococo inner structure begins to lead the eye to move restlessly about and pick out details, relationships, and finally the significant moral patterns. The emergent structure might be a simple spectrum of a vice: in *A Midnight Modern Conversation* (ill. 28) a spectrum of drunkenness, in plate 6 of *A Rake's Progress*, a spectrum of gambling. The structure is often extraordinarily complex. Exploiting the intricate pattern of light and shade, conveyed in many representational objects, Hogarth complicates or modifies the meaning of the general expressive shape.

In the second plate of her story (ill. 26) the harlot and her Jewish merchant keeper are juxtaposed with the pictures he keeps on his walls: she with the oxen pulling the Ark of the Covenant and he with Uzzah rashly touching the sacred Ark. This 'reading' is conveyed through the parallel shapes of the tea table and the toppling Ark, both falling, both at the same angle;

and these shapes activate the allusion to the story of the Ark, which causes the reader to draw imaginary lines to the parallel figures in the scene below. These include the priest stabbing Uzzah, above the departing lover, whose sword appears to be stabbing the Jew in the back. Likewise, in the third plate (ill. 27) there is the rectangle of the picture and the roughly rectangular shape of the picture on the harlot's wall of Abraham sacrificing Isaac: the shapes support a parallel between the microcosm of Abraham–Isaac on the wall and Gonson and the harlot in the macrocosm of the picture itself.

I have by no means exhausted the reading structure of these plates,[17] but what the combined expressive-readable form says is that the Jew acts this way—keeping the Gentile girl and then casting her out—because he collects pictures and other status objects, because he emulates the 'great' collectors and their history paintings (here Old Testament subjects concerning rigorous justice and no mercy). And the harlot herself behaves analogously, living up to her model of 'great ladies' by cuckolding her keeper, and to his example by maintaining appearances with finery, a servant woman and her own pitiful collection of penny prints of Abraham and Isaac, Captain Macheath and Dr Sacheverell (yet other models of harlotesque conduct). These artistic and architectural formulae are what do in fact contract, change and destroy Hogarth's people. The rectangular boxes of frames and of rooms emphasize a grid that is artificially imposed on experience, by society and by the victim himself.

II

Like the reader of a Hogarthian progress, the visitor to a garden was often instructed to take a particular path in a particular direction, and his per-ambulation even had something like a beginning, middle and end. At Stourhead (ill. 24) the visitor was told to 'keep to the right-hand walk, which will lead us to a small temple with a Doric portico' (the Temple of Flora).[18] If he turned to the left, he would have begun at the Temple of Apollo, where the garden in fact came to an end.

Shenstone, at the Leasowes, also required that the visitor follow a particular path, suggesting that his path may 'resemble an epick or dramatick poem' which builds to dramatic climaxes.[19] The analogy of garden and epic poem was a commonplace, deriving from classical authorities, but it seems particu-larly appropriate in the gardens of Pope, Kent, Shenstone and Lord Cobham. At this period the garden is as allusive a structure as the poem. The association of a grotto with Numa, who communed there with the muses, might suggest that a river issuing from it is meant to represent a source of inspiration. Or the scene itself might be composed to recall a Claude land-scape, possibly a particular one with a relevant story out of the *Aeneid*, as has been suggested of the entrance to Stourhead.[20]

A parallel to the journey of Aeneas runs through the garden at Stourhead (there are also allusions, though less consistent, at the Leasowes). The inscriptions, the temples and the statues allude to the various prophecies pointing Aeneas to his founding of the New Troy on the shore of Latium (across the lake). From the steps of the Temple of Flora, with its emblems of harvest abundance and its prophetic inscription from the *Aeneid*, the Pantheon across the lake is a symbol of Rome towards which the visitor is progressing (it contains a statue of Hercules with its allusions to Aeneas and Augustus). The end of the journey is the Temple of Apollo, now first

revealed high on a hill. Thereafter the seats arranged along the way give other views of it, as if to keep it in mind on the arduous journey, and from its porch the whole journey can be viewed in retrospect. The 'message' of Stourhead was that here a banker was 'seeking out his ancient mother', transplanting the values of the city (old Troy) to a country life of harvest plenty and Roman values.

As Pope naturally drew for his poems upon the relationship of his form with the epic, and Hogarth of his form with the history painting, so the landscape gardener built on the norm of Pliny's descriptions of Roman gardens, on Roman architectural structures, and on the idealized Roman landscapes of Claude. The context of association was especially rich, combining the norm of the classical garden and its nymphs, satyrs, and spirits of the place, with the Garden of Eden, the Fall and Man's Redemption from the Christian tradition. These were, of course, implicit in the idea of the garden long before the eighteenth century,[21] but it was natural for the English Augustan, preoccupied with the *Aeneid* and *Paradise Lost*, with the literature of repose and retirement, to emphasize this symbolic aspect of the garden.

The Elysian Fields, which William Kent began at Stowe in the 1730s, were less formally laid out than the LeNôtresque alleys of the main park, one reason being that Kent wished to juxtapose with those alleys the Golden Age before fallen man imposed geometrical patterns upon nature. In fact, the garden progresses in much the same way as do those ostensible narratives, *The Rape of the Lock* and *The Dunciad*—by a series of tableaux full of witty juxtapositions. In the Elysian Fields Kent relates three elements: the temples of Ancient Virtue, Modern Virtue and British Worthies. The first and second are little more than verbalized equivalents. The first is a solid, classical structure, the second (now destroyed) was a chaotic heap of stones, which showed the 'ruinous state' of modern virtue. But there are also refinements of witty, allusive juxtaposition which recall Kent's friendship with Pope. The Temple of Ancient Virtue is modelled on the Temple of Vesta at Tivoli, which would carry the proper associations; but to a knowledgeable con-temporary it would probably have recalled Hawksmoor's version of that temple at Castle Howard, which served as the family mausoleum. It was, of course, placed in a valley called the Elysian Fields, associated with a lost Eden or Golden Age, separated from the temple of British Worthies by a river flowing out of the 'Styx', and was itself a tomb: the comment on the status of ancient virtue in the contemporary world is not unlike that of *The Dunciad*. The British Worthies are also qualified by the contrast of their sixteen busts with the four statues across the valley (of the greatest lawgiver, philosopher, poet and general of the ancient world). The British Worthies are also dead, and they are placed if not diminished in relation to the ancient worthies by their number, truncation, size and proportions; and finally by their juxtaposition with the memorial on the rear of the temple to a hound, Signor Fido, whose eulogy is clearly mock-heroic.[22]

The garden, however, offered possibilities for experience far beyond either the Augustan poem or the Hogarthian progress. Though the direction of its path was predetermined, the progress from scene to scene involved a kind of movement by no means linear: quick turns, sudden shifts of scene, sometimes the same scene viewed from a different perspective; abrupt revelations as well as spots in which to stop for some time and absorb the visual and verbal effects. The over-all principle on which the poetic garden

was structured was the series of stops, each a focus of meditation, in which the expression of the artist mingles with the interpretation of the viewer. But the gravelled path and the static bench were only relatively confining. The viewer could step off the path, leave the bench, and circle the temple or urn, and enter the temple or grotto.

The garden reflected and extended the Augustan mode in that it offered infinite possibilities for 'the disposition of a single figure to answer several points of view'.[23] If a bed curtain knot is also a screaming face, an obelisk or urn is revealed in different aspects as it is seen down different garden paths from various directions. Ultimately this structure becomes a central one: the 'perimeter belt' around the garden which circles scenes and sees them from various perspectives. But a radical loosening of the Augustan pun or couplet has taken place as the emphasis shifts from the many-faceted object to the various responses of different observers.[24] Even in Pope's garden there was obviously a great deal more than the moral emblem; from one garden bench he noted that 'you lose your eyes upon the glimmering of the Waters under the wood, & your ears in the constant dashing of the waves'.[25]

III

I chose the garden and the Hogarthian progress as my examples because both tended to adapt 'readable' structures from literary forms and also exploited to the end of readability the plastic characteristics of their own media. Both were verbal in the particular sense that they made visual certain ideas that are ordinarily expressed in words but that are too complex to be adequately so expressed.

Built into the English garden's poetic subject matter was a hostility to the geometry of the French garden; its man-made objects were consciously employed to do more than merely fill symmetrical or decorative niches. The garden was central to the age because it served as the great example of nature—artfully neglected shapes and serpentine paths—against geometrical patterns imposed on nature. This was the example that was rephrased in Hogarth's contrasts between human nature and the constricting shapes men try to adopt. In *Taste in High Life* he shows beautiful girls being pared and corseted to conform to the fashion, with an example of topiary gardening nearby. His *Analysis of Beauty* of 1753 codified the assumptions expressed by Addison, Pope, Stephen Switzer and others on the garden, and by Hogarth himself in his satiric prints. It may be through the mediation of his prints and of the garden that writers became aware of those potentialities of their own medium that had been borrowed and adapted.

At least it seems clear that the importance—the centrality—of Hogarth and the garden lies in the fact that while the interaction between the arts— particularly active in the eighteenth century[26]—went both ways, the powerful pull was from the direction of the visual (the sense of sight, the immediately perceptible) and the over-all result was less a verbalization of the visual than a visualization of experience usually conveyed by verbal structures, which now seemed no longer adequate.

On the one hand, the spokesman for the age, Joseph Addison, defined the pleasures of the imagination as seated primarily in the sense of sight: 'Our Sight is the most perfect and most delightful of all our Senses'.[27] On the other, the philosopher of the age, John Locke, pointed out that 'in all languages, certain words . . . if they be examined, will be found, in their

first original and their appropriated use, not to stand for any clear and distinct ideas'.[28] The distrust of the word—that mainstay of the English genius—can be traced back to the seventeenth century, to Bacon, Hobbes and the Royal Society. Twenty years after Locke wrote, Berkeley began his *Principles of Human Knowledge*: 'We need only to draw the curtain of words, to behold the fairest tree of knowledge, whose fruit is excellent, and within the reach of our hand'.[29]

The idea that error stems from our tendency to think in words instead of about the things the words signify, and indeed that English culture of the period was felt to be dominated in some unhealthy way by words and the book, is easily documented. *The Dunciad* and *Tristram Shandy*, Hume's *Treatise* and Burke's *Enquiry*, the poems of Blake and Wordsworth are preoccupied with the problem. In their different ways they all show attempts to escape the tyranny of syntactic and semantic structures and seek a more immediate response.

For Swift and Pope, looking around them at contemporary writing, the stable relation between the word and the thing had broken down, was no longer trustworthy. The word could, in the hands of a fanatic, mean anything he wanted it to mean, and utterly false images of experience were flooding London's bookstalls. One response was to satirize the phenomenon; by parodying it, as Swift did in *A Tale of a Tub*, or by creating a myth out of it, as Pope did in *The Dunciad*. Both produced imitative structures, making use of the rigid patterns of verbal discourse: dialectical argument, prefaces, digressions, appendices, footnotes, linear progression—in order to satirize their distortions of reality; and in the process their own meaning became spatial instead, arrived at through juxtapositions of parallel and contrast, allusions and the shifting meanings of words. Meaning emerged independently of the linear verbal structure in these works that attacked uncommunication and communicated simultaneously. We have seen something of their influence on Hogarth's visual-verbal structures.

Pope in particular endows his pages with a remarkably visual quality. In his Horatian imitations the reader constantly has before him the visual effect of the Horatian Latin on one page and Pope's vigorous, often anti-Horatian English on the other, with the obvious gaps on the Horatian side clearly indicating where Pope has indignantly exceeded his model, speaking his own mind. Above all, the *Dunciad Variorum* (1729) juxtaposes the handsome, generously spaced lines of Pope's poetry at the top of the page with the crowded, dusky double-columns of prose, pedantic, Scriblerian annotation at the bottom (ill. 29). Generalizing names and actions are in the orderly couplets at the top, and ugly words (vomit, merde) are domesticated in beautiful poetry ('the fresh vomit run for ever green', 'How young Lutetia, softer than the down, / Nigrina black, and Merdamante brown').[30] Below are the particular names, titles, places, dates and facts out of which poetry has been made. If the process dramatized in the text of the poem is the metamorphosis of the dirty and ugly (the dunces' perversion of beauty) back into beauty of a kind, the process of Scriblerus in his notes (though incidentally bringing out many of the poet's satiric points) is to reclaim the beauty of the poetry for dulness through his duncical scholarship. Visually the satire of Horace and Pope, and the worlds of dulness and poetry, engage in a continuing dialogue or conflict.

The initial response, then, was to dramatize rigid linear patterns, and while attacking what these did or did not communicate, communicating

oneself through non-linear, perhaps irrational patterns. This was of course largely limited to satire. But Pope for one found another outlet in gardening: his garden, though in a way intensely literary, was a solution to the false relationship between words and things because words are made secondary to things. The trees, columns, vistas, relationships between water and stone, cave and river, are not confused, though sometimes augmented, by the presence of words.

In 1740 appeared Pamela's letters, her spiritual autobiography, which attested to the truth of the word; they were for Mr B., Lady Davers, and the countryside around, not only true but so efficacious as to convert each of those reprobates. Fielding, reading *Pamela* in the light of rather different assumptions, saw the word of Pamela as only that, a counter related in some way to what really happened: perhaps as hypocritical self-justification. In the same way, Hume went to great lengths in his *Treatise* to show that logical and other verbal structures have no more real validity than any other 'beliefs', and that the truth is merely an immediate, wordless sympathy. The final illustration of these assumptions was *Tristram Shandy* (1759), which had to do with attempts on all levels to substitute a linguistic experience for a real happening—most obviously in Uncle Toby's efforts to explain 'where were you wounded?'. Verbal structures conceal rather than communicate, and contact is only possible through the sympathy that occasionally breaks through.

For writers like Fielding, Richardson and Sterne, Hogarth was the *pure* artist of the time, doing what they attempted with the faulty vehicles of words. As they realized, nature is more immediately apprehended in a painting than in a poem because the objects are without the counters of words, and so without as much opportunity for confusion and misunderstanding. Words themselves may bear connotations, while in a painting only the objects do (and a garden, of course, is an even more immediate apprehension). But Hogarth (and the garden) offered the further advantage that he used words too, emphasizing his awareness of these counters as entities in relation to visual images. The label 'harlot' or the title *Midnight Modern Conversation* activates an ironic discrepancy between word and thing. Even Hogarth's theme of the constricting nature of the framed visual images (framed and sanctioned by time) finds its equivalent in the letters, sermons, marriage contracts, legal opinions and other documents in the novels of Fielding and Sterne. But the essential way out was also indicated by Hogarth—the way towards kinds of visualization. Those phrases used by novelists of the time, 'Had I but the brush of a Hogarth . . .' tell the story.

Richardson, who asked Hogarth to illustrate *Pamela* for him, was aware of the limitation of visualization: how was the 'spirit' of Pamela to be made visible?[31] Nor did he share Fielding's distrust of the word; in fact, at the beginning he believed in the transcendent power of the unmediated word, as his faith in Pamela's letters shows. Nevertheless, he shared with Hogarth the pictorialism of the Puritan tradition, the belief that for purposes of teaching verbal structures were inferior to emblems and visual constructs, and the desire to 'present this [his moral] lively to your eyes, which I am fain to do now only to your minds and understandings'.[32]

Visualization appears most obviously in the pictorial quality of the scenes in Richardson's novels—in vivid gesture and facial expression, in attempts to produce scenes that duplicate the visual effect of a Hogarth print (its discrete, framed, stage-like effect) in ways extending from the letter form

itself to the occasional copying of scenes straight from a particular print. The death of Mrs Sinclair in *Clarissa*, for example, draws on the fifth and sixth plates of *A Harlot's Progress*. More interesting, he visualizes experience in typography, making pictorially expressive the printed page itself. This shows in the immediate appearance of the imitated letter, but also in the expressive representation of extreme situations. Pamela's interruption by the sudden arrival of Mr B. is indicated by a gap on the page; Clarissa's rape is followed by her disordered thoughts rendered in jumbled lines going every which way on the page (ill. 30). These letters are symbolic objects, Clarissa's writing of them symbolic actions: they express, far better than words, her independent will, and their disintegration and extinction represent the last shreds of her earthly identity that disappear with the rape. Her silence and the chattering of the letters of other writers around her represent Richardson's message about spiritual success through physical defeat. The visual strategy is carried much further by Sterne in *Tristram Shandy*, where in order to make himself understood Tristram must rely upon dashes of varying length, curious typography, blank or marbled or completely black pages, and sundry diagrams (ills. 31, 32).

Richardson's letters are segments, like the stops in the garden or the plates of a progress, and indicate a progression that, at least in *Clarissa*, is by no means straight. *Clarissa* not only does not progress in a chronologically straight line, its arrangement of letters forces the reader to cross-reference from one account to another to fill in the action. While Fielding tells his story in linear chronology, he complicates it so by his own ironic commentary that it becomes a matter of some importance to relate scenes and speeches spatially as well as chronologically. In *Tristram Shandy*—the most Hogarthian novel of all—Sterne makes the point explicit when he tells his reader to go back and re-read chapters he has not retained, and in fact attempts to replace the linear structure he inherited from the writer of narrative with a spatial, painterly one. He urges his readers to read his book not as if it were a book but a Hogarthian picture.

Nothing like the picture's immediate impression followed by gradual unfolding is possible in prose fiction. But Fielding and Richardson and Sterne, quite unlike Defoe and their other predecessors, present an immediately experienced scene (Richardson's 'writing to the moment') and then follow it with attempts to understand it or with other views of it—by other correspondents, characters, or the author himself (and, with Fielding, various projections of the reader as well)—so that it grows and does indeed unfold in time like a garden scene or a plate from *A Harlot's Progress*.

Notes

1 Charles Lamb, 'On the Genius and Character of Hogarth', *The Reflector*, II (1811), 61.

2 Derek Clifford, *A History of Garden Design* (revised ed., London 1966), pp. 144–5.

3 *An Essay on the Theory of Painting*, pp. 44–5; see Paulson, 'The *Harlot's Progress* and the Tradition of History Painting', *Eighteenth-Century Studies*, I (1967), 69–92.

4 Horace Walpole, *Anecdotes of Painting in England*, ed. James Dallaway (London 1828), IV, 135.

5 See Paulson, *Hogarth's Graphic Works* (revised ed., New Haven 1970), cat. no. 216, plate 240. The other Hogarth prints discussed can also be found there.

6 'Unconnected Thoughts on Gardening', *The Works, in Verse and Prose of William Shenstone, Esq.* (2nd ed., 1765), II, 113.

7 Max Raphael, *The Demands of Art* (Princeton 1968), p. 12.

8 See William Ivins, Jr, *Prints and Visual Communication* (Cambridge, Mass. 1946), and Marshall McLuhan, *The Gutenberg Galaxy* (Toronto 1962).

9 A comparison of Hogarth's paintings and prints shows that he made the paintings with print-reversal in mind, and so they do not read the way the prints do. For example, plate I of the *Rake's Progress* is constructed so that the eye moves up from the objects denoting the miserly father, to the lawyer settling the estate, to the son spending the money, to the girl he has made pregnant and is buying off; reversed, in the painting the girl blocks us and turns the composition into a static, sentimental view of the situation from her point of view. The painting is usually closer to a genre piece. I treat this matter in some detail in *William Hogarth: His Life, Art, and Times* (New Haven 1971), chapter 14.

10 Gotthold Ephraim Lessing, *Laocoön* (1766), chapter 16; tr. E. A. McCormick (Indianapolis 1962), pp. 78–9. See also Joseph Frank, 'Spatial Form in Modern Literature', *Sewanee Review* (spring, summer, autumn, 1945); Etienne Souriau, 'Time in the Plastic Arts', *Journal of Aesthetics and Art Criticism*, VII (1949), 294–307; Micheline Sauvage, 'Notes on the Superposition of Temporal Modes in the World of Art', *Revue d'Esthétique*, VI (1953), 277–90.

11 *The Dunciad*, IV, 605 foll.

12 *Epilogue to the Satires*, I, 88; *Rape of the Lock*, III, 158.

13 'Wit and Poetry and Pope', in *Pope and his Contemporaries*, ed. L.

Landa (Oxford 1949), p. 28. The reader will notice that for convenience I have structured the categories of Augustan juxtaposition according to Mr Mack's classic essay.

14 Op. cit., p. 36.

15 *Dunciad*, III, 1–5.

16 *The Analysis of Beauty*, ed. Joseph Burke (Oxford 1955), p. 209.

17 See Paulson, *William Hogarth: His Life, Art and Times*, I, 255–8.

18 Sir Richard Colt Hoare, ms. memoirs, Stourhead. See Kenneth Woodbridge, *Landscape and Antiquity. Aspects of English Culture at Stourhead 1718 to 1838* (Oxford 1970). Part one is especially relevant.

19 Shenstone, 'Unconnected Thoughts on Gardening', p. 114.

20 Woodbridge has argued (op. cit.), not altogether convincingly to me, that Henry Hoare had in mind Claude's *Coast View of Delos with Aeneas* (National Gallery, London); this would be an appropriate picture, because it shows Anius receiving Aeneas and preparing to prophesy about the New Troy. There seems little chance, however, that Hoare could have known the picture, which was in a private collection in France, and none that his visitors could have. He himself owned a copy of Claude's *View of Delphi with a Procession*, which has a roughly similar composition (a bridge, a round-domed and a square building), which was also available in an engraving of 1764.

21 Maynard Mack, *The Garden and the City* (Toronto 1969), pp. 21–4.

22 On Stowe and the 'reading' of the Elysian Fields, see John Dixon Hunt, 'Emblem and Expressionism in the Eighteenth-Century Landscape Garden', *Eighteenth-Century Studies*, IV (1971).

23 Mack, *The Garden and the City*, p. 28.

24 I have treated this subject in a separate, forthcoming essay, 'The Pictorial Circuit and Related Structures in Eighteenth-Century English Art'.

25 To Martha Blount, 22 June [1724], *Correspondence of Alexander Pope*, ed. George Sherburn (Oxford 1956), II, 238.

26 See Jean Hagstrum, *The Sister Arts* (Chicago 1958).

27 *Spectator*, no. 411.

28 *Essay concerning Human Understanding* (1690), III.X.I.

29 *Principles of Human Knowledge* (1710), I.I.

30 *Dunciad Variorum*, II, 156, 311–12.

31 See Aaron Hill, *Works* (1753), II, 300–1; *Pamela*, 2nd ed. (1741), I, xxxvi–vii.

32 John Robinson, *The Birth of a Day* (1655), pp. 5–6.

Turner and the romantic poets

J. R. Watson

There are so many discriminations of romanticism (to adapt A. O. Lovejoy's phrase) that poets and painters and musicians can pursue their own visions and preoccupations while remaining under the wide umbrella of the romantic movement. Indeed, their dissimilarity is a part of that movement. Each of the figures is unique, yet in their uniqueness they are together; their individuality, paradoxically, is their common feature. This is most obvious in the work of the romantic poets, and there is always a tendency to discuss the history of ideas primarily with reference to the verbal arts; and yet it is possible to observe the varied and contradictory elements of romanticism as better united in the work of artists who are basically non-verbal, like Beethoven and Turner. The fact that both of these figures find it necessary at times to use words as a part of their processes of expression gives to their work a direction which is explicit, but does not prevent them from experiencing and expressing all kinds of romantic sensations with a fullness which was denied to the poets; by its very explicitness the 'verbal icon' limits, particularly with regard to what Schiller saw as the centre of romanticism, *die Kunst des Unendlichen*. In Beethoven the search for the infinite, for unknown modes of being, for the inexpressible experience, is carried out with words and music. We know the mood and direction of the third symphony from its title of 'Eroica', and the progression of the sixth symphony by the descriptions of the movements; though the works themselves are not limited or defined by this. Turner's poems, and his use of the poetry of others, perform the same function in relation to his paintings. So does his habit of giving his pictures long and cumbersome titles. The result is an art in which we have (in John Gage's words) 'the world offered to physical vision and the attempt of the mind to understand it'.[1] And Gage has recently shown that Turner's preoccupation with colour and light, his experiments, his work on 'Goethe's Theory', do not set Turner apart from the poets, in the sense that he is a painter exercising his mind on a painter's problems only; but that his use of colour has a symbolic function in the way that his choice of subject has. In addition, Jerrold Ziff has noted the way in which Turner was interested in evoking associations, after the manner of Akenside, whose 'Pleasures of the Imagination' was a favourite poem of his; which, as Ziff points out, runs counter to the idea of Turner as a painter primarily interested in colour effects for their own sakes, and a forerunner of impressionism.[2] In effect, most modern scholarship points to Turner, both in his approach to a subject and in his execution, as a poetical painter. The phrase is from Lawrence Gowing's discussion of an early work, *Buttermere Lake*, which dates from 1797–8:

F. M. Piper *General Plan of the Pleasure Gardens at Stourton* 1779 drawing
Royal Academy of Fine Arts, Stockholm

25 Hogarth *A Harlot's Progress* plate 1 1732 engraving 11 13/16 × 14 3/4 in. (30 × 37.5 cm.)
 British Museum, London

26 Hogarth *A Harlot's Progress* plate 2 1732 engraving 11 7/8 × 14 5/8 in. (30 × 37 cm.)
 British Museum, London

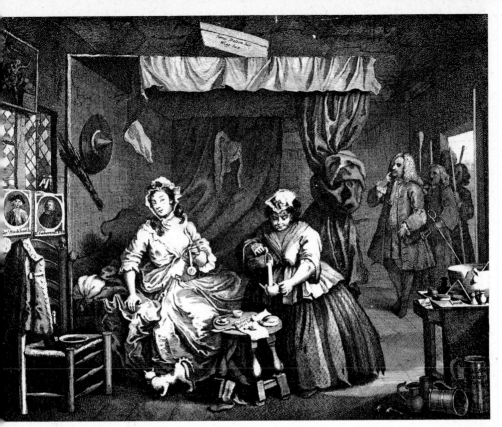

7 Hogarth *A Harlot's Progress* plate 3 1732 engraving 11⅝ × 14⅞ in. (30 × 38 cm.)
British Museum, London

8 Hogarth *A Midnight Modern Conversation* 1733 engraving 12¹³⁄₁₆ × 18 in. (33 × 45 cm.)
British Museum, London

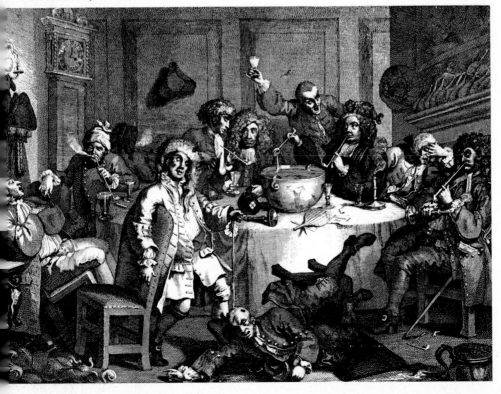

305 Shaking the horrors of his ample brows,
 And each ferocious feature grim with ooze.
 Greater he looks, and more than mortal ſtares ;
 Then thus the wonders of the Deep declares.
 Firſt he relates, how ſinking to the chin,
310 Smit with his mien, the Mud-nymphs ſuck'd him in
 How young Lutetia, ſofter than the down,
 Nigrina black, and Merdamante brown,
 Vy'd for his love in jetty bow'rs below ;
 As Hylas fair was raviſh'd long ago.
315 Then ſung, how ſhown him by the nutbrown maids,
 A branch of Styx here riſes from the Shades,
 That tinctur'd as it runs, with Lethe's ſtreams,
 And wafting vapours from the Land of Dreams,
 (As under ſeas Alphæus' ſacred ſluice
320 Bears Piſa's offerings to his Arethuſe)

REMARKS.

VERSE 314. *As Hylas fair.*] Who was ra- | true Hiſtory. *Lethe* and the *Land of Dreams*
viſh'd by the water-nymphs and drawn into the | allegorically repreſent the *Stupefaction* and vi-
river. The ſtory is told at large by *Valerius* | ſionary *Madneſs* of Poets equally dull and extra-
Flaccus, Lib. 3. *Argon.* See *Virg. Ecl.* 6. | vagant. Of *Alphæus* his waters gliding ſecretly
VERSE 316. *&c. A branch of Styx, &c.*] | under the ſea of *Piſa,* to mix with thoſe of
Homer, *Il.* 2. *Catal.* | *Arethuſe* in *Sicily, vid. Moſchus Idyl.* 8. *Virg.*
'Οἱ τ' ἀμφ' ἱμερτὸν Τιταρήσιον ἔργ' ἐνέμονlο, | *Ecl.* 10,
Οἵ ῥ' ἐς Πηνειὸν προΐει καλλίρροον ὕδωρ, | *Sic tibi, cum fluctus ſubter labere Sicanos,*
Οὐδ' ὅγε Πηνειῷ ſυμμίſγεlαι ἀργυροδίνῃ, | *Doris amara ſuam non intermiſceat undam.*
Ἀλλὰ τέ μιν καθύπερθεν ἐπιρρήει ἠΰτ' ἔλαιον· | And again, *Æn.* 3.
Ὅρκꙋ γὰρ δεινꙋ, Στυγὸς ὕδαlꙋ, ἐςιν ἀπορρώξ. | — *Alphæum, fama eſt, huc Elidis amnem*
Of the land of Dreams in the ſame region, he | *Occultas egiſſe vias, ſubter mare, qui nunc*
makes mention, *Odyſſ.* 24. See alſo *Lucian*'s | *Ore Arethuſa tuo, Siculis confunditur undis.*

IMITATIONS.

VERSE 307. *Greater he looks, and more than* \ ——— *majorque videri*
mortal ſtares.] Virg. 6. of the Sybil. | *Nec mortale ſonans* ———

LEAD me, where my own thoughts themselves may lose me ;
Where I may dose out what I've left of life,
Forget myself, and that day's guile !——
Cruel remembrance !———how shall I appease thee ?

—— Oh! you have done an act
That blots the face and blush of modesty ;
 Takes off the rose
From the fair forehead of an innocent love,
And makes a blister there !

 Then down I laid my head,
Down on cold earth, and for a while was dead ;
And my freed soul to a strange somewhere fled !
 Ah ! sottish soul ! said I,
When back to its cage again I saw it fly ;
Fool ! to resume her broken chain,
And row the galley here again !
Fool ! to that body to return,
Where it condemned and destined is to *mourn !*

Oh, my Miss Howe ! if thou hast friendship, help me,
And speak the words of peace to my divided soul,
 That wars within me,
And raises every sense to my confusion.
 I'm tottering on the brink
Of peace ; and thou art all the hold I've left !
Assist me——in the pangs of my affliction !

When honour's lost, 'tis a relief to die :
Death's but a sure retreat from infamy.

 Then farewell, youth,
 And all the joys that dwell
 With youth and life !
 And life itself, farewell !

For life can never be sincerely blest.
Heaven punishes the *bad,* and proves the *best*

(right margin, rotated:) To frighten children. Pull but off the mask, / And he'll appear a friend. / Would harrow up thy soul——

(margin, rotated:) By swift misfortunes / How am I pursued ! / Which on each other / Are, like waves, renewed !

pity and esteem for him; ——a foot-
way crossing the church-yard close by
the side of his grave, — not a passenger
goes by without stopping to cast a look
upon it, ——and sighing as he walks
on,

Alas, poor YORICK!

CHAP.

CHAP. XL.

I Am now beginning to get fairly into
my work; and by the help of a
vegitable diet, with a few of the cold
seeds, I make no doubt but I shall be
able to go on with my uncle *Toby*'s story,
and my own, in a tolerable straight line.
Now,

Inv. T.S *Sculp TS*

These

These were the four lines I moved in
through my first, second, third, and
fourth volumes.——In the fifth volume
I have been very good,——the precise
line I have described in it being this:

A B c c c c c D

By which it appears, that except at the
curve, marked A. where I took a trip
to *Navarre*,—and the indented curve B.
which is the short airing when I was
there with the Lady *Baussiere* and her
page,—I have not taken the least frisk
of a digression, till *John de la Casse*'s
devils led me the round you see marked
D.—for as for *c c c c c* they are nothing
but parentheses, and the common *ins*
and *outs* incident to the lives of the great-
est ministers of state; and when com-
pared

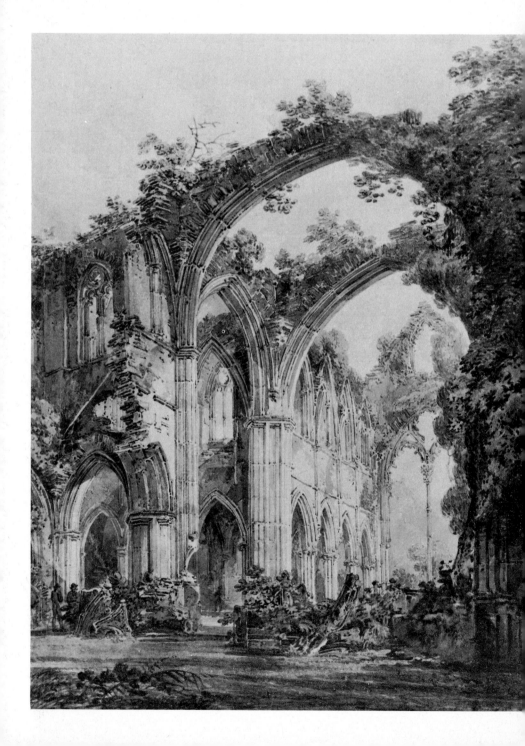

34 J. M. W. Turner *Salisbury Cathedral from the Cloister* 1796–7 watercolour 26¾ × 19½ in.
(68 × 49.5 cm.) Victoria and Albert Museum, London

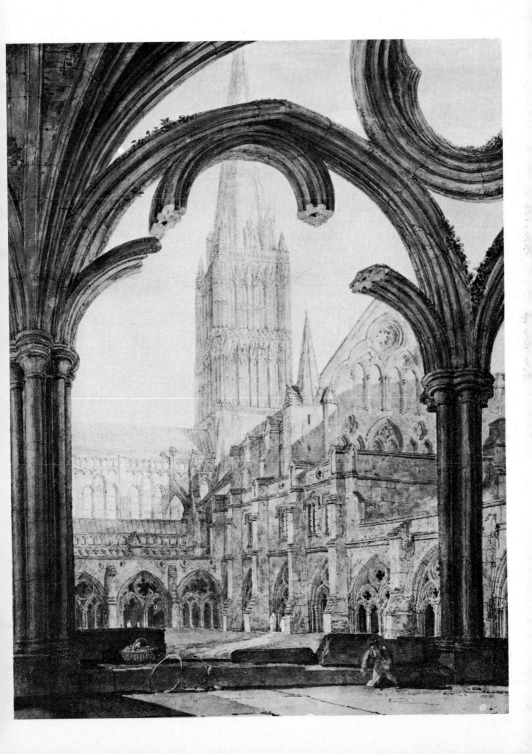

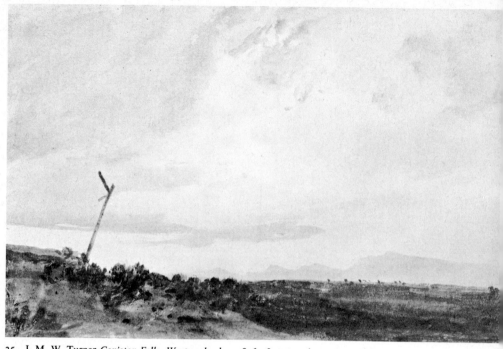

35 J. M. W. Turner *Coniston Fells, Westmorland, c.* 1816–18 watercolour 9⅞ × 16¼ in. (25 × 41 cm.) Whitworth Art Gallery, University of Manchester

36 J. M. W. Turner *The Fall of an Avalanche in the Grisons, c.* 1810 oil on canvas 35½ × 47¼ in. (90 × 120 cm.) Tate Gallery, London

7 J. M. W. Turner *The Slave Ship* 1840 oil on canvas 35¾ × 48 in. (91.5 × 122 cm.)
Museum of Fine Arts, Boston, Henry Lillie Pierce Fund

38 J. M. W. Turner *The Shipwreck*, *c.* 1805 oil on canvas 67½ × 95 in. (171.5 × 241.5 cm.)
Tate Gallery, London

39 J. M. W. Turner *Dolbadern Castle*, *c.* 1800 oil on canvas 47 × 35½ in. (119.5 × 90 cm.)
Royal Academy of Arts, London

40 J. M. W. Turner *Snowstorm: Hannibal and His Army Crossing the Alps*, *c.* 1812 oil on
canvas 57 × 93 in. (145 × 236 cm.) Tate Gallery, London

To a contemporary it looked merely dull. Hoppner, the fashionable portraitist, went to Turner's studio to see it and pronounced him 'a timid man afraid to venture'. To us the stillness has a different meaning. It gives a sense of awe, as if the painter and subject were both subdued by the unearthly majesty of light.

Turner's vision of the rainbow over Buttermere was poetic, and he knew it. It was one of the pictures to which he attached lines of poetry in the Academy catalogue, for the first time. For *Buttermere* he strung together fragments of Thomson's *Spring*, as if forcing them to compose a poem of his own.[3]

To say that Turner was a poetical painter is to recognize his interest in the 'sentiment' of his pictures, in a way which has not been clear since Ruskin; the difficulty has been, not in admitting Turner's associations but in deciding what those associations were, and there has been much disagreement about the associative and 'poetical' experience offered by the various aspects of Turner's work. He has been compared to Wordsworth, in various ways;[4] to Keats,[5] to Byron,[6] and to Shelley.[7] While many of the comparisons are not exactly wrong, they are often excessively impressionistic and limited to one aspect of the painter's work; and yet in making them the critics felt that they were identifying some characteristics of Turner's elusive art. The present essay is an attempt to approach this process of 'identification through comparison' more systematically; though any attempt to say something about Turner's relation to the poets of his time may serve to emphasize only the painter's many-sided genius, his Protean quality.

And yet the painter does share many common assumptions and preoccupations with his contemporaries, if only because of the time in which he was working. As Lawrence Gowing put it, 'Something in the spirit of the age, the affinities and rivalries of nations, and interweavings of one art with another, motivate individual artists of various schools, all at the same time, in the way of an unconscious response to the cultural matrix.'[8] An examination of this interweaving of one art with another, in Turner's connections with the poets of his age, should tell us more about the painter's art, and about the cultural matrix of romanticism from which it sprang.

II

We may observe, to begin with, that Turner's early influences in landscape were the same as those felt by the romantic poets of his age. At school at Brentford he read Thomson and Akenside, Homer in Pope's translation and Virgil in Dryden's; in his twenties he was exhibiting pictures with quotations from Milton and Thomson, Mallet and Langhorne appended to the catalogue entries. It is interesting that these poets remained his favourites. He was particularly fond of Thomson and Akenside, knew Milton well, and used Homer for one of his greatest compositions, *Ulysses Deriding Polyphemus*. His contemporaries remarked upon his love of poetry, and the depth and understanding of his wide reading; and yet Turner took little notice of the original poets of his age, with whom he has since been compared. Late in his life he used *Prometheus Unbound* in his caption to *Light and Colour (Goethe's Theory)*, and he knew *Childe Harold's Pilgrimage*; but the poets he quoted in his lectures were Akenside, Thomson and Milton. The poets whose work he illustrated, too, were the conventional ones of his day: Scott, Rogers, Campbell. For an artist as original as Turner to be associated

with the more traditional poetry of his time requires some explanation. It may be simply that these were the best known poets of the day, as Byron's estimate of them shows; but if Turner was so well read, and so fond of poetry, why did he fail to respond to a contemporary like Wordsworth, or to others in whom critics have seen such affinities with his own art?

The answer may lie in a certain insensitivity to verbal effects, which is suggested by the clumsiness of Turner's own writing in prose, and the unoriginal forms of his poetry. His criticism of Thomson, while penetrating, is significantly concerned with the succession of images in the piece under discussion rather than with verbal qualities and effects.[9] It may also be a part of Turner's stance of isolation, so that he had no close connection, after the death of Girtin, with any contemporary artist, either poet or painter. Certainly this is indicated by Turner's competitiveness, his sense of rivalry with painters alive or dead which is shown in his emulation of Claude, or Wilkie, or Martin, and his behaviour on that celebrated varnishing day at the Royal Academy when he ruined the effect of Constable's picture of the opening of Waterloo Bridge by slapping a daub of red lead on to his own seascape nearby.[10] To his competitiveness may be added Turner's secrecy about his private affairs, the construction of his own gallery, the disinclination to sell his pictures; and to some extent his isolation from his contemporaries, and from contemporary poetic influences, may have been part of a necessary preservation of an individual temperament.

As we have seen, Turner was well read in the orthodox literary taste of his time. A delight in Thomson and his followers sent him naturally in the direction of the picturesque, and so did the work of the topographical artists whose watercolours he copied at the house of Dr Monro. His first visits out of London were to picturesque landscapes: the Avon Gorge, the Wye valley, the Lake District. And yet, as we should expect, Turner modifies the picturesque for his own purposes, takes a landscape and demonstrates his imaginative response to it. There are, for instance, three early oils, all of which are connected with places known to be picturesque, which depart strikingly from the picturesque and from each other: they are *Fishermen at Sea* (1796), which is set off the coast of the Isle of Wight; *Buttermere Lake* (1798), from the Lake District; and *Dolbadern Castle* (1800) from North Wales. These represent three sides of Turner's art which call for attention in terms of this study; and, setting aside Turner's divisions of landscape in the *Liber Studiorum*, I think it is possible to see Turner's relation to the romantic poets through his sea pictures, his rendering of local and specific landscape, as in *Buttermere Lake*, and his heroic landscapes, of which *Dolbadern Castle* (ill. 39) is an example, and to which I link the paintings of heroic subjects. From the isolation of his individual vision, Turner's work moves towards his contemporaries in these three branches of his art.

III

Turner's first reaction to picturesque subjects was to make them more striking and dramatic. This may be seen in his watercolour of Tintern Abbey (ill. 33) exhibited in 1794, now in the Victoria and Albert Museum, where every picturesque detail is heightened and made more powerful. The perspective is taken from low down, giving an impression of extra height and slenderness to the pillars and the arches of the crossing, and the

whole structure acquires a delicacy and lightness because of this. Meanwhile there is an abundant use of the traditional picturesque effects: Turner exploits the contrast between the stone and the ivy which entwines it, the play of light upon the irregularities of the ruin, the whole producing what one theorist of the picturesque, Richard Payne Knight, called a 'grateful irritation'. Even in such an early visit to a traditional landscape for connoisseurs, Turner's individual treatment is discernible in the excitement which his painting gives to the eye. Less directly picturesque, but more dramatic, is the watercolour of *Salisbury Cathedral from the Cloister*, painted around 1796 (ill. 34). Lit by sunlight, the shining spire of the cathedral is seen tapering upwards, though its top is never seen, and we may imagine it reaching upwards to an infinite height. Like the ruins of Tintern Abbey, it is seen from low down, from what seems to be the floor of the cloister; and it is seen through the broken ribs of the open trefoil arch of the cloister light. In the foreground is a small boy who appears to be playing marbles; across the archway he has put down his basket and hoop. Ruskin noted Turner's fondness for trivia in the foreground; and in this case the eye is carried from the boy and his things, through the broken arches, ivy-covered again, to the sunlit completeness and perfection of the spire, reaching up towards heaven. The boldness of the conception is typical of Turner: the spires perform a somewhat similar function in a poem attached to the picture of *London* exhibited in 1809, a poem which looks backwards to Blake and the chartered streets, forwards to Carlyle and Dickens and the fog:

> Where burthen'd Thames reflects the crowded sail,
> Commercial care and busy toils prevail,
> Whose murky veil, aspiring to the skies,
> Obscures thy beauty, and thy form denies,
> Save where thy spires pierce the doubtful air,
> As gleams of hope amidst a world of care.

Here the poetical imagination of Turner is at work in an obvious way. John Gage quotes the obituary notice of Turner by John Burnet in the *Art Journal*, which stressed the way in which Turner was 'careful in choosing the characters of his figures to embellish the several scenes, for even the most trifling incident was pressed into the service that could excite or heighten the association of ideas; this it is that gives an imaginative or poetical stamp to his works.'[11]

Turner shares with the romantic poets this symbolizing or mythologizing power, involving an approach to nature which is interpretative and expressive rather than descriptive. It is difficult, however, to go beyond this generalization, because of the abundance and variety of Turner's landscape. He is able to respond with such accuracy of technique and such sensitivity of mood to so many different kinds of landscape, that he resembles now one romantic poet, and now another. One example of this is his visit to the Lake District during his northern tour of 1797. The paintings of the Lake District depart from the picturesque in an entirely different direction from the watercolours of Tintern Abbey and Salisbury Cathedral. They are un-picturesque, not by being dramatic or exciting to the eye, but rather by a lack of flamboyance, a concentration on the mood and spirit of the place which expresses itself in the subdued tones of the paintings and in the disregard of outline. The two Lake District paintings which Turner exhibited

at the Royal Academy in 1798, *Morning amongst the Coniston Fells* and *Buttermere Lake*, take no account of the ideas on mountainous landscape put forward by a writer like William Gilpin, with his strong sense of outline and the balancing of forms to make a whole. The picture of Coniston Fells, for instance, is of a hillside which Gilpin would have called 'lumpish', and takes no account of the conventional arrangement of foreground, middle distance and 'offskip'. Instead the side of the hill climbs the painting until at the top there is a swirl of clouds and hilltops, mingling together as the morning sun disperses the mist. At the foot of the picture (and of the hill) the landscape is dark, except for the silver of a little waterfall; the eye travels up towards the brown hillside, with the shepherd, his boy and his flock of sheep; and thence to the morning light on the summit, rendered in white and yellow and grey. It is an amazing and original picture; in its avoidance of picturesque elements it is very like Wordsworth's description in *An Evening Walk* of the evening sunlight on an oak:

> . . . And, fronting the bright west, yon oak entwines
> Its darkening boughs and leaves, in stronger lines . . .

Commenting on this, Wordsworth remarked that he remembered exactly where and when he observed this effect, and that he dated from it 'my consciousness of the infinite variety of natural appearances which had been unnoticed by the poets of any age or country, so far as I was acquainted with them'.[12] The directness of response, overriding all picturesque considerations, is typical of both Turner and Wordsworth: both the morning light of *Coniston Fells* and the poem's evening light are directly observed. None of the picturesque writers who were known to Wordsworth had been interested in the effects which he wanted to describe, and he thought that the cult of the picturesque led to superficiality, of which he had been guilty himself at one time:

> . . . giving way
> To a comparison of scene with scene,
> Bent overmuch on superficial things,
> Pampering myself with meagre novelties
> Of colour and proportion; to the moods
> Of time and season, to the moral power,
> The affections and the spirit of the place,
> Insensible. (*The Prelude*, xii.114–21)

It is precisely the capturing of 'the moods of time and season', and 'The affections and the spirit of the place' which distinguishes Turner's *Coniston Fells* from Lake District paintings by Gilpin, or Farington, or Laporte. The resemblance to Wordsworth is in the intensity of the vision of one particular place at one particular time, as opposed to the generalized conception of landscape embodied in one prospect. Thus *Buttermere Lake* plays down its conventional effects by subdued tones, its lack of clear outline, and its concentration of sunlight on the flat valley at the head of the lake. As we have seen, a contemporary of Turner saw it as dull and timorous, and Lawrence Gowing has added that 'the picture seems almost styleless'.[13] If I read this phrase rightly, it suggests an abandoning of contemporary devices in painting in order to achieve an original and immediate authenticity; much as Wordsworth attempted to use simple language for the fundamental passions of the human heart.

To Turner's feeling for the mood and spirit of a place, and his sense of a style that is styleless, we may add from these Lake District paintings a third Wordsworthian quality. This is Turner's awareness of a strange desolation. It occurs, for instance, in a watercolour of Coniston Fells (ill. 35) in the Whitworth Art Gallery of the University of Manchester, which is in my view the nearest approach in painting to the 'visionary dreariness' that Wordsworth describes in book XII of *The Prelude*. Under a cloudy sky is a flattish moor of browns and sombre greens; beyond on the skyline can be seen the further mountains, quite lacking in the elegant lines of the picturesque; while on the left of the picture, stuck at an angle and pointing across the moor, is a finger-post. The effect is very like that of Wordsworth's description of the

> . . . moorland waste, and naked pool,
> The beacon crowning the lone eminence,
> The female and her garments vexed and tossed
> By the strong wind.
>
> <div align="right">(The Prelude, xii.258–61)</div>

Yet in spite of the closeness of Turner's Lake District paintings to the descriptions in Wordsworth's poetry, the similarities in mood and style, I do not think it is possible to claim that Turner is exclusively or even primarily Wordsworthian in his approach to landscape. He is much too varied and original a landscape painter to confine himself either in his subject-matter, as Constable was inclined to do, or in his approach to it. The alpine landscapes, for instance, have affinities with a whole range of romantic poetry: the sixth book of *The Prelude*, Byron's *Manfred*, Shelley's *Mont Blanc*, Coleridge's *Hymn before Sunrise in the Vale of Chamouni*. These poems have in common an awe and wonder at the majesty and terror of the higher alps; Turner shares this because once more he is representing 'the affections and the spirit of the place', and these are spectacular and terrifying, as in *The Passage of the St Gothard, from the Centre of the Devil's Bridge*, with its accentuated verticals dwarfing the tiny travellers, or the *Fall of an Avalanche in the Grisons* (ill. 36), where an enormous boulder is hurtling into the trees and smashing the tiny cottage beneath it. The storm is rendered in astonishing black and white, with black clouds and white, whirling snow. Here Turner is both attracted and repelled, by the magnificence of the natural forces and by their destructiveness. His approach to the alps is like that of Shelley, who was bored by English landscape but responded enthusiastically to the alps:

> I never knew, I never imagined what mountains were before. The immensity of these aerial summits excited, when they suddenly burst upon the sight, a sentiment of extatic wonder, not unallied to madness— And remember this was all one scene. It all pressed home to our regard and to our imagination. Though it embraced a great number of miles the snowy pyramids which shot into the bright blue sky seemed to over hang our path—the ravine, clothed with gigantic pines and black with its depth below. . . .[14]

Here is the love of contrast, the excitement and wonder, 'not unallied to madness' which is found in Turner's alpine landscapes. In its sense of the power of natural forces, it is connected with the turbulence of many of his sea-pictures, and his interest in volcanoes, which is something else that he

shares with Shelley. An example is the picture of the eruption of the Souffrier Mountains (on the island of St Vincent). Turner paints a night eruption, which gives him an opportunity to contrast the glow of the volcano with the darkness of the sky; but it is also an example of the violence and strength of nature, as Turner's lines on the picture suggest:

> Then in stupendous horror grew
> The red volcano to the view,
> And shook in thunders of its own,
> While the blaz'd hill in lightnings shone,
> Scattering their arrows round.
> As down its sides of liquid flame
> The devastating cataract came,
> With melting rocks, and crackling woods,
> And mingled roar of boiling floods,
> And roll'd along the ground!

In another branch of Turner's landscape painting, the Italian scenes, John Gage also finds a similarity with Shelley (whose poetry Turner discovered late in life). 'It is noteworthy', he writes, 'how close, in . . . sections of the *Lines Written among the Euganean Hills* and elsewhere, Shelley's incandescent vision of Venice is to Turner's own.'[15] Shelley sees the towers 'Quivering through aereal gold', and his whole picture of the sunrise looks forward to Turner's paintings of Venice:

> Lo! the sun upsprings behind,
> Broad, red, radiant, half-reclined
> On the level quivering line
> Of the waters crystalline;
> And before that chasm of light,
> As within a furnace bright,
> Column, tower, and dome, and spire,
> Shine like obelisks of fire,
> Pointing with inconstant motion
> From the altar of dark ocean
> To the sapphire-tinted skies . . . (100–10)

Shelley and Turner are both concerned to capture the effect of sunlight reflected on the buildings and on water, the mixture of stillness and movement, that quality of movement which Turner recognized as one of the great challenges to the painter's techniques.

To Shelley one might add Byron when considering Turner's Italian landscapes. In the same year that Turner visited Venice, 1819, Byron was galloping on the sands of the Lido, admiring the sunsets which fascinated the painter. With the publication of the fourth canto of *Childe Harold's Pilgrimage*, in 1818, Turner had a guide to the scenes of Italy, and access to the sentiments of a poet brooding over the Italian past. His tribute to Byron, painted after a later visit in 1828–9, was entitled *Childe Harold's Pilgrimage—Italy*, and exhibited in 1832. A quotation from canto IV was added:

> . . . and now, fair Italy!
> Thou art the garden of the world.
> Even in thy desert what is like to thee?
> Thy very weeds are beautiful, thy waste

More rich than other climes' fertility:
Thy wreck a glory and thy ruin graced
With an immaculate charm which cannot be defaced.

This quotation, which characteristically omits a line and a half from the original (stanza XXVI), illustrates very well the preoccupation of the picture with beauty and decay. In the foreground there is a Watteau-like group of people enjoying themselves, but behind is a strange and remote landscape, almost oriental in character, with a bridge nearly broken, terraces covered with ivy, a single tree, and empty-looking castles on the hilltops. More than any of Turner's landscapes, perhaps, this one deserves the comment made by Thomas Green of Ipswich: 'Turner's views are not mere ordinary transcripts of nature: he always throws some peculiar and striking *character* into the scene he represents.'[15] That the character of Turner's landscapes varies so greatly is a testimony to his ability to respond to so many different kinds of scenery and to so many moods. This makes his work impossible to compare with that of his poetic contemporaries except in detail, and in specific instances; though over all Turner's landscapes there is the power of his original mind, and the interpretation of his symbolizing imagination.

IV

Fishermen at Sea is the first of the notable sea paintings, including, in Turner's early years, *Calais Pier* and *The Shipwreck* (ill. 38). That Turner, London born, should have had such a powerful feeling for the open sea is not easy to explain, but it does suggest that his inspiration was of an entirely different order from that of Constable. As Constable was fond of saying that the scenes of the Stour valley 'made him a painter', so Turner claimed the same function for a picture by Vandevelde. No doubt something of this admiration was due to the painter's technical mastery, the skill of capturing the flow and movement of the sea in the medium of oil on canvas; but there must also have been an attraction in the sea itself, in its power and grandeur as well as in its beauty, and in the sea as contrasted with the frailty and temerity of human beings. In his study of the romantic iconography of the sea, *The Enchafed Flood*, W. H. Auden writes of sea-obsession as a romantic phenomenon. The sea is 'that state of barbaric vagueness and disorder out of which civilization has emerged and into which, unless saved by the effort of gods and men, it is always liable to relapse' (pp. 18–19). He tabulates what he calls 'the distinctive new notes in the Romantic attitude':

1 To leave the land and the city is the desire of every man of sensibility and honour.

2 The sea is the real situation and the voyage is the true condition of man . . .

3 The sea is where the decisive events, the moments of eternal choice, of temptation, fall and redemption occur. The shore life is always trivial.

4 An abiding destination is unknown even if it may exist: a lasting relationship is not possible nor even to be desired. (p. 23)

The relevance of this to a poem like *The Ancient Mariner* or to *Moby Dick* does not need labouring; and it indicates a way in which Turner's sea pictures belong to an archetypal pattern which goes very deep in the romantic movement.

The sea was important to Turner's art in two ways. In the first place it fascinated him by its appearance, its ability to reflect different colours and lights. Critics were always ready to find fault with Turner for his rendering of the sea: Sir George Beaumont, who disliked Turner's work with a disagreeable and prejudiced consistency, said that the sea in *Calais Pier* 'appeared like batter'.[17] 'Soapsuds and whitewash' was the description applied to the *Snowstorm* of 1842 by a later critic. Yet each of these paintings originated in a personal experience: *Calais Pier* in a stormy channel crossing of 1802, and the *Snowstorm* in the remarkable episode on board the *Ariel*, when Turner had himself lashed to the mast. The result was a painting which was as accurate a visual impression as Turner's remarkable memory could create; its unusual qualities may be seen as a confirmation of this. In the same way the 'colour beginnings' were the product of an observation which transcended the current rules. The River Thames, the English sea-coast, and above all Venice, stimulated Turner to these experiments designed to catch the play of light on water exactly as he saw it. When Sir George Beaumont, admiring a picture by Vandevelde, said that 'Vandevelde's picture made Turner's *Sea* appear like pease soup',[18] it is likely that Turner was attempting to render a green found in the sea which was unregarded by earlier sea painters.

The second way in which the sea was important to Turner is that it provided a scene for certain kinds of human activity which interested him. *Fishermen at Sea* shows two frail-looking boats, tossed to and fro in a stormy night within sight of the menacing rocks of the Needles. *The Shipwreck* (ill. 38) carries the idea further, as the sea is overwhelming the small boats; one, its mast at forty-five degrees, is hopelessly overloaded with canvas—a huge beige-coloured sail which stands out startlingly against the background of the storm clouds. It is as though it is an emblem of the foolhardiness of man, or of his defiance of the forces against him in the world. In the episode of the snowstorm off Harwich, we find the same conception of frail yet heroic man pitted against the elements. In this case the man is Turner himself, and his words are worth recalling: 'I wished to show what such a scene was like; I got the sailors to lash me to the mast to observe it; I was lashed for four hours, and I did not expect to escape but I felt bound to record it if I did. But no one had any business to like it.'[19] In this mood Turner is Byronic. His pictures show people in extreme danger, and *The Snowstorm* is his announcement of his own capacity to endure hardship. It is contrasted with the critics' liking or disliking, as the authentic experience against the inauthentic. It is like Byron's scorn of the woman who at Chamonix, 'in the very eyes of Mont Blanc', exclaimed 'How rural!'[20] Byron, the great swimmer, the rider, the crack shot, the man of action who had knocked about the world, despised the lake poets for what he considered the pettiness and triviality of their provincial attitudes; and Turner's position is a similar one.

To his conception and experience of the sea as dangerous and terrifying must be added a further element, that of the sinister. This is found in a picture like the *Sunrise with a Sea Monster*, or in the lines appended to *The Sun of Venice Going to Sea*:

Fair shines the morn, and soft the zephyrs blow,
Venezia's fisher spreads his painted sail so gay,
Nor heeds the demon that in grim repose
Expects his evening prey.

All these elements of Turner's sea painting combine in the terrifying *Slave Ship* of 1840 (ill. 37). On the left of the picture a ship is almost obscured, apart from the masts, by the spray of the waves breaking over the deck. The violent sky heralds the typhoon which is coming on; while in the right foreground the man-eating fish devour the body of a dead or dying slave. Turner wrote, under the catalogue entry:

Aloft all hands, strike the top-masts and belay;
Yon angry setting sun and fierce-edged clouds
Declare the Typhon's coming.
Before it sweep your decks, throw overboard
The dead and dying—ne'er heed their chains.
Hope, Hope, fallacious Hope!
Where is thy market now?

It becomes clear that he was thinking not only of the storm clouds, but also of man's cruelty to man, and further of his favourite theme of the fallacies of hope—so much a favourite theme that he collected his scattered writings under the heading of 'The Fallacies of Hope'. The *Slave Ship* is the greatest of Turner's terrifying sea pictures, not only in its triumphant use of blazing colour to portray the 'Typhon', but also in its definitive completeness of statement which comes from a skilful amalgamation of two different anti-slavery sources. One was Thomson's *Seasons*; the other, as T. S. R. Boase discovered, the account of the slave ship *Zong*, which Turner would have found in Thomas Clarkson's *History of the Abolition of the Slave Trade*. Boase tells the story—

... of how Captain Collingwood, when an epidemic broke out amongst his cargo, threw the slaves overboard rather than let them die of disease, as insurance could be claimed for those lost at sea, but not for those dead through sickness. At his trial one plea in defence was that there was great shortage of water, but it was established that even while the deed was being done, a storm that would replenish their supplies was bearing down upon the ship.[21]

In Turner's picture, this is joined with the lines from Thomson, and, in Boase's words, 'Turner, in his crucible-like mind, melts poem and police case into one glowing whole.' The storm is not going to replenish the ship's water supply, but destroy it. It was Thomson who had written about the typhoon, and described the destruction of the slavers as well as their prisoners; by joining this to the *Zong* case Turner is able to portray not only the cruelty, but the futility of the cruelty, since the slavers will never reach the land where they can claim their insurance benefits or sell their remaining slaves. It is a portrayal of man's inhumanity to man, which at the same time makes clear man's insignificance in the face of the power and violence of natural forces.

When viewing what Boase calls Turner's 'sea horrors', of which the *Slave Ship* is the climax, one thinks of Thomson's description of the shark:

> . . . Lured by the scent
> Of steaming crowds, of rank disease, and death,
> Behold! he rushing cuts the briny flood,
> Swift as the gale can bear the ship along;
> And from the partners of that cruel trade
> Which spoils unhappy Guinea of her sons
> Demands his share of prey—demands themselves.
> The stormy fates descend: one death involves
> Tyrants and slaves; when straight, their mangled limbs
> Crashing at once, he dyes the purple seas
> With gore, and riots in the vengeful meal. (*Summer*, 1013–25)

or of William Falconer, whose poem *The Shipwreck* ran to twenty-four editions between 1762 and 1830; or of Byron, and the shipwreck in canto II of *Don Juan*. In these paintings Turner is giving pictorial form to an idea of some importance to the romantic imagination of the poets.

Turner's river paintings, which deserve mention here, are less disturbing. In a picture like *Keelmen Heaving in Coals by Night*, Turner is concerned with the effect of the fires reflected in the water. Most of the river pictures are temperamentally quieter; as so often in romantic art, the external surroundings reflect the expressive mood. An example of the 'sentiment' of a scene which is thus discovered is found in an elegiac painting like *The Fighting 'Temeraire' tugged to her last berth to be broken up, 1838*, to which may be added a calm sea picture, the memorial for Wilkie, *Peace—burial at sea*. In both of these pictures the water is tranquil, allowing the reflection of the ships to be seen in the water—the golden Temeraire, bare-masted, pulled along in the evening sunlight by a steaming black paddle-tug, or the black sails and hull of the ship on which Wilkie died. Reflected too is the brilliant light which guides the seamen who are lowering Wilkie's coffin into the sea, which contrasts with the deep black of the sails ('I only wish I had any colour to make them blacker', Turner said). The black and white at the centre, surrounded by the greys and yellows of the evening sky and sea, show at its best Turner's use of colour as an expressive medium to convey his idea—the elegiac mood of the sea, the mourning of the ship, the merit (Turner's word) of the dead painter.

<div align="center">V</div>

When Turner was elected a Royal Academician in 1802, he sent in as his diploma picture the *Dolbadern Castle* which he had exhibited in 1800. Although Turner had doubts about it, and later sent another picture for consideration, *Dolbadern Castle* (ill. 39) was a good choice to represent him. It belongs to a class of heroic landscapes in which the natural effects are joined to historical events, so that Turner's genius for landscape was linked with his aspirations in what was then the most highly regarded branch of painting, history painting. The historical content of *Dolbadern Castle* is emphasized in the lines which the painter wrote for its exhibition:

> How awful is the silence of the waste,
> Where nature lifts her mountains to the sky.
> Majestic solitude, behold the tower
> Where hopeless OWEN, long imprison'd, pin'd,
> And wrung his hands for liberty, in vain.

The picture is dark in tone: high rocks fall to a stream at the foot of the picture, with an overhanging crag on the right giving an effect after Salvator Rosa. Two banditti-like figures at the edge of the stream continue the Salvatorian mood; high up on the crags, and seeming higher from yet another of the low viewpoints which Turner used so well, stands the castle. It has a ferocity and grandeur which is taken up by the 'majestic solitude' and reflected in the stormy conditions, for there are dark clouds overhead, giving way to a lighter sky behind. In its gloom and severity, the landscape is an expression of the forbidding historical fact, that Owen was imprisoned in the castle for much of his life by his brother Llywellyn, Prince of Gwynedd, after leading an unsuccessful rebellion in 1255. For similar examples in romantic poetry, there is Byron's *Prisoner of Chillon*, concerned with the imprisonment of Bonnivard, and Shelley's short poem about Ugolino, *The Tower of Famine*, not to mention *Prometheus Unbound*. Tyranny enters, too, into Turner's poem attached to *Caernarvon Castle*. The picture is more conventionally topographical than the one of Dolbadern, but the poem echoes Gray's *Bard*:

> And now on Arvon's haughty tow'rs
> The Bard the song of pity pours,
> For oft on Mona's distant hills he sighs,
> Where jealous of the minstrel band,
> The tyrant drench'd with blood the land,
> And charm'd with horror, triumph'd in their cries,
> The swains of Arvon round him throng,
> And join the sorrows of his song.

It seems likely that Turner knew something of Welsh history and had the Edwardian conquest in mind when visiting North Wales; and in this mingling of landscape and history, Turner is close to Scott, whose feeling for the Scottish landscape was inextricably connected with a knowledge of its history. The knowledge of events in the past assists the beholder in the full understanding of the scene before him; and while Turner's heroic landscapes show an instinctive feeling for the composition and visual organization of a scene, he rarely neglects an opportunity to include history and action. At times the painter's observation meets the poet's imagination, as a storm in Wharfedale becomes *Snowstorm: Hannibal and his Army Crossing the Alps*, and a fierce day in Snowdonia becomes part of *The Fifth Plague of Egypt*. The picture of Hannibal (ill. 40) is a major example of Turner's interest in the Carthaginian theme, with its powerful contrast between the material wealth of a great city and its eventual conquest and extinction (as Lindsay points out, it had been used by Turner's favourite Thomson).[22] The picture captures Hannibal at the moment of promise, looking down over the plains of northern Italy; but the poem, and the storms of the picture, present a forbidding background to his optimism:

> Craft, treachery, and fraud—Salassian force,
> Hung on the fainting rear! then Plunder seiz'd
> The victor and the captive,—Saguntum's spoil,
> Alike became their prey; still the chief advanc'd,
> Look'd on the sun with hope;—low, broad, and wan;
> While the fierce archer of the downward year
> Stains Italy's blanch'd barrier with storms.
> In vain each pass, ensanguin'd deep with dead,

Or rocky fragments, wide destruction roll'd.
Still on Campania's fertile plains—he thought,
But the loud breeze sob'd, Capua's joys beware!

The fierce archer of the downward year is Sagittarius, whose November storms destroyed a good number of Hannibal's army, and the captives taken after the siege of Saguntum; as in the *Slave Ship*, victor and victim are indistinguishable in their helplessness against the power of the elements. Hannibal points onwards to his victories, not realizing that although he might win the battles, the luxuries of Capua were to be the downfall of his army. It is the kind of irony that would have appealed to Turner: one of the fallacies of hope, greatness destroyed not from without, in battle, but from a weakness within. Another of the Carthaginian paintings, *The Decline of the Carthaginian Empire*, returns to the idea:

> . . . At hope's delusive smile,
> The chieftain's safety and the mother's pride,
> Were to th'insidious conqu'ror's grasp resigned;
> While o'er the western wave th'ensanguin'd sun,
> In gathering haze a stormy signal spread,
> And set portentous.

The angry setting sun is one of Turner's clearest emblems; the promise of foul weather accompanies the statement of human folly in expecting happiness. It appears in the poem on the *Slave Ship*, and in one of his last pictures, *The Visit to the Tomb*, in which he imagines Dido visiting the tomb of her husband Sychaeus: 'The sun went down in wrath at such deceit'. In every case the poem makes explicit the painter's meaning, his use of scene and weather to say something about man and his hopes. Here Turner is poet-painter, expressing himself in two ways. At other times he uses other poets: two battle scenes in which he does so are *The Field of Waterloo* (1818), which has lines from Byron, and the *Battle of the Nile*, which has lines from *Paradise Lost* describing the artillery of Satan, as though Turner associated a naval battle with the devil. But to the end of his life Turner was concerned with images of ferocity and destruction, and most powerfully with the relationship between the destructiveness of man and the destructiveness of nature. An example is found in the lines appended to *The Battle of Fort Rock, Val d'Aouste, Piedmont, 1796*:

> The snow-capt mountain, and huge towers of ice,
> Thrust forth their dreary barriers in vein;
> Onward the van progressive forc'd its way,
> Propell'd, as the wild Reuss, by native Glaciers fed,
> Rolls on impetuous, with ev'ry check gains force
> By the constraint uprais'd; till, to its gathering powers
> All yielding, down the pass wide devastation pours
> Her own destructive course. Thus rapine stalk'd
> Triumphant; and plundering hordes, exulting, strew'd,
> Fair Italy, thy plains with woe.

Following in the steps of Hannibal, Napoleon's army resembles the devastating glacier, while the beauty of Italy adds pathos to its helplessness. Turner's portrayal of man as oppressor and victim and yet also as a pathetic and self-deluded optimist is one that sets him very close to the romantic poets.

VI

Even in a short study of Turner's art, it will be clear that large-scale comparisons between Turner and individual romantic poets cannot be made. Even a division of his art into sections allows for a variety of comparison, in landscape painting for instance, which is of very limited value. Certain pictures connect with certain poets: the Lake District ones with Wordsworth, the volcano pictures with Shelley, the sea paintings with Byron, the castles with Scott, and so on. More interesting than such an observation of individual paintings, however, is the kind of romantic experience which is represented by Turner in the general attitudes of his work.

In the first place, we may remark Turner's mythologizing imagination. The extent of this can vary, from the character which is given to a landscape, to the use of landscape and weather to illustrate a legendary or historical subject. It is an approach to the external world which is essentially symbolic. René Wellek has argued, in reply to Lovejoy's discriminations, that this is one of the features of a workable concept of romanticism. There are, in Wellek's view, three arguments for the unity of European romanticism: an emphasis on the creative imagination, a particular regard for nature and its relationship with man, 'and basically the same poetic style, with a use of imagery, symbolism, and myth which is clearly distinct from that of eighteenth-century neoclassicism.'[23] The poet, with his individual imagination, looks at the external world, and sees it as something alive, rich with meaning which the imagination finds: the imagination which, in Coleridge's words, 'is essentially *vital*, even as all objects (*as* objects) are essentially fixed and dead'.[24] Turner possesses pre-eminently the individual vision, and the imaginative power which transforms the world which he sees. The direction of his transformation is archetypally romantic also. There is the fascination with nature in all its forms, and particularly with its transient forms—the play of light, the change of colour; there is the interest in the terrible manifestations of nature, and the relation between nature and man, in which man perceives his littleness under the power of the sea or the crashing of the avalanche; and, in his littleness, we also see his cruelty and inhumanity, his futile tyrannies; there is the heroism of the brave, and the prosperity of the wicked. For Turner's imagination has a basic tendency towards pessimism.

I have said that the individual comparisons of Turner's paintings with the poets are of little value. Yet, taken together they serve to indicate the way in which Turner's art includes so many of the emotions and attitudes which we associate with romanticism. It is an art which is individualistic, rebellious, pessimistic, yet also aware of the beauty of the world, and especially the beauty of colour. It has Byron's and Shelley's hatred of tyranny, Wordsworth's love of nature, Coleridge's sense of the vitality of nature seen with the imaginative eye. In the abundance and variety of his art, Turner includes them all; and it is possible that, in England particularly, we have been so conscious of the fragmentary nature of romanticism because of a propensity to approach the movement from the poets, each of whom expresses an important aspect of it. If we turn from the limitations of the poet's art, we may find—and this essay has attempted to suggest some ways in which we may find—that however varied our discrimination of romanticisms may be, in England they are united in the work of Turner.

Notes

The poetry which Turner added to the catalogue entries of his exhibited pictures will be found in the Appendix to A. J. Finberg's *The Life of J. M. W. Turner*, 2nd ed. (Oxford 1961); and it is printed, together with some other unpublished poetry of Turner, in Jack Lindsay's *The Sunset Ship* (London 1966).

1 John Gage, *Colour in Turner, Poetry and Truth* (London 1969), p. 188.

2 Jerrold Ziff, 'J. M. W. Turner on Poetry and Painting', *Studies in Romanticism*, iii (1964) no. 4, pp. 193–215.

3 Lawrence Gowing, *Turner: Imagination and Reality* (New York 1966), p. 7.

4 E.g., by Walter Thornbury: 'All Turner's works betray a truly Wordsworthian recognition of detail and a love of common things.' (*The Life of J. M. W. Turner, R.A.*, 2nd ed., London 1877, p. 544) or by Harry Goodwin: 'both left old paths; both sought after new methods, fresh truths of nature, rarely hesitating to use the most homely incidents to illustrate their themes'. There is, says Goodwin, in both poet and painter, 'a strange mingling of the sublime and the ridiculous' ('Wordsworth and Turner', in *Wordsworthiana*, ed. W. A. Knight, London 1889, p. 269). Another critic, Charles Clare, finds a peace and harmony, a spaciousness and dignity, in them both (*J. W. M. Turner, His Life and Work*, London 1951, p. 36). Russell Noyes observes unexceptionably that 'Turner shared with Wordsworth a delight in poetic interpretations of scenery', but concludes that 'in style and handling there is scant parallel between them' (*Wordsworth and the Art of Landscape*, Bloomington and London 1968, p. 87).

5 Ian Jack observes that both Turner and Keats were 'particularly interested in the effect of light and mist in scenery' (*Keats and the Mirror of Art*, Oxford 1967, p. 112). A J. Finberg, observing that two articles in the *Examiner* by the Hunt brothers, Robert and Leigh, appear on the same page—the one damning Turner, and the other praising Keats—comments that the painter and poet are attacked and praised for the same reason, for their richness and splendour in the treatment of nature (*The Life of J. M. W. Turner*, 2nd ed., Oxford 1961, p. 248).

6 C. B. Tinker points out Turner's interest in Byron, 'of whose stormy emotions he seems to have had an instinctive understanding' (*Painter and Poet*, Cambridge, Mass. 1939, p. 152).

7 John Gage finds in one of Turner's pictures that 'the elements and feeling of his treatment are very close to Shelley', and that 'both poet and painter were concerned to evolve a poetic language out of the most intimate understanding of the workings of nature' (op. cit., p. 147).

8 Gowing, op. cit., p. 5.

9 Ziff, op. cit., p. 199.

10 C. R. Leslie, *Autobiographical Recollections*, ed. Tom Taylor (London 1860), I, p. 202.

11 Gage, op. cit., p. 133.

12 *The Poetical Works of William Wordsworth*, ed. E. de Selincourt and H. Darbishire (Oxford 1940–9), I, 318–19.

13 Gowing, op. cit., p. 7.

14 *The Complete Works of Percy Bysshe Shelley*, ed. R. Ingpen and W. E. Peck (London 1965), ix.184.

15 Gage, op. cit., p. 146.

16 Finberg, op. cit., p. 57.

17 The Farington Diary, 1 April 1804.

18 Ibid.

19 Finberg, op. cit., p. 390.

20 *The Works of Lord Byron. Letters and Journals*, ed. R. E. Prothero (London 1898), iii.352.

21 T. S. R. Boase, 'Shipwrecks in English Romantic Painting', *Journal of the Warburg and Courtauld Institute*, xxii (1959), nos. 3–4, pp. 332–46.

22 Jack Lindsay, *J. M. W. Turner, A Critical Biography* (London 1966), p. 118.

23 René Wellek, 'The Concept of Romanticism in Literary Scholarship', *Concepts of Criticism* (New Haven and London 1963), pp. 160–1.

24 Coleridge, *Biographia Literaria*, ed. J. Shawcross (Oxford 1907) I, 202.

Dickens and the traditions of graphic satire

John Dixon Hunt

Any one who would rightly . . . estimate the genius of Mr Dickens,
should first read his works . . . and then read the essays by Charles
Lamb and by Hazlitt, on the genius of Hogarth . . .

This invitation (by R. H. Horne in 1844) to read Dickens in the light of a
major graphic artist has never been fully accepted.[1] Yet we know that at
his death the novelist possessed a 'complete set' of Hogarth engravings and
that by 1848 he could show himself familiar with many major works:

> . . . witness the Miser (his shoe new-soled with the binding of his Bible)
> dead before the Young Rake begins his career; the worldly father,
> listless daughter, impoverished nobleman, and crafty lawyer in the
> first plate of the 'Marriage à la Mode'; the detestable advances in the
> Stages of Cruelty; and the progress downward of Thomas Idle . . .
> one immortal journey down Gin Lane . . .[2]

Dickens was obviously one of the 'few great writers' that, according to
Horne, had recognized 'the tragic force, and deep moral warnings, contained
in several of the finest works of Hogarth' and it is doubtless this enthusiasm
for Hogarth, at a time when his raciness and vulgarity were regarded rather
dubiously, that informed the discussions of Hogarth by two of Dickens's
associates on *Household Words*, Horne himself and George Sala.[3]

Nor is it only a question of Hogarth. His art was perpetuated and
modified by a host of graphic journalists, of whom Gillray and Rowlandson
are outstanding.[4] And from this tradition of popular art came most of
Dickens's illustrators—George Cruikshank, Seymour (briefly for *Pickwick*),
and Hablôt K. Browne ('Phiz'). If Dickens's suggestion for the collection
of 1836 was *Sketches by Boz and Cuts by Cruikshank*,[5] it should be remem-
bered that he was writing the sketches long before the cuts were required.
That the engravings sometimes seem to capture so unerringly the qualities
of Dickens's imagination testifies, I believe, less to the aptness of the
collaboration than to the fact that Dickens drew upon and was conditioned
by the same graphic traditions that gave him his illustrators. And it would
seem inconceivable that, so attentive to Hogarth, he should not be affected
also in some measure by the vast graphic output of Hogarth's successors.
It is true that he wrote disparagingly of Gillray and Rowlandson:

> . . . they are rendered wearisome and unpleasant by a vast amount of
> personal ugliness. Now, besides that it is a poor device to represent
> what is satirized as being necessarily ugly . . . it serves no purpose but

to produce a disagreeable result. There is no reason why the farmer's daughter in the old caricature who is squalling at the harpsichord (to the intense delight, by the bye, of her worthy father, the farmer, whom it is her duty to please) should be squab and hideous. The satire on the manner of her education . . . would be just as good if she were pretty.[6]

Yet his parenthesis on the farmer, as well as an earlier remark about their 'great humour', suggests some real involvement with Gillray's and Rowlandson's work. When in *Sketches by Boz* he offers the tale of Miss Amelia Martin,[7] not only are such musical parties a familiar topic in graphic caricature, but Dickens elicits from the scene much of the same range of humour (without the ugliness) as his visual predecessors.

At times it is hard, inevitably, to disentangle the various strands of Dickens's visual inheritance. It is much easier to identify the elements of his 'Gin-Shops' (in *Sketches*) that owe *nothing* to graphic tradition: the slight titillation of bourgeois voyeurism ('for the edification of such of our readers as may not have had opportunities of observing such scenes') and the concluding homily on England's 'great vice'. But it is especially difficult to adjudicate between, say, the presence of Hogarth's *Gin Lane* (ill. 46) in the 'wretched houses with broken windows patched with rags and paper' and the gin-shop drawings of Gillray or Rowlandson or Cruikshank. The facetious and pell-mell writing at the beginning of the sketch may parallel the zany frenzy that whirls through a Gillray scene; while the 'stout coarse fellow . . . [with] a knowing air, and . . . sandy whiskers' and the 'faded feathers' paraded by the woman customer (185)* recall the figures of Rowlandson's drinking establishments, where the softness and sketchiness of his lines delay, for just a crucial moment, our recognition of the coarseness. Above all, the way in which the grotesquerie and sense of social malaise are allowed to grow during Dickens's sketch parallels exactly our slowly developing awareness of the full meaning of Hogarth's essay on drunkenness, *A Midnight Modern Conversation* (ill. 28), or Rowlandson's 'Dram Shop' in *The Dance of Death*. Even Cruikshank's *Gin Shop*, closer to Dickens's homiletic vein with its obvious captions about the burial society and with the skeleton at the door, needs scanning for a time before the snare (or gin) on the floor and the skull behind the mask of the young serving girl make their point.

This kind of analysis can stress only parallels between Dickens's imagination and that of the graphic artists rather than exact sources. Yet we are used to critical applause for his visual imagination and it needs substantiating with some account of the habits of his creative eye as he disposes a 'scene' or presents a 'character' and of how these habits were formed. The *Sketches by Boz*, for example, are usually offered as evidence of Dickens's love and knowledge of London and often we are told that this is 'recognizably the London Hogarth drew'.[8] But if we do recognize Hogarth in Dickens it may well be because the writer's presentation of material was shaped by his acquaintance with graphic art. For, as Professor Gombrich reminds us in *Art and Illusion*, the artist (in this case, Dickens) will see what his eye has learnt to look for rather than paint 'what he sees'. So my essay proposes to explore the conditioning of Dickens's vision by the graphic arts from Hogarth onwards, especially the 'language' and 'grammar' of objects (the words are Hogarth's)[9] which he employs.

* All page references in the text are to the *Oxford Illustrated Dickens* (1948–58).

In the first place it would appear that such early works as the *Sketches* and *Pickwick Papers* were directly nourished by the world of graphic journalism and that the large readership Dickens soon commanded is perhaps a measure of his success in extending into literary form the topics, treatment and attitudes of popular engravings.[10] I shall also show that in later novels Dickens's imagination is sustained on many occasions that we admire most in his art by the techniques and ideas suggested by the graphic arts.

<center>I</center>

Nowhere is Dickens's debt to the world of popular engraving better seen than in his handling of crowds, themselves a characteristic motif of the caricaturist's vision. In the opening scene of the *Sketches by Boz* (in their book form) a crowd gathers at the sight of the parish beadle and, as Dickens remarks, 'we revel in a crowd of any kind—a street "row" is our delight'.[11] He seizes many opportunities of creating the profusion of street life:

> Men and women—boys and girls—sweethearts and married people—babies in arms, and children in chaises . . . Gentlemen in alarming waistcoats, and steel watch-guards, promenading about, three abreast, with surprising dignity (or as the gentlemen in the next box facetiously observes, 'cutting it uncommon fat!')—ladies, with great, long, white pocket-handkerchiefs . . . (95)

The human interest is undeniably abundant in such crowds. But our delight in the very different crowds of Hogarth,[12] Gillray or Rowlandson owes as much to their organizing an essentially inchoate mass of people as to their keen observation. Highlights are dispersed among the crowd and we must pick out, one by one, the various sub-plots and variations on a central theme, like the complex political allusions in *An Election Entertainment* (ill. 41). Even with graphic work that does not require this interpretative reading, like Gillray's *Union Club* (ill. 42), we still learn to focus upon a profusion of detail. Dickens similarly delights in invoking the mass of a crowd and then in singling out the 'gentleman in the next box' in the passage just quoted, or lingering upon another figure to suggest something of his history by means of a brief anecdote.

Just as Hogarth's and Gillray's mobs are held (Gillray's very precariously) by the frame of their engraving, so Dickens's crowds are given coherence by their presence at some focal point or by the author's imposition of his own specific framework:

> The row of houses in which the old lady and her troublesome neighbour reside, comprises, beyond all doubt, a greater number of characters within its circumscribed limits, than all the rest of the parish put together. (13)

and we then learn about both the mass and the individuals held in this focus. In 'Greenwich Fair' we are first asked to 'imagine yourself in an extremely dense crowd, which swings you to and fro, and in and out' and then to follow Dickens in distinguishing the 'screams of women' from the 'clanging of gongs' or the 'squeaking of penny dittoes' (114–15). 'The Prisoners' Van' begins (272) with a crowd at the 'corner of Bow Street', moves closer to observe its 'thirty or forty people, standing on the pavement

and half across the road', widens the focus momentarily to notice 'a few stragglers' in visual contrast to the mass and narrows by the end of the first paragraph to the 'sallow-looking cobbler', through whom the central event is partly seen.

This method of scanning a sketch from its outer framework and general locale through its divergent yet unifying detail is a graphic device that Dickens manipulates, I believe, with far more skill than his illustrator. Compare Cruikshank's 'A Harmonic Meeting' with Dickens's paragraph:

> In a lofty room of spacious dimensions, are seated some eighty or a hundred guests knocking little pewter measures on the tables, and hammering away, with the handles of their knives, as if they were so many trunk-makers. They are applauding a glee, which has just been executed by the three 'professional gentlemen' at the top of the centre table, one of whom is in the chair—the little pompous man with the bald head just emerging from the collar of his green coat. The others are seated on either side of him—the stout man with the small voice, and the thin-faced dark man in black. (56)

Dickens then records various ejaculations made by these figures which seem very much the literary equivalent of those cartoons by Gillray such as *Titianus Redivivus* where each of the assembled company utters balloon-enclosed observations. We then concentrate on 'that little round-faced man, with the small brown surtout, white stockings and shoes' (57) before returning into the crowd. And this is a technique that Dickens retains in later work: the mob in *Barnaby Rudge* is a 'vision of coarse faces . . . a dream of demon heads and savage eyes', where, with a lingering scrutiny of its Gillray-like vortex, we can make out the 'chief faces . . . distinctly visible' (385–6).

The love of identifying people by objects or clothing is surely a means of our 'picking them out' of the crowd, like the Whig candidates in Hogarth's *Election Entertainment* (ill. 41) with their refined and modish wigs. Dickens learns very early to borrow this graphic device and, through it, to exercise his fondness for literary phantasmagoria. Grotesque or facetious images are, in the cartoonist's armoury, a characteristic device for making ideas visible.[13] Dickens frequently evades the normal verbal mode of explaining ideas in favour of visualizing them, often with facetious fantasy. There are small items: the 'train of smock-frocks and wheelbarrows' (i.e. porters) that beset the Tuggses' arrival at Ramsgate (341); the covert amorousness of Tibbs, rubbing his hands and going round in circles, with one eye assuming 'a clock-work sort of expression' (299); the parish curate, so encumbered with presents from female sympathizers that 'he was as completely fitted out, with winter clothes, as if he were on the verge of an expedition to the North Pole' (8)—the caption-like point of Dickens's sentences also contributes to the graphic effect. But whole sketches can be constructed upon this phantasmagoric visualizing of idea. In 'Meditations in Monmouth Street' there are the clothes which 'must at different periods have all belonged to, and been worn by, the same individual, and had now, by one of those strange conjunctions of circumstances which will occur sometimes, come to be exposed together for sale in the same shop. The idea seemed a fantastic one . . .' (75). And the zany vision of the dancing boots and old clothes visualizes, without making explicit, the notion of human existence as precarious and empty as a discarded wardrobe. It is a visual device used with dreadful economy in

Fagin's vision of his friends' reversion to 'a dangling heap of clothes' upon the scaffold (407).

These 'Meditations' also employ the very Hogarthian device of the progress. A sequence of plates that narrate the careers of rake, London apprentice or harlot (ills. 25–7) offered to Dickens a particularly forceful structure for his own reading of human life. Thus, abandoned clothes speak as distinctly as any moral tale: 'the man's whole life written as legibly on those clothes, as if we had his autobiography engrossed on parchment before us' (75). We are offered visually what would otherwise require much explication. Dickens is also particularly fond of the device whereby Hogarth hints in one engraving at the complete progress through a whole sequence:[14] the goose in the basket in the first plate of *A Harlot's Progress* (ill. 25) intimates her final predicament, just as the boys picking pockets in the crowd at the hanging of Thomas Idle recall the start of Idle's career. Dickens recalls these visual structures when he notes how the 'vices of the boy had grown with the man', who finally occupies some 'metropolitan workhouse' (77)—here the literary form allows Dickens to invoke the final stage of a progress even while looking at its intermediate points.

Pawnbrokers' and prisons—symbolic locations in a Hogarth progress—serve a similar purpose in Dickens. The 'young delicate girl of about twenty' occupies the same private box at the pawnshop counter as an 'elderly female' (193), and the history of decline to which they are all subject is instantly clear. Similarly, in 'The Prisoners' Van' the 'progress of these girls in crime' is made quite explicit by a device that is comparable with Hogarth's *Before* and *After*: 'What the younger girl was then, the elder had been once; and what the elder then was, the younger must soon become' (274). Their exact counterparts are found on 'A Visit to Newgate', juxtaposed without comment, the carefully stressed visual details of decrepit and miserable age already announced in the features of youth (204). And there is even, as we might expect with Dickens, a comic progress in the person of Mr Dounce, who after the aphrodisiacal excursions to the oyster shop declined into making 'offers successively to a schoolmistress, a landlady, a feminine tobacconist, and a housekeeper', only at the last to be accepted by his cook, 'with whom he now lives, a henpecked husband, a melancholy monument of antiquated misery, and a living warning to all uxurious old boys' (249).

These Dickensian progresses would be less remarkable if they were not often presented with special emphasis upon their momentary and therefore painterly focus: 'passing hastily down the yard, and pausing only *for an instant* to notice the little incidents we have just recorded' (205), whereby the sequence of verbal narrative is offered as the result of an instantaneous glance. Writing to John Forster from Lausanne in 1846 Dickens declared how much he missed London—'the toil and labour of writing, day after day, without that magic lantern'.[15] His emphasis is striking; the streets and figures he misses have become projected *pictures*. Perhaps the frequent painterly formulations of both Dickens ('little pictures of life') and Forster ('Things are painted literally as they are . . . whatever the picture')[16] may well be, not careless description, but a precise indication of the novelist's literary aims. And this is doubtless why it is customary to compare Dickens's scenes with Victorian genre painting, like Frith's *Derby Day*.[17] But Dickens's visual imagination is of course endebted to earlier graphic representations of metropolitan life from Hogarth onwards and to their inevitably static, discrete structures.

The instantaneity of graphic representation provides Dickens with some rudimentary form for his descriptions and anecdotes: 'Watch the prisoner attentively for a few moments', he tells us in 'Criminal Courts', 'and the fact is before you in all its painful reality' (198). The whole moral history of 'The Pawnbroker's Shop' is registered 'for a moment, and only a moment' (195). A great deal of Dickens's much praised detail is the result of giving this visual focus to a sequential analysis: the account by Mr Bung of life as a 'broker' is not only brought alive but sharply visualized in the discrete image of the child peering round the door 'at the man' (27).

The *Sketches* contain many other instances, many other 'perspectives' (336), that suggest the nourishment derived from graphic journalism. There are several apparently deliberate variations upon famous themes by Hogarth (that we have seen Dickens knew at least by 1848): the *Stages of Cruelty* motif is canvassed in 'The Pawnbroker's Shop', where the drunken man, fresh from 'kicking his wife', vents his 'ill-humour on a ragged urchin' before resuming the torture of his family (191–3); in 'Criminal Courts' we witness the path by which, as for Hogarth's apprentice, 'idleness' leads to crime and transportation for a young boy; the section entitled 'Scenes' in the collected version of *Sketches by Boz* recalls Hogarth's plates on *The Times of Day*; the dwarfs, the noise, the public-house balconies and stage booths of Dickens's 'Greenwich Fair' have close parallels with similar items in Hogarth's *Southwark Fair*.

Doubtless much of this similarity arises from the sameness of topic. Yet the very extent to which Dickens handles subjects from the traditions of graphic journalism is itself extraordinary: popular theatres; coaching scenes—especially the way ladies are forced into stage coaches by 'dint of a great deal of pulling and pushing' (83 and 136) as in Hogarth, Gillray and Rowlandson; the haunts, trials and punishment of criminals; the legal profession as a whole;[18] the popular meeting points of the gin shop and, its economic corollary, the pawnshop. In the world of pastime, holiday excursion and 'The Amusements of the People'[19] the 'humourous proceeding' of the donkeys on Ramsgate sands (347) recalls the winnowy ironic lines of a Rowlandson escapade; or compare Dickens's 'Vauxhall Gardens by Day' with Rowlandson's watercolour of them by night (ill. 44). The similarity of detail is not only due to the subject, but there is a closeness of purpose between the artists. Dickens offers the soft and seductive scenes of Vauxhall at night with only a touch of irony: 'We loved to wander among these illuminated groves, thinking of the patient and laborious researches which had been carried on there during the day, and witnessing their results in the suppers which were served up beneath the light of lamps and to the sound of music at night . . .' (126); and then Dickens disturbs 'the vein of mystery' by reporting the disappointments of day-time, just as in the water-colour we learn to read the discomforting coarseness and vulgarity beneath the charm of the execution, after the initial effect of the picturesque line and colour has worn off.

II

It is, however, the uses to which Dickens puts this range of ideas and visual structures in his later novels that make their presence important in this early work. Four main elements of the graphic tradition were to remain, I think, crucial in the shaping of his imagination: first, the use of a

Hogarthian symbolism or the identification of emblems in the details of daily life to act as some form of moral commentary; second, and closely related, the intricate ramifications of topic and idea that we may trace equally through a Dickens plot or a Hogarth progress; third, the element of the phastasmagoric; fourth, the notion of expressive 'character' as distinct from yet informed by its proximity to 'caricature'. Yet Dickens learnt only with difficulty to isolate these elements from the other, random debts to graphic satire.

In their fascinating account of *Dickens at Work* John Butt and Kathleen Tillotson speculate upon some of his motives in revising the *Sketches* and in adjudicating between his journalistic and his novelistic ambitions: Dickens's collection and revision of the *Sketches* was, they say, 'working his way out of journalism'. What often appears to be the controlling factor behind these alterations is a serious attempt to isolate the more useful elements of graphic journalism. The removal of merely incidental topical references suggests that he realized that the constantly allusive idiom of Gillray was structurally less harmonious than Hogarth's vision, where details ultimately contribute to the idea of the whole design rather than referring mainly to some topical reality beyond the frame. The random facetiousness of 'a full-dressed Lord Mayor looks like a South Sea idol, on which grateful devotees have hung a variety of gorgeous ornaments without the slightest regard to the general effect of the whole'[20] is appropriately discarded. The thoroughly journalistic emphasis of 'our duty as faithful parochial chroniclers' (13) or of the opening paragraph of 'A Parliamentary Sketch' rarely appears after *Sketches*, while in such late additions as 'Meditations in Monmouth Street' and 'A Visit to Newgate' the structure already leaves the idiom of reporter's notebook for the more substantial, formalizing devices of moral symbolism and phantasmagoric representation of idea.

Yet, as Butt and Tillotson also remark, the *Pickwick* project drew Dickens firmly once again into the journalistic mode. Although he resisted Seymour's theme of a Nimrod Club—itself derived from such contemporary visual journalism as Cruikshank's *Comic Almanack* or Surtees' *Jorrocks*—Dickens, as in *Sketches*, invokes a range of motifs in *Pickwick* amazingly similar to the current graphic scene, as well as continuing the careful allusion to topical event, as with the Norton-Melbourne case. From coaching to skating, hunting to courtship, theatres to law courts, the *Pickwick Papers* eventually touches upon all these familiar graphic themes. Dickens's image of lawyers 'constantly hurrying with bundles of papers under their arms' recalls the general effect and occasional items of C. Williams's *A Flight of Lawyers*; the Pickwickian visit to Bath affords some echoes of Rowlandson's *Comforts of Bath* in the 'vast number of queer old ladies and decrepid old gentlemen'.

Perhaps we may identify the influence of one particular graphic form that Cruikshank had used in the late 1820s: under the umbrella of a general theme—'Christmas Time' (ill. 43), for example, or 'Travelling' or 'Courtship' —are gathered vignettes which afford facetious or merely descriptive variations on the designated theme. The account of Christmas at Dingley Dell works in this way, gathering into one episode a full range of appropriately seasonal ideas, as if Dickens, like Cruikshank, was determined to include every possible association with the given event or topic. Similarly, in *Oliver Twist*, Mr Sowerberry's new apprentice 'beheld with great admiration' (39) the varieties of behaviour at funerals.

But there is also in *Pickwick*, I believe, a determination (much more pronounced in the next two novels) to concentrate upon more functional and creative elements of graphic satire. Dickens himself said 'that every number should be, to a certain extent, complete in itself'[21] and this care for the integrity of each episode, each 'plate' of the sequence, forced him on several occasions to see the structural problem as that of the visual arts: the 'exciting scene' of the inauguration of the Pickwick Club is 'a study for an artist' (3). Many subsequent scenes need this discrete, framed shape, already used rather randomly in the *Sketches*. For example, a critic has recently drawn attention to an apparent discrepancy between the plate of 'Mr Pickwick slides', where 'Phiz' shows various events 'happening' together, and the text where Winkle has been restored to his feet before Mr Pickwick starts sliding.[22] Yet I think that this difference is apparent only: the incident is reported with little sense of a sequential, unfolding action and, though we read it in temporal sequence, it has rather more the force of a multiplicity of simultaneous images; again, Cruikshank's series of gathered vignettes is the revelant analogue. (There is, incidentally, much in this marvellous scene that parallels the incidents and moral commentary of Gillray's *Elements of Skating*.) Elsewhere, in the interpolated 'Stroller's Tale', the scene of the tumbler's sickbed is carefully detailed in the instant before the sick man is aware of his visitor (37); while the description of the refreshment room at Mrs Lee Hunter's 'déjeûné' is controlled as if we were reading, say, a Rowlandson society piece:

> Count Smorltork was busily engaged in taking notes of the contents of the dishes; Mr Tupman was doing the honours of the lobster salad to several lionesses, with a degree of grace which no Brigand ever exhibited before; Mr Snodgrass having cut out the young gentleman who cut up the books for the Eatanswill Gazette, was engaged in an impassioned argument with the young lady who did the poetry. (205)

Pickwick also allows Dickens his first opportunity of sustaining characters and here too he seems to work at consolidating certain graphic techniques. The various Pickwickians have each some distinctive 'tag' that makes them immediately recognizable in successive episodes, continuing mnemonics for the reader of serial parts, just as Gillray kept Fox permanently in mind as a fox or *sans-culotte*. There are Tupman's amorousness and Winkle's putative sportsmanship; more crucially for Dickens's later work, there are the expressive speech habits of Jingle and Sam Weller (Sam has intriguing affinities in both his speech and his general outlook with William Heath's series, *The Man Wot Drives the Sovereign*, *The Guard Wot Looks After the Sovereign*, etc.). Further, Sam is allowed the habit that Dickens himself is later to exploit of identifying human beings by objects associated with them: 'There's a wooden leg in number six; there's a pair of Hessians in thirteen; there's two pair of halves in the commercial; there's these here painted tops in the snuggery inside the bar; and five more tops in the coffee-room.' (125) The very Hogarthian image of the law courts in *Pickwick* shows Dickens deploying this same mode of vision: from 'a numerous muster of gentlemen in wigs, in the barristers' seats: who presented, as a body, all that pleasing and extensive variety of nose and whisker for which the bar of England is so justly celebrated' (465) to Mr Justice Stareleigh, 'all face and waistcoat' (466), the humans are taken over and absorbed by their most prominent accessories. It is, as we shall see, the intimation of a peculiarly important

Dickensian technique and owes much, especially in this instance, to Hogarth's *The Bench* (ill. 45).

But the uncertainties of Dickens's effort to establish himself as a novelist are still apparent in the enterprises that followed. *Oliver Twist* returned to what Forster called 'a series of pictures from . . . lower life' (I.90) that had absorbed Dickens's best energies in the *Sketches*, as it had absorbed Hogarth's. While *Nicholas Nickleby* continued *Pickwick's* rather picaresque structure of scenes and characters—Forster incidentally thought Nicholas stepped into Pickwick's shoes (I.95). In both *Oliver Twist* and *Nicholas Nickleby* Dickens can be seen learning the creative possibilities of his graphic predecessors, and it is the demonstration of this activity that might provide the 'alert modern critic'[23] with his opportunity.

Of the two novels *Oliver Twist* is probably more fully and unambiguously Hogarthian. The careers of Oliver and Noah Claypole in this 'Parish Boy's Progress' approximate the rival careers of Hogarth's apprentices. Nancy's life, 'squandered in the streets, and among the most noisome of the stews and dens of London' (301) is an exact replica of Moll Hackabout's: Fagin has 'led her, step by step, deeper and deeper down into the abyss of crime and misery' (337), and Rose Maylie—with Hogarthian point—speculates before the final stage of this progress on the 'end of this poor creature's life' (334). The decay and gradual degradation of moral life is everywhere echoed in the decomposition of buildings—'houses . . . insecure from age and decay' (35); the Bumbles proceed for their midnight rendezvous with Monks into 'a scattered little colony of ruinous houses . . . erected on a low unwholesome swamp' (277).

Much of *Oliver Twist* requires us to visualize the *idea* of innocent youth threatened, even temporarily submerged, in Fagin's 'abyss'. Much of the scenery is offered, with strict Hogarthian point, as emblematic of those confusions which beset Oliver. Sikes and Nancy lead him through a dark and foggy night, where the lights 'could scarcely struggle through the heavy mist, which thickened every moment and shrouded the streets and houses in gloom; rendering the strange place still stranger in Oliver's eyes; and making his uncertainty the more dismal and depressing' (109). And the later expedition to the robbery takes the boy through the dirty and hideous market crowd, 'a stunning and bewildering scene, which quite confounded the senses' (153).

For the first time in *Oliver Twist* Dickens contrives to suggest, what is so dominant in Hogarth's engravings, that society is intricately interconnected. That 'the palace, the night-celler, the jail, the madhouse' (348), revealed by the moon's levelling monochromes, are contiguous and their inmates mysteriously and unerringly dependent upon each other's fortunes. This idea, which is to inform the great novels more strongly, is an obvious, even rather melodramatic, part of the plot of *Oliver Twist* and is visualized with emblematic sharpness on several occasions. The most notable of these occurs after Oliver's recapture, when Master Bates 'produced the identical old suit of clothes which Oliver had so much congratulated himself upon leaving off at Mr Brownlow's; and the accidental display of which, to Fagin, by the Jew who purchased them, had been the very first clue received, of his whereabout' (117). And there are further touches that seem the exact equivalent of those Hogarthian items, like the pictures in the second plate of *A Harlot's Progress* (ill. 26), which we need to 'read' to add further significance to the scene: Bumble's buttons, with their image of 'the Good

Samaritan healing the sick and bruised man' (24) ironically presented to the unfortunate recipients of the beadle's 'charity'; the book of the lives of criminals that Oliver reads before the robbery; the white handkerchief—'Rose Maylie's own' (362)—that Nancy manages to hold towards heaven as she dies.

The most interesting aspects of *Nicholas Nickleby* for this study are the habits of characterization, the pervasive visualizing of idea, and the invocation of emblematic scenery. Bernard Bergonzi reminds us that Squeer's headquarters in London are overshadowed by Newgate; but the passage visualizes a central and larger Dickens preoccupation in a firmly Hogarthian fashion:

> There, at the very core of London, in the heart of its business and animation, in the midst of a whirl of noise and motion: stemming as it were the giant currents of life that flow ceaselessly on from different quarters and meet beneath its walls: stands Newgate; and in that crowded street on which it frowns so darkly—within a few feet of the squalid tottering houses—upon the very spot on which the vendors of soup and fish and damaged fruit are now plying their trades—scores of human beings, amidst a roar of sounds to which even the tumult of a great city is as nothing, four, six, or eight strong men at a time, have been hurried violently and swiftly from the world, when the scene has been rendered frightful with excess of human life; when curious eyes have glared from casement, and housetop, and wall and pillar; and when, in the mass of white and upturned faces, the dying wretch, in his all-comprehensive look of agony, has met not one—not one—that bore the impress of pity or compassion. (29-30)

The chapter had started with a rival idea of Snow Hill, so that this 'rather different reality' focuses more sharply than ever the ideas that Dickens holds about the emprisoning conditions of metropolitan life—ideas that are perhaps of only intermittent point in this novel but will come to pervade all of *Little Dorrit*. The vortex of movement in the passage recalls Gillray, in, say, *The March to the Bank*, but the insistence upon the intricate ramifications of society—the currents that flow from various quarters and mingle around the 'heart' of Newgate, the implied contiguities of prison and the City—recall the great Hogarthian engravings: the appearance of the Idle Apprentice before the Industrious one, acting as magistrate. The arrival of the Harlot (ill. 25) joins the image of the York coach and the provincial traveller with the proprietress of a St James's Street *bagnio* and the seducer, Charteris, who lurks in the doorway; Moll's fate is inevitably sealed by these coincidences.

The scene in *Nicholas Nickleby* also recalls part of the curiously powerful effect of *Gin Lane* (ill. 46) where the solitariness of its central sufferers is emphasized by the loneliness of the man and the woman on the steps as well as by the fragmented and inchoate crowd. The very structures, too, of Hogarth's buildings reinforce his ideas of moral disintegration—the church spire presides emptily and the houses collapse. The ruined building on the right reveals the hanged man and the idea of death is introduced again and again—by the body placed in the coffin, the child falling from the steps, the skull beneath the skin of the man at the bottom right. Hogarth's visual variations on one moral idea are equally a characteristic device of later

Dickens: here in *Nicholas Nickleby* we *see* the solitary human predicament in the criminals and the crowd, both 'disembodied', the one by death, the rest by their metamorphosis into mere face and eyes. They are related, too, in the irony of the implied social connections between the 'frightful . . . excess of human life' and the temptations that result from such over-crowding and lead criminals to their death. Hogarth seems to make the same point in the penultimate plate of the *Idle Apprentice*. The human dimension of buildings in Hogarth—their symbolic decay—is used by Dickens in the anthropomorphic image of Newgate frowning and in the curious fashion by which 'casement, and house-top, and wall, and pillar' assume the eyes of those crowded to watch the executions. And, finally, it is worth noticing Dickens's efforts at making us attend to the scene in ways that ignore its temporal, literary structure: he points with 'there', insists with 'now', upon the visibility of the scene.

When Squeers appears a page later we might be pardoned in thinking that the rapacious environment of Newgate has taken his missing eye. A special advantage of the literary mode of presenting character is that fanciful distortions may be implied—the single eye looking like the 'Fan-light of a street door' (30)—without having to distort the actual features, like the fashionable amateurs of late eighteenth-century graphic *caricatura*.[24] Similarly, such names as Hawk, Gride, Squeers or Quilp suggest relevant ideas more effectively than explicit distortions of graphic caricature, where Hawk would presumably appear part man and part bird. Dickens's interest, in fact, begins to be in expressive features, details of physiognomy that identify the controlling idea of a man—the forced respectability, in Squeers's case. And if the central action of the novel is, as Hillis Miller says,[25] 'the elaborate performance of a cheap melodrama', the arbitrariness of Squeers's costume announces his part in this theatricality.

The school to which he conducts Nicholas is presented exactly as we have seen crowds in the *Sketches*. Yet the increased effectiveness of his verbal handling of a Hogarthian scene may be tested, I think, by contrasting it with the famous 'Phiz' illustration of *The Internal Economy of Dotheboys Hall*, about which it seems difficult to say, as John Forster did about the text that 'Dotheboys was, like a piece by Hogarth, both ludicrous and terrible' (1.96). The impact of the school upon Nicholas is precisely that of a graphic satire upon its 'reader': 'there were so many objects to attract attention, that, at first, Nicholas stared about him, really without seeing anything at all. By degrees, however, the place resolved itself . . .' (87–8). And the visual idea that emerges from the crush of grotesque and chaotic youth is again a symbolic one, announcing one of the novel's themes, the inadequacies of parents. For Nicholas's and our reading of the Hall

> told [sic] of unnatural aversion conceived by parents for their offspring, or of young lives which, from the earliest dawn of infancy, had been one horrible endurance of cruelty and neglect. There were little faces which should have been handsome, darkened with the scowl of sullen, dogged suffering; here was childhood with the light of its eyes quenched, its beauty gone, and its helplessness alone remaining; there were vicious-faced boys, brooding, with leaden eyes, like malefactors in a jail; and there were young creatures on whom the sins of their frail parents had descended, weeping even for the mercenary nurses they had known, and lonesome even in their loneliness. (88)

This educational jail at Bowes has caught and extended into more horrible refinements the ambience of Newgate, from the shadows of which Nicholas began his journey. The infernal regions of Squeers's establishment are perhaps too hideous to be entirely Hogarthian, the boys too fanciful (if such a word may apply to things so terrible) to resemble his very solid characters: I suspect that, whatever he felt about the ugliness of Gillray or Rowlandson, Dickens knew how to invoke their grotesque habits of distortion for purposes of explicit moral satire.

III

These early novels reveal Dickens's obvious interest in the techniques and structures of graphic satire and the process by which he discovered how best to employ them. This study would, however, be incomplete without considering their presence in the major works. Certain, largely Hogarthian, modes not only continue to appear; they often sustain what we take to be the most original and compelling aspects of the 'great Dickens'.

The first of the four major items of graphic provenance that Dickens learnt to use is the symbolic or emblematic[26] image. The technique had appeared briefly in the *Sketches* with the labyrinthine images of Newgate (203), the unpainted commandments in the prison chapel and the neglected Testament in the condemned cell, which are all eloquent in precisely the same *visual* way as the cobwebbed poor box in Hogarth's church. Similar devices inform much of, say, *Little Dorrit*, where the image of the Marshalsea provides the dominant and pervasive emblem of Dickens's theme of society's self-imprisonment. As in Hogarth, the controlling idea is realized in many 'readable' moments throughout the novel: some offer actual images of imprisonment like the literal topographical isolation of Bleeding Heart Yard, or of bolstered, false gentility, like Mrs Clennan's house (31). It is clear from Dickens's drafts that he attended specifically to these devices: thus, a plan for *Little Dorrit* decides:

> Work out Tattycoram's spiriting away.
> Dark Lane Picture. Evening
> ===================
> Empty house

Moreover, we know that in his inability to settle to writing the novel he began exploring 'the strangest places in London by night'[27] and these experiences seem to be reflected in the novel's especial invocation of emblematic place. Other scenes, like the resignation of Merdle's butler or Mr Dorrit 'much among the Counts and Marquises',[28] ensure that the same stultifying restrictions are *visible* throughout the narrative.

The extent to which the environment in a later Dickens novel is as important as the characters[29] is essentially Hogarthian. I am thinking, not only of the houses of *Gin Lane*, but of the need in most of Hogarth's engravings to read the items of scenery or furniture. Dickens's literary version of this is to animate the non-human, forcing us to read its features: Mr Dombey's house, for example, contained 'cellars frowned upon by barred windows, and leered at by crooked-eyed doors leading to dust-bins' (21); or the dwelling of Miss Tox, 'squeezed . . . into a fashionable neighbourhood at the west end of the town, where it stood in the shade like a poor relation of the great street round the corner, coldly looked down upon by mighty mansions' (83). In contrast, the 'prevailing idea'—they are Dickens's own words (33)—of the Midshipman is announced by the happy facetiousness

of the 'woodenest' effigy (32). Such items are endless in this extraordinary novel, where objects seem to have caught the animation and life lost by so many characters. There is the dawn of Dombey's marriage 'with its passionless blank face' (436), the church of Paul's christening, or the industrial landscape where Dombey 'found a likeness to his misfortunes everywhere' (280). These techniques show the same congruence of 'circumstantial story-telling' and 'fantastic symbolism' that are said to be characteristic of Hogarth's caricature.[30]

The point to establish in this discussion of connections between Dickens and the graphic satirists is that these and other acknowledged examples of the novelist's art—Tom-All-Alone's or the fog in *Bleak House* would be another example—are the literary analogues or transmutations of visual devices. Unlike other novelists, but exactly like the best of the graphic satirists, Dickens involves us in 'reading' his scenes: indeed, reading suggests altogether too passive a role. We share in his creativity, in his visualizing of ideas. Todger's in *Martin Chuzzlewit* will serve as an example: nothing is really made explicit ('Nobody had ever found Todger's on a verbal direction'!) and instead Dickens works by emblem (damaged oranges, for example), or by such a passage as this: 'surely London, to judge from that part of it which hemmed Todger's round, and hustled it, and crushed it, and stuck its brick-and-mortar elbows into it, and kept the air from it, and stood perpetually between it and the light, was worthy of Todger's'. The basic, but only hinted, idea becomes the groundwork for infinite variations upon the theme of claustrophobia, waste and atomism, in which the reader must participate to appreciate them fully. There is a similar involvement by the reader in the second chapter where the wind announces with boisterous aptness the eventual overthrow of Mr Pecksniff.

An essential ingredient of this demand upon the reader is the recognition of what Dickens called the 'coincidences, resemblances and surprises of life'. Not only that Mr Pecksniff should have been the one to be knocked down by his own front door or that his daughter's voice could have 'belonged to a wind in its teens' (10); but also, as Dickens (rather surprisingly) spells out in *Bleak House*: 'What connection can there have been between many people in the innumerable histories of this world who from opposite sides of great gulfs have, nevertheless, been very curiously brought together!' (232) This was, we know, a favourite theme of the novelist's, as Forster recounts: 'The world, he would say, was so much smaller than we thought it; we were all so connected by fate without knowing it; people supposed to be far apart were so constantly elbowing each other.' (1.59) 'Elbowing' is a striking emphasis: it intimates that world of crowds and urban life, a dominant motif in *Sketches* and graphic cartoon, where the physical proximities of Thomas Idle and Goodchild, or of ginshop and pawnshop, carry their own meanings which *we* discover as we read. And that Dickens undoubtedly recognized his graphic inspiration in this matter may be gathered from his speech in 1851 to the Metropolitan Sanitary Association: 'the air from Gin Lane will be carried, when the wind is easterly, into May Fair'.[31] A month after that speech he began *Bleak House*, where the pervasive fog affects all segments of society with its deadness, notably—it is another Hogarthian image—the 'attendant wigs . . . stuck in a fog-bank' (6).

The opening of *Bleak House* forces us both to *see* the enveloping fog and to recognize its 'prevailing idea'. This congruence in Dickens between real and symbolic elements has been identified, in another interesting essay by

Gombrich that is relevant to our understanding of Dickens's debt to visual satire,[32] as characteristic of much art from Hogarth onwards. The presence in some object or even person of both literal fact and symbolic meaning is, obviously, connected with the cartoonist's need to visualize ideas (to which Gombrich has also pointed),[13] for an idea has to be made available through a visible item. Thus Mr Dombey staring icily into the garden is real, but his chilly presence is complicated by the 'brown and yellow leaves [which] came fluttering down, as if he blighted them' (65): we may be delighted by the fantasy, but remembering that such elements of phantasmagoria were most evident in, say, Gillray when he visualizes ideas[33], we should also be alert to Dickens's suggestion of the symbolic blight that Dombey casts upon the whole of his environment.

In the *Sketches* there were the zany dancing clothes in Monmouth Street; this was a hint of the immensely suggestive value of that device in which literal fact is metamorphosed into symbolic vision. The major novels are constantly full of it. The Circumlocution Office aptly and sharply satirizes an idea which would be laborious and lengthy if presented any other way. Similarly, the destructive forces of the railway age—already visualized in such cartoons as Cruikshank's *The Railway Dragon* of 1845—are imaged in the account in *Dombey* of the transformation of Staggs' Gardens: 'Night and day the conquering engines rumbled at their distant work, or, advancing smoothly to their journey's end, and gliding like tame dragons into the allotted corners grooved out to the inch for their reception, stood bubbling and trembling there . . .' (219) Dickens's very ambivalent attitude to this cutting up of 'English ground . . . root and branch' (219) includes an ironic celebration of the waste ground at Staggs' Gardens transformed by buildings which then advance along the railway: 'the carcasses of houses, and beginnings of new thoroughfares, had started off upon the line at steam's own speed, and shot away into the country in a monster train' (218). This image is the exact verbal equivalent of another graphic satire (ill. 48). The kind of fantasy that is used by Dickens and by *London Going Out of Town* to sustain their satire seems to me especially relevant to a reading of the peculiarly poetic and symbolic techniques of *Hard Times*.

The most delightful and persuasive moments of *Hard Times* may be seen, I believe, as strict literary equivalents of visual satire; and, correspondingly, its least successful items, like the character of Stephen Blackpool, may perhaps be attributed to the lack in a 'cartoonist's armoury' of adequate expressions, suitably visual symbolic equivalents, for the perfect and the good.

The novel opens with facts and the uncompromising school room, where Gradgrind's appearance, offered in architectural terms of 'wall of a forehead' and the eyes' 'cellerage', links him closely with the red brick ambience of Coketown: in that ugly citadel, where Nature was as strictly bricked out as killing airs and gases were bricked in; at the heart of the labyrinth . . ., which had come into existence piecemeal, every piece in a violent hurry for some one man's purpose, and the whole an unnatural family, shouldering, and trampling, and pressing one another to death . . . (63).

London Going Out of Town or the March of Bricks and Mortar sees urban mis-planning in exactly the same terms as Dickens: bricks and mortar seem to inherit the earth. Much of the imagery in *Hard Times* emphasizes this same domination of man by the environment that he should control: 'love was made on these occasions in the form of bracelets; and . . . took a manufacturing aspect' (107). Or there are the machinery's 'shadows on

the walls, [which] was the substitute Coketown had to show for the shadows of rustling woods; while, for the summer hum of insects, it could offer, all the year round, . . . the whirr of shafts and wheels' (111). The fantasy of the imagery, like the cartoonist's animated masonry, underlines the horror of its idea, of what in *Hard Times* is called the 'keynote' of the novel. Moreover, just as the graphic piece includes literal, unfacetious images, like the pall of smoke, so Dickens insists upon the chimneys' 'puffing out their poisonous volumes' which hide the sky (164): such straightforward facts do not allow us to dismiss the whole as fantasy and they provide a literal basis for the symbolism.

The sharpness of the satire in *Hard Times* owes much to this range of distinctly graphic images for various aspects of what Dr Leavis calls Dickens's 'critique of Utilitarianism and industrialism'.[34] The 'national dustmen', Gradgrind's 'staggering over the universe with his rusty stiff-legged compasses' (222)—these are visual formulae for the satire. In this respect it is worth recalling Cruikshank's engraving of the privileged child being fed with a silver spoon before the eyes of five starving paupers—it was printed in 1829 at the head of Bentham's pamphlet on the 'Greatest Happiness Principle'. It images exactly Bounderby's idea of 'the Hand who was not entirely satisfied'—that he would want to be 'fed with turtle soup and venison, with a gold spoon' (70).

Other contemporary cartoons can also help to define the peculiarly visual satire of *Hard Times*. The anonymous cartoons of 1831 displaying the *Effects of the Rail Road on the Brute Creation* suggest both the energies of the animal world that are ignored by mechanization and the depravity and degradation that are wreaked even upon horses. It is, of course, precisely with Sleary's Riding Circus and the attendant myths of such fabulous horses as the centaur and Pegasus (29) that Dickens identifies the world of release and escape from Benthamite soullessness (for Tom, it is a very literal escape). And the machines of Coketown, deprived of the world of Sleary's salvation, are allowed the phantasmagoric indulgence of imitating circus animals, but always imprisoned in 'a state of melancholy madness' (22), like the affected Brute Creation in the cartoon.

IV

Perhaps the mature Dickens's most persistent use of these fantasy images to convey ideas occurs in his characterization. The 'Coriolanian style of nose' (42) that identifies the affected patrician airs of Mrs Sparsit, the Cleopatran attitude adopted by Mrs Skewton in *Dombey* (306) and unfailingly reiterated by Dickens—they are simple examples, and examples, too, of a style of visual mock-heroic very characteristic of Gillray.[35] In both cases Dickens is concerned to identify ideas by which the characters themselves control their lives, and it is this, I think, that distinguishes the extraordinary achievement of his later characters from earlier creations like Mrs Gamp or Uriah Heap. Dickens advanced from (an often effective) description of expressive feature—in Mrs Gamp's case expressing the 'Platonic *idea* of London's hired nurse'[36]—to such an understanding of human personality that he recognized how people can become their own caricaturists.

Dickens was always alert, he tells us in *Sketches* (216), to 'something in [a] man's manner and appearance which told us, we fancied, his whole life, or rather his whole day, for a man of this sort has no variety of days'.

Already, there is an interest in how society forces men into typical patterns and the *Sketches* testify to Dickens's early attention to types of character. But he also at that stage betrays an absorption in expressive detail, though not always yet with the tact to let it speak for itself: 'He is a tall, thin, bony man, with an interrogative nose, and little restless perking eyes, which appear to have been given him for the sole purpose of peering into other people's affairs with.' (18) And, with an even more prophetic sense of his own imagination, he advances a crucial theory of character reading:

> Some phrenologists affirm, that the agitation of a man's brain by different passions, produces corresponding developments in the form of his skull. Do not let us be understood as pushing our theory to the full length of asserting, that any alteration in a man's disposition would produce a visible effect on the feature of his [door]-knocker. (41)

He announces, with a humorous scepticism that does not altogether conceal his hopes, the habit by which in his later works not only buildings and furniture are visibly stamped by their owner's personality, but the soul moulds the body. Ernest Kris says the caricaturist shows 'how the soul of the man would express itself in his body if only matter were sufficiently pliable to Nature's intentions'.[37] In Dickens the matter *can* be made flexible and responsive to the spiritual condition of characters, and in that sense he might well be seen as a caricaturist.

But Dickens knew his Hogarth too well to allow us to rely solely upon the term 'caricature'. In two plates Hogarth was at pains to distinguish between 'character' and 'caracatura'. In *The Bench* (ill. 45) he sanctioned what was to be Dickens's eagerness to find 'the living Face . . . as an Index of the mind'; what he resists in caricature is the inadequate grasp by their executants of the '*Ideas* of the Objects' (my italics) and the consequent reliance upon mere distortions uninformed by idea. The relevance to Dickens of these reflections on *The Bench* is considerable. For the novelist it was always the 'prevailing idea' or 'keynote' of scene, narrative or character that needed expression. Thus the *Pickwick* passage already quoted (*supra*, p. 131) appears to identify the legal profession's delight in appearance rather than in professional competance: it is an idea we might equally read into Hogarth's judges, but not into the grotesques above them. The architectural features of Mr Gradgrind, because they identify the idea of the man, may be said to avoid caricature; they are functional, not arbitrary.

The other engraving, *Characters and Caricaturas* (ill. 47), shows Hogarth's concern to distinguish between 'Distortions and Exaggerations' and the expression of the 'Affections of Men on canvas'.[38] Here again I think we may see connections with Dickens's art. Mere distortion and exaggeration are not really his concern; the controlling idea in his characterizations is the imaging—immediate visualizing, not explaining at length—of human affections. Thus he obliges 'Phiz' to prepare a page of sketches of Dombey's head[39] so that the range of expressive feature (fascinatingly similar to Hogarth's *characters*) can be sampled. Yet the juxtaposition by Hogarth of his characters to the grotesques of Raphael, the Carracci or Leonardo da Vinci implies that the expressive variety of the characters depends upon our sense that they are often just held on the 'right' side of distortion—for which the bottom row of heads serve as *exempla*. Dickens, too, can suggest how close his characters can approach to grotesque exaggeration—and allows us to recognize that they have only themselves to blame for this.

So we may read all of Dickens's characters in the major novels as the expression of their author's 'ideas' of them, his identification of their essential qualities. He specifies, for example, in the notes that he sends to 'Phiz' that the illustrator should attend to what he had already achieved in the text, that Major Bagstock 'is the incarnation of selfishness and small revenge'.[40] If he occasionally seems to rely upon the barest details in this expressionism, it is often because—as, say, with Captain Cuttle or Susan Nipper—Dickens has isolated their prevailing idea and spares us all but its essential attributes. Like the Chinese landscape painters who observe that 'Ideas present, brush may be spared performance'.[41]

But we have also learnt in modern painting to read the grotesques of expressionism as a compelling language of reality and to respond as a consequence to an author like Dickens who anticipated that 'everything becomes weird and fantastic. Behind the visible appearance of a thing lurks its caricature, behind the lifelessness of a thing an uncanny, ghostly life, and so all actual things become grotesque . . .'.[42] These words of Wilhelm Worringer in 1911 are a most apt account of the most fascinating mode of Dickens's characterization. Behind the lifelessness of many a figure lurks that character's own identification of his essential idea. The person of Toots, for example, reveals the mysterious human habit of living within a self-constructed image ('It's of no consequence, thank'ee'). Sometimes it is society that forces these 'tabs of identity'[43] upon them, as it has done upon Merdle's butler and the Father of the Marshalsea, and which they continue to sustain with obsessive gentility. A novel like *Great Expectations* displays a world of characters insulated within their own ideas of themselves: Wemmick with his post-box face and castle drawbridge, Mrs Havisham in her role as jilted lover, Pumblechook and the Pockets, Pip in the comfortable security of his expectations—they are all seen as participating in the world on the limited terms that they have themselves defined. They have become the literal embodiment of a consuming idea— and since they are their own caricaturists it maybe explains why Dickens for this novel, for only the second time in his career, determined to dispense with illustrations.

According to William Morris, Dickens would be remembered for fashioning a fantastic and unreal world. What that prediction ignores, however, are the inevitable connections that Dickens learnt to perceive between fantasy and reality, between 'prevailing idea' and the multitudinous world of rich detail. In these lessons he was taught—as much as by anyone or anything—by the traditions of graphic satire.

41 William Hogarth *An Election Entertainment* 1755 engraving 15⅞ × 21 9/16 in.
(40.5 × 54.5 cm.) British Museum, London

42 James Gillray *Union Club* 1801 engraving 11 × 7½ in. (28 × 18 cm.) British Museum,
London

43 George Cruikshank *Christmas Time* 1829 engraving 9 × 12 in. (23 × 30.5 cm.)
British Museum, London

44 Thomas Rowlandson *Vauxhall Gardens* 1785 aquatint 19 × 29½ in. (48.5 × 75 cm.)
British Museum, London

The BENCH.

Design'd & Engrav'd by W. Hogarth ——— Published as the Act directs. 4 Sep. 1758.

Of the different meaning of the Words **Character**, **Caracatura** and **Outrè** in *Painting* and *Drawing* ——
This Plate would have been better explain'd had the Author lived a Week longer.

There are hardly any two things more essentially different than **Character** and **Caracatura** nevertheless
they are usually confounded and mistaken for each other: on which account this Explanation is attempted
It has ever been allow'd that, when a **Character** is strongly mark'd in the living Face, it may be consider'd as
an Index of the mind, to express which with any degree of justness in Painting, requires the utmost Efforts of a great
Master. Now that which has of late Years got the name of **Caracatura**, is, or ought to be totally divested of every
Stroke that hath a tendency to good Drawing: it may be said to be a Species of Lines that are produced rather by the
hand of chance than of Skill: for the early Scrawlings of a Child which do but barely hint an Idea of an Human
Face, will always be found to be like some Person or other, and will often form such a Comical Resemblance
as in all probability the most eminent **Caracaturers** of these times will not be able to equal with Design, be
cause their Ideas of Objects are so much more perfect than Childrens, that they will unavoidably introduce some
kind of Drawing: for all the humourous Effects of the fashionable manner of **Caracaturing** chiefly depend on
the surprize we are under at finding our selves caught with any sort of Similitude in objects absolutely re
mote in their kind. Let it be observ'd the more remote in their Nature the greater is the Excellence of these
Pieces: as a proof of this, I remember a famous **Caracatura** of a certain Italian Singer, that Struck at
first sight, which consisted only of a Streight perpendicular Stroke with a Dot over it. As to the French
word **Outrè** it is different from the foregoing, and signifies nothing more than the exagerated
outlines of a Figure, all the parts of which may be in other respects a perfect and true Picture of
Nature. A Giant may be call'd a common Man **Outrè**. So any part as a Nose, or a Leg made
bigger than it ought to be, is that part **Outrè**. † which is all that is to be understood by this word so
injudiciously us'd to the prejudice of **Character**. ———

† See Excess, Analysis of Beauty Chap 6.

46 William Hogarth *Gin Lane* 1751 engraving 14 3/16 × 12 in. (36 × 30.5 cm.) British Museum, London.

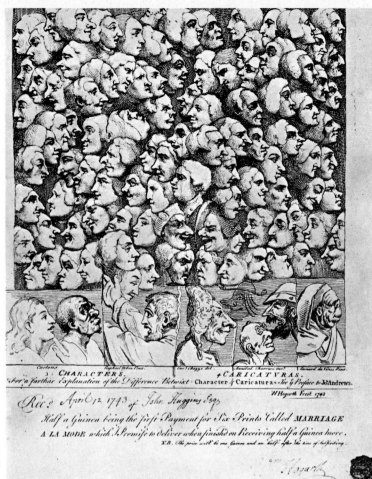

7 William Hogarth
*Characters and
Caricaturas* 1743
engraving 17 11/16 × 8 ⅜ in.
(45 × 21 cm.)
British Museum, London

8 George Cruikshank *London Going Out of Town* 1829 engraving 7 × 10 in. (18 × 25.5 cm.)
British Museum, London

opposite

49 Thomas Cole *The Mountain Ford* 1846 oil on canvas 28¼ × 40 1/16 in. (72 × 102 cm.)
The Metropolitan Museum of Art, New York

50 Robert Delaunay *Window on the City, no. 4* 1910–11 oil on canvas 44¾ × 51½ in.
(113.5 × 131 cm.) The Solomon R. Guggenheim Museum, New York

51 Rik Wouters *Red Curtains* 1913 oil on canvas 39⅜ × 31⅞ in. (100 × 81 cm.) Collection
P. Vermeylen, Brussels

3 Pablo Picasso *The Old Guitar Player* 1903 oil on wood panel 48⅛ × 32½ in.
(122.5 × 82.5 cm.) Helen Birch Bartlett Memorial Collection, Art Institute of Chicago

5 Charles Sheeler *Church Street El.* 1920 oil on canvas 16⅛ × 19⅛ in. (41 × 48.5 cm.)
Collection Mrs Earle Horter, Philadelphia

56 John Marin *On Morse Mountain, Small Point, Maine* 1928 watercolour 21 × 16½ in.
(53.5 × 42 cm.) Collection Philip L. Goodwin, New York

Notes

The place of publication is London, unless otherwise stated.

1 R. H. Horne, *A New Spirit of the Age* (World's Classics 1907), p. 14, and for the quotation later in the first paragraph, p. 7. For other brief acknowledgements of possible connections between Dickens and Hogarth, see Mario Praz, *The Hero in Eclipse in Victorian Fiction* (1956), pp. 11 foll.; F. R. and Q. D. Leavis, *Dickens the Novelist* (1970), pp. 26 and 334n; Frederick Antal, *Hogarth and his Place in European Art* (1962), pp. 189–90 and 251. And since writing this essay I have read with interest the fullest account yet to appear of Dickens's involvement with graphic art in John Harvey, *Victorian Novelists and their Illustrators* (1970), especially chapter three. I am also indebted to the M.Phil dissertation on 'Dickens and Hogarth' submitted in 1970 to the University of York by Christopher J. Emberton.

2 *To Be Read At Dusk and other Stories, Sketches and Essays* (1898), pp. 79–80. See also Dickens's references to Hogarth in the 1841 Preface to *Oliver Twist*, reprinted in *Collected Papers*, Biographical Edition of the Works, XIX (1903), p. 263. The reference to Dickens's 'complete set' of Hogarth engravings is in *The Dickensian*, XLV (1949), p. 204; but, as Allen Samuels has kindly pointed out to me, the collection was not complete, according to the *Reprints of the Catalogue of the Libraries of Charles Dickens and W. M. Thackeray* (Piccadilly Fountain Press 1935); from that catalogue it is evident that Dickens possessed at least many of the major engravings of Hogarth—they are listed on p. 59.

3 For Horne, see note 1; George Augustus Sala, *William Hogarth* (1866).

4 Some sense of the richness and variety of this graphic art may be gathered from M. D. George, *Hogarth to Cruikshank: Social Change in Graphic Satire* (1967).

5 See John Butt and Kathleen Tillotson, *Dickens At Work* (1968), p. 40.

6 *To Be Read At Dusk*, pp. 123–4.

7 *Sketches by Boz*, pp. 250 foll.

8 See Robert Browning in *Dickens and the Twentieth Century*, ed. John Gross and Gabriel Pearson (1966), p. 20.

9 Draft for *The Analysis of Beauty*, quoted in the edition of *The Analysis*, ed. by J. Burke (Oxford 1955), p. 20.

10 See Forster's comment on the *Sketches* 'unusually truthful observation of a sort of life between the middle class and the low, which, having few attractions for bookish observers, was quite unhackneyed ground', *The Life of Charles Dickens* (1966), 1.61. All further references are to this edition.

11 From omitted section of 'The Prisoners' Van', quoted Butt and Tillotson, p. 44. Perhaps its omission was due to its inappropriateness at the start of a Hogarthian 'progress' piece, from which its editorial fussiness distracted.

12 R. H. Horne writes (op. cit., p. 5): 'Charles Lamb in his masterly essay "On the Genius of Hogarth", says, that in the print of the "Election Dinner", there are more than thirty distinct classes of face, all in one room, and disposed in a natural manner, and *all partaking in the spirit of the scene*' (my italics).

13 See E. H. Gombrich, 'The Cartoonist's Armoury', *Meditations on a Hobby Horse* (1963).

14 I am indebted for my discussion of Hogarth to Ronald Paulson, *Hogarth's Graphic Works*, 2nd revised ed. (New Haven and London 1969).

15 W. Dexter, *The Letters of Charles Dickens* (1938), I.782.

16 Quoted Butt and Tillotson, pp. 37 and 38. See also such little painterly touches as Mrs Tuggs 'flinging open the door of the little parlour and disclosing Miss Tuggs in perspective' (*Sketches*, 336), or the various injunctions, *passim*, to 'picture' a scene for ourselves.

17 A typical invocation of Frith's *Derby Day* occurs in the introduction to the Oxford Illustrated *Sketches*, p. vii. Frith's painting, of course, dates from 1858.

18 See the sections on the law in M. D. George, op. cit.

19 The phrase is used by Dickens as the title of an essay as late as 1850: see *To Be Read At Dusk*.

20 Quoted Butt and Tillotson, pp. 54–5. The aptness of what Dickens cuts as advice to his own graphic imagination could surely not have escaped him.

21 Ibid., p. 65.

22 Robert L. Patten, 'Boz, Phiz and Pickwick in the Pound', ELH, XXXVI (1969), pp. 575–91.

23 It is Bernard Bergonzi who suggests that the 'alert modern critic' has nothing to say in face of *Nicholas Nickleby*; *Dickens and the Twentieth Century*, p. 66.

24 See F. D. Klingender, *Hogarth and English Caricature* (London and New York 1944), p. 28.

25 *Charles Dickens. The world of his novels* (1958), pp. 89–90.

26 Dickens himself uses the word 'emblem' in *Pickwick Papers*, p. 596. See also the discussion of this topic by John Killham in *Dickens and the Twentieth Century*, pp. 35 foll.

27 *The Dickensian*, XXXIX (1942), pp. 165–6. For the draft notes for *Little Dorrit*, see the catalogue of the Victoria and Albert Museum centenary exhibition, *Charles Dickens* (1970), p. 90.

28 Page 472, and a few pages later Dickens gives to Little Dorrit an explicit identification of this emblematic point: 'She felt that in what he had just now said to her, and in his whole bearing towards her, there was the well-known shadow of the Marshalsea'.

29 On this theme, see especially Dorothy van Ghent, 'The Dickens World: A View from Todger's', *Sewanee Review*, LVIII (1950), 419–38.

30 Klingender, op. cit., p. iv.

31 K. J. Fielding (ed.), *The Speeches of Charles Dickens* (Oxford 1960), p. 128.

32 'Imagery and Art in the Romantic Period', *Meditations on a Hobby Horse*.

33 See *Fashionable Contrasts. Caricatures by James Gillray*, introduced and annotated by Draper Hill (1966), plate 39 and *passim*.

34 Leavis, op. cit., p. 194. There is also in *Hard Times* a frequent use of what I noticed in the *Sketches*, a caption-like syntax that reinforces the graphic sense: i.e. 'the Good Samaritan was a Bad Economist'.

35 E.g. the fat Regency Dido of Lady Hamilton or Mrs Fitzherbert.

36 George Gissing, *Charles Dickens. A critical study* (1902), p. 106.

37 *Psychoanalytic Explorations in Art* (New York 1952), p. 190.

38 Phrases from Fielding's *Preface to Joseph Andrews*, written with Hogarth in mind, and to which Hogarth's engraving in its turn refers.

39 Illustrated as plate 9 in the section, 'Dickens's Characters', *Charles Dickens 1812–1870*, ed. E. W. F. Tomlin (1969).

40 Quoted Butt and Tillotson, op. cit., p. 17.

41 Quoted Gombrich, *Art and Illusion* (1961), p. 331.

42 Quoted Herbert Read, *A Concise History of Modern Painting* (1969), p. 54.

43 Kris, op. cit., p. 192.

Wallace Stevens and William Carlos Williams:

Poetry, painting, and the function of reality

Bram Dijkstra

The study of the influence of painting on literature is primarily a study of motive and method. It deals with the writer's aesthetic, with his conception of the world, his perception of current realities and his motivation as an artist. A poet's response to painting, as reflected in his work, can tell us why he is a poet and why his poetry has taken its specific form, and allow us to compare his unconscious manipulation of sources with his professed intentions. Such study is therefore of direct importance to the development of a sociology of literary form.

The response of Wallace Stevens and William Carlos Williams to painting is a case in point. These poets were close contemporaries and the superficial aspects of their literary development are remarkably analogous. But as their poetry developed they found themselves moving in opposite directions. The details of their debt to the visual arts have been explored in several recent studies.[1] I shall therefore limit myself here to a more general delineation of the role of painting in the development of their poetics, and in the expression of their intellectual and social motivation as poets. Of the two, Stevens's case is the more complex and therefore requires fairly extensive elaboration. But this should not obscure the significance of Williams's contribution, which is of crucial importance to any understanding of the contradictory forces at work in the American psyche.

For both Stevens and Williams the meaning of painting was directly related to their attempts to discover how objective reality functioned in the establishment of a viable alliance between man and his intellectual and social environment. As budding poets dissatisfied with the comatose state of poetry in the United States during the years preceding the First World War, they felt intuitively that their only escape from imitative torpor lay in a redefinition of the realities of existence within their native environment. Or, as the young Stevens wrote in his journal in 1899, art 'must be part of the system of the world'.* A few years later, in 1904, he marvelled about 'how utterly we have forsaken the Earth, in the sense of excluding it from our thoughts'. Man, he remarked, 'has managed to shut out the face of the giant from his windows' (*L*, 73). Stevens here seems to have recognized something about an attitude which had dominated the American consciousness from the start. For its immigrant inhabitants America was never a 'native soil', with all the instinctive ties that term implies, but an object for functional exploitation. Their economic motivation made them see their

* Wallace Stevens, *Letters*, ed. Holly Stevens (New York 1966), p. 24. In subsequent citations this volume will be referred to as *L*.

adopted environment almost exclusively as a medium for industrial development, an attitude which they imparted even to their native-born children. To regard the soil, or more generally, the inanimate objects which surround human existence, as an essential part of the structural modalities of being would have seemed to them a preposterous form of sentimentalism.

America's artists and writers were in large part unable to dissociate themselves from this general attitude of neglect. Instead of attempting to explore the unique characteristics of their environment, they insisted on finding correspondences with the traditional elements of European landscape and form. The paintings of the immigrant Thomas Cole, for instance, are more representative of the ordered nature of European romanticism than of the realities of the American scene (ill. 49). American literature is striking in its tendency toward idealism and intellectual abstraction, and in its inability to capture the elements of self and understanding which are hidden in the inarticulate configurations of inanimate form we call objective reality. Yet America's best artists have intuitively sought to cope with the absence of reality in their surroundings, and often their work clearly reflects these attempts.

How difficult it was, and for that matter still is, for the American writer to keep a foothold in reality, is clearly indicated in the lifelong struggle and ultimate failure of Wallace Stevens to reconcile the conflicting demands made upon him by his perception of the importance of objective reality in the poet's registration of the elements of existence, and his determination to make his own life conform to the intellectual and social values prevalent in the United States. Stevens's early journal entries and letters provide a moving account of that struggle.

From the very first Stevens's observation of natural objects was prejudiced by his ambiguity toward the value of reality as an object of study. As early as 1899 he saw that reality was at odds with 'accepted' literary values: 'Out in the open air with plenty of time and space I felt how different literary emotions were from natural feelings' (L, 27). And he realized that 'the true and lasting source of country pleasure' is 'the growth of small, specific observation' (L, 30). As a result the journals of these years are filled with descriptions of nature which are, in fact, remarkably specific, and distinctly sensuous in quality, although they also reveal the self-conscious posturing of the budding 'artist'. But Stevens's desire to see the world around him in objective terms was soon tempered by the realization that he who sees clearly cannot see only that which he wishes to see. The encroachment of the less pleasant aspects of reality made Stevens conclude that 'the sea is loveliest by far in the abstract when the imagination can feed upon the idea of it. The thing itself is dirty, wobbly and wet' (L, 59).

As Stevens passed his bar exams and was admitted to practice, the demands upon him to behave in a manner acceptable to an orderly society sharpened the conflict between what he was beginning to see as his 'youthful fervor' for the physical excitements of reality and his belief in abstract ideals. Sometimes, while in the city (which represented to him his social responsibilities) he rebelliously remembered the attractions of freedom:

> I feel a loathing (large & vague!), for things as they are; and this is the result of a pretty thorough disillusionment. Yet this is an ordinary mood with me in town in the Spring time. I say to myself that there is nothing good in the world except physical well-being. All the rest is philosophical compromise. (L, 82)

To Elsie Moll, his wife-to-be, he wrote at one point desperately: 'I want to see green grass again—a whole field of it, shining in the light' (L, 97). It is clear that Stevens was coming to associate the reality of the natural world (however unconsciously) with the unbridled passions of the body and with freedom from social responsibility. A glance at Elsie's picture and 'suddenly the idea of a hay-field comes into my head and I imagine myself lying on a pile of hay watching swallows flying in a circle' (L, 97). And a few days later he confides to Elsie an experience of the previous summer which is straight out of (but antedates) D. H. Lawrence. He tells that he 'went swimming in a secluded spot. I let myself float under water . . . and looked at the blue and brown colors there and I *shouted* when I came up.' This is in a letter in which he writes that his life in the city makes him 'full of misery' and in which he begs Elsie to 'never grow old', because 'to be young is all there is in the world' (L, 97–8).

Thus youth, the pleasures of the body and the delights of the sensuous apprehension of concrete reality had already become objects of nostalgic recollection rather than part of present experience for Stevens, not quite thirty years old, a poet who had yet to write the first of his mature poems. Occasionally he would break loose from his professional life and try to regain a sense of his independent selfhood in the world of sensuous experience, by taking a long walk in the woods: 'The sheets of mist, the trees swallowed up at a little distance in mist, the driving cold wind, the noisy solitude, the clumps of ice and patches of snow—the little wilderness all my own, shared with nobody, not even with you—it made me myself . . .' he admitted to Elsie (L, 99). But he had already begun to see such experiences as unlawful escapes from the proper restraints of aesthetic responsibility into the freedom of unmediated reality: 'I play a silver lute for you, when I am good . . . and now that I have come back it seems as if I might play my lute more sweetly and more gladly' (L, 99). Stevens, brought up in a strict environment, and about to be married to a very prim young lady, now even began to see his interest in objective reality as associated with the tempting but destructive enticements of sexual evil, as becomes very clear in the following fantasy from his journal:

> Has there ever been an image of vice as a serpent coiled round the limbs and body of a woman, with its fangs in her pale flesh, sucking her blood? Or coiled round the limbs and body of a man? Fancy the whole body fainting, in the distorting grip, the fangs in the neck—the victim's mouth fallen open with weakness, the eyes half-closed. Then the serpent triumphing, horrible with power, gulping, glistening. (L, 91)

The image of vice in this pseudo-moral specimen of *fin de siècle* imagination is clearly representative of sensuous experience, and the vividness with which Stevens portrays the scene indicates the mixture of fascination and intense fear with which he approached physical reality.

For Stevens, then, youth and pure sense were representative of what is real—but opposed to the life of the mind, which was that of responsibility and society. He developed the position, which he would maintain throughout his life, that to exist in an ordered society one must relinquish the life of sense for the life of the mind. He came to deal with the real world through a screen of very pronounced, 'precious' aesthetic attitudes, and backed away in revulsion from the 'ugliness' and 'vulgarity' of that world. His longing

for the real was an attempt to re-create the enticements of physical experience and nature, of body and earth, which he had known in childhood and as a young adult. His revulsion from the real was an action of his will to prevent him from having to face the possible disintegration of his position within the restrictive certainties of the conventional societal structure in which he had found his public function. Ultimately the conflict was one between the 'order' of society and the 'chaos' of objective reality, between security and uncertainty, even between old age and youth (as Stevens himself once remarked, 'when one is young everything is physical; when one is old everything is psychic').

Considering Stevens's progressive dissociation from the reality of sensuous experience, it is not surprising that the poems he wrote during this time were pale things, typical of the thin, uninspired poetry of the period, redolent with landscapes in the manner of Claude Lorrain, or romantic English meadows, cottages and castles, with not a hint of the actual American environment. The following effete attempt at 'true' poetry, which he composed in 1908, is a good example:

> Back within the valley,
> Down from the divide,
> No more flaming clouds about,
> O! the soft hillside,
> And my cottage light,
> And the starry night.[2]

Stevens still often regretted his willing entrance into the world of affairs; he knew what he was sacrificing:

> When I complain of the 'bareness'—I have in mind, very often, the effect of order and regularity, the effect of moving in a groove. We all cry for life. It is not to be found in railroading to an office and then railroading back—I do not say the life we cry for is, as a question of merit, good or bad. (L, 122)

And in trying to tell Elsie how much she meant to him, he wrote: 'It is as if I were in the proverbial far country and never knew how much I had become estranged from the actual reality of the things that are the real things of my heart . . .' (L, 131). He still felt 'a tremendous capacity' for enjoying a life of the senses, 'but', he decided with resignation, 'it is all over, and I acknowledge "the fell clutch of circumstance"—How gradually we find ourselves compelled into the common lot!' To overcome the sense of defeat this recognition gave him, Stevens had to construct a rationalization which could absolve him from his feelings of cowardice in the face of the real, and thus he continues: 'Perhaps it is best, too, that one should have only glimpses of reality—and get the rest from the fairy-tales, from pictures, and music and books' (L, 141). This is a statement of crucial importance, for it announces the procedure Stevens was to follow for the rest of his life. If reality threatened the order of the existence he had chosen, he had to find a way to prevent its encroachments, and he therefore decided to make art the intermediary between his perceptions and the real world.

Since painting is the art most closely associated with the observation of reality, it is not surprising that Stevens turned to it for the notations of reality with which he came to nourish his imagination. He learned to use painting as an energizing agent, much as he had once used his walks in the

woods. But as long as painting was primarily concerned with the observation, registration and interpretation of national objects—that is, as long as it was composed of rural or local anecdote and the delineation of pastoral or stylized romantic landscape, all elements of experience foreign to the American situation, it could do little to help Stevens gain an individual voice in poetry.

It seems to me extremely doubtful whether Stevens could ever have transcended these weaknesses of focus without the help of the revolutionary new styles of painting which made their official American début at the famous First International Exhibition of Modern Art in the Armory of the Sixty-ninth Regiment in New York, in February 1913. For Stevens, as for many other Americans, the Armory Show must have been a stunning experience. It suddenly confronted him with the incredible range of new methods of visual expression manifested in the work of painters ranging from Renoir to Picasso and Braque, from Van Gogh to Kandinsky, Matisse and Marcel Duchamp. In this exhibition of more than thirteen hundred works he encountered the unfamiliar configurations of expressionism, fauvism and cubism for the first time. The Armory Show and subsequent exhibitions of modern art opened an entirely new range of theoretical and stylistic possibilities for Stevens, and soon after the Armory Show his first important poems began to appear in little magazines.

The new forms of painting taught Stevens some crucial things about the significance of the close observation of objects in poetry, and about the evocative power of unexpected conjunctions of material things. He also learned from the gaiety of line and colour and from the lack of artistic decorum in the work of these new painters, that poetry did not have to be an affair of leafy glades and wilting maidens. A work such as Delaunay's *Window on the City, no. 4* (ill. 50), which was exhibited at the Armory Show, with its cross-rhythms of bright colour and its capacity to give a new tactile significance and sense of musical movement to visual structures, probably helped to give Stevens the impetus he needed to venture into the structural experiments of such poems as 'Metaphors of a Magnifico' and 'Ploughing on Sunday'. It certainly taught him to brighten the contrasts of colour in his verse. Although Stevens did not feel he understood the work of Marcel Duchamp, he had ample opportunity to study it, and it is clear that the title of one of the first poems in *Harmonium*, 'The Paltry Nude Starts on a Spring Voyage', is directly inspired by Duchamp's titles for his paintings, such as *Nude Descending a Staircase* (ill. 52), which became the most debated work in the Armory Show, and *The King and Queen Surrounded by Swift Nudes*. Titles of certain later poems, such as 'The Revolutionists Stop for Orangeade', still show this influence.

Under the influence of the new painting, and armed with a new range of visual possibilities, Stevens once more turned his attention to reality, and specifically to the ordinary objects of his immediate environment. But the poet's reaction to the more extreme visual structures of the cubists remained one of puzzled amusement and reservation. Characteristically he was somewhat repelled by the 'ugliness' of their works. 'Floral Decorations for Bananas' is an interior monologue on style in which he decides that with 'These insolent, linear peels / And sullen, hurricane shapes' of cubism to challenge him, his habitual poetic fare of plums 'In an eighteenth-century dish, / And pettifogging buds, / For the women of primrose and purl, / Each one in her decent curl', won't do any more. On the other hand, the 'hacked and hunched' bananas of cubism will cause the table of poetry to be

> . . . set by an ogre,
> His eye on an outdoor gloom
> And a stiff and noxious place.
> Pile the bananas on planks.
> The women will be all shanks
> And bangles and slatted eyes.

The other possibility is to

> . . . deck the bananas in leaves
> Plucked from the Carib trees,
> Fibrous and dangling down,
> Oozing cantankerous gum
> Out of their purple maws,
> Darting out of their purple craws
> Their musky and tingling tongues.

These lines are clearly a response to the exotic world of Gauguin and the bright colours of the fauves, which obviously had a special if, apparently, somewhat morbid, fascination for Stevens, with his weakness for everything that was brightly coloured and far away.

On the basis of such stylistic deliberations, Stevens began to incorporate the visual elements of the new painting in his poetry. In 'The Public Square', the opening lines,

> A slash of angular blacks
> Like a fractured edifice
> That was buttressed by blue slants
> In a coma of the moon . . .

could not have been written without the structural revelations of the cubists. The poet's use of bright, solid, primary colours in such poems as 'Disillusionment of Ten o'Clock', where 'an old sailor, / Drunk and asleep in his boots, / Catches tigers / In red weather', is unmistakably fauvist or expressionist in origin, and it is not difficult to recognize the influence of Cézanne's *Les Grandes Baigneuses* or a similar work, on the lines 'I figured you as nude between / Monotonous earth and dark blue sky', from 'The Apostrophy to Vincentine'. Matisse is now generally recognized as being indirectly responsible for the brightness and atmospheric lucidity of the opening lines of Stevens's most famous poem, 'Sunday Morning':

> Complacencies of the peignoir, and late
> Coffee and oranges in a sunny chair,
> And the green freedom of a cockatoo
> Upon a rug mingle to dissipate
> The holy hush of ancient sacrifice . . .

although the stylistic qualities of the poem are perhaps closer to those of Rik Wouters's famous painting *Red Curtains* (ill. 51).

Influences such as these are apparent throughout Stevens's mature poetry, and are, in fact, largely responsible for his reputation as a realist. Had Stevens consistently followed the indications of the new painters, and had he continued to apply their techniques toward the delineation of the objects within his immediate environment, as he did in the poems cited and in an occasional later poem, that reputation might be deserved. But very soon

Stevens, as before, decided that it was sufficient to have 'glimpses of reality' now and then. Painting, although more pervasively present than ever, became a substitute for the real, rather than serving as intermediary between the poet and the world.

The old uncertainties had begun to reassert themselves as a result of Stevens's renewed venture into the real world, and made him cry: 'Unreal, give back to us what once you gave: / The imagination that we spurned and crave.'* He was responding to the very clear recognition that any sustained confrontation with the elements of reality might be fatal to his ability to sustain his participation in the fictions of society. One of the most astonishing, and chilling, aspects of Stevens's intellectual development is that he knew very well that he had chosen to live in a world of fictions. His only major self-deception was his decision that poetry belonged to this world of fictions, and was, in fact, the Supreme Fiction. He had come to the conclusion that pure reality was too bleak, too depressing, and, for that matter, too chaotic, to sustain man's creative energies. The imagination was consequently for Stevens the will to fiction, and poetry its tool, the means by which we could move from reality into the world of 'fictive music'. It was for Stevens one of the niceties of civilization that, with the withering away of religious dogma and fiction, man should now be in the process of gaining full control over his fictionalizing capacity, able to choose his own fictions to believe in, while knowing that they were fictions:

> . . . to speak of the whole world as metaphor
> Is still to stick to the contents of the mind
> And the desire to believe in a metaphor.
> It is to stick to the nicer knowledge of
> Belief, that what it believes in is not true. (*CP*, 332)

What Stevens here admits to, essentially, is that he was more concerned with establishing a theoretical framework for man's will to order than in objective fact. In light of this his aphorism that 'accuracy of observation is the equivalent of accuracy of thinking',† takes on a striking significance. It means that Stevens recognized that he who would observe reality closely, would have to learn to think with accuracy. This is essentially what Stevens recognized as Sigmund Freud's major concern, when he came to discuss him in his essay 'The Noble Rider and the Sound of Words'. The interesting thing is that the poet considered Freud an enemy. The object of Freud's *The Future of an Illusion*, he said, was 'to suggest a surrender to reality'. And he continued:

> [Freud's] conclusion is that man must venture at last into the hostile world and that this may be called education to reality. There is much more in that essay inimical to poetry and not least the observation in one of the final pages that 'the voice of the intellect is a soft one, but it does not rest until it has gained a hearing'. This, I fear, is intended to be the voice of the realist.³

If we add to this the remarks from the 'Adagia', that 'as the reason destroys, the poet must create', because 'the reason is a part of nature and is controlled

* Wallace Stevens, *Collected Poems* (New York 1954), p. 88. In subsequent citations this volume will be referred to as *CP*.
† From 'Adagia', in Wallace Stevens, *Opus Posthumous* (New York 1957), p. 158 (*OP* in subsequent citations).

by it', we must come to the conclusion that for Stevens, under the pressures of his will to order and his need to adhere to the demands of the world of affairs, reason and reality had become dangerous, negative concepts, from which it was best to escape as quickly as possible into the comforting fictions of the imagination: 'The final belief is to believe in a fiction, which you know is a fiction, there being nothing else. The exquisite truth is to know that it is a fiction and that you believe in it willingly' (*OP*, 163). As Ivor Winters has remarked, for Stevens 'the Imagination would seem to be the power which gives order to the reality which has no order; but on the other hand this order is imaginary and not real; it is a kind of willed delusion'.[4]

On the basis of such astonishing rationalizations, then, Stevens turned his back almost entirely on the delineation of immediate reality and began to rely in the construction of his poems not only on the elements of style he had learned from the painters, but also on the paintings themselves as a primary source for his poems, using them as a substitute for reality. In doing so he, in essence, merely extended the procedure he had used initially to transpose the suggestions of modern painting to the realm of poetry. In those early explorations he had been likely to isolate a scene, a group of objects, or an incident in the visual world, structure it and delineate it as a painter would, and then use this visual structure to develop a poem which would incorporate large elements of the original construction, but would go beyond its visual basis to become what might sometimes be a stylistic or theoretical meditation, or at other times a large-scale philosophical disquisition. Considering this procedure, and keeping in mind that a painting is a visual construct of reality, not a part of unmediated reality, and as a product of human perception represents already an act of selectivity and judgement, it becomes understandable that it was tempting for a man like Stevens, with his ambiguous attitude toward reality, to forego the initial step of observation and limit himself to the further arrangement and organization of structures which were themselves already organized interpretations of the objective world. Thus the world of art became the 'real' world for Stevens, because in its tendency toward internal order it corresponded more closely to the world as Stevens wished it to be than the real world. Consequently poetry for Stevens became 'never the thing but the version of the thing' (*CP*, 332).

Stevens's use of painting as a basis for poetry began early. The poem 'Floral Decorations for Bananas' is a good example. Another is 'The Paltry Nude Starts on a Spring Voyage', which is, in fact, based on a comparison of two paintings: Botticelli's famous *Birth of Venus*, and Duchamp's image of a new Venus, *The Nude Descending a Staircase* (ill. 52). Without a mental image of Botticelli's Venus we cannot fully understand the context of the opening lines: 'But not on a shell, she starts, / Archaic, for the sea', nor the development of the contrast in this poem between discontent over old forms and the high promise of renewal inherent in the image of Duchamp's 'goldener nude / Of a later day', which

Will go, like the centre of sea-green pomp,
In an intenser calm,
Scullion of fate,
Across the spick torrent, ceaselessly,
Upon her irretrievable way.

In fact, many of Stevens's poems are clearly based on paintings. 'A Study of Two Pears' for instance, is quite obviously a meditation on a still-life by Cézanne or one of his followers, and 'Someone Puts a Pineapple together' apparently had its origin in a watercolour by Mariano Rodriguez which Stevens owned.[5] Often the original sources are, though tangibly there, not easy to identify, because Stevens usually proceeded by seizing upon a detail of the painting he was using, transforming it into a metaphoric construct of his own imagination, and then developing a poem out of the configurations which had been suggested to him in this way. He did this, for instance, in his poem 'Angel Surrounded by Paysans', based on a painting by Pierre Tal-Coat he acquired a few days before he wrote the poem. The painting was a still-life which consisted of 'a Venetian glass vase with a sprig of green in it and then, nearby, various bottles, a terrine of lettuce, I suppose, a napkin, a glass half full of red wine, etc.' (L, 652). Stevens, in his poem, transformed this painting as follows: 'The Angel is the Venetian glass bowl on the left with the little spray of leaves in it. The peasants are the terrines, bottles and the glasses that surround it' (L, 650). When we are faced with such a prodigious capacity for transformation, it is understandable that the sources for many of the poems or sections of poems which are palpably based on pictures, continue to elude identification. This is, however, not the case with the most famous example of Stevens's use of a painting as the source for a meditative poem (or rather, sequence of poems), 'The Man with the Blue Guitar'. Most readers correctly associate the poet's description of 'The man bent over his guitar, / A shearsman of sorts', with his 'hero's head, large eye / And bearded bronze', with a well-known painting from Picasso's blue period, *The Old Guitar Player* (ill. 53).*

In order to nourish his imagination, Stevens became an insatiable collector of paintings, exotic *objets d'art*, art magazines and art books, even of picture postcards and other such seeming ephemera. He urged his friends and acquaintances to indulge this collectorship. To one of his correspondents, for instance, he wrote, late in his life, 'I do wish that you were more profuse in your postcards. The reproduction of the Picasso is almost as good as the original' (L, 845). And to Paule Vidal, who served as his buying agent in Paris, he sent wholesale requests for reproductions, such as the following:

* William York Tindall, in his *Wallace Stevens* (Minneapolis 1961), p. 30, remarks that Stevens once denied that he had Picasso's picture in mind. The poet did in fact write to Renato Poggioli, who was preparing a book of translations of Stevens's work, and who had evidently asked him about the relationship: 'I had no particular painting of Picasso's in mind and even though it might help to sell the book to have one of his paintings on the cover, I don't think we ought to reproduce anything of Picasso's' (L, 786). But Stevens, in an apparent effort to protect himself from being associated too closely with Picasso, about whose later work he had grave reservations, was being less than candid. The poet, who was an inveterate frequenter of museums and galleries, is certain to have attended the first American Picasso retrospective, which was held at the Wadsworth Atheneum in Hartford in 1934, to celebrate the opening of a new wing of the museum. Many paintings of Picasso's blue and rose periods were exhibited there, *The Old Guitar Player* among them, according to Louis L. Martz (see Brown and Haller, op. cit., 221). It is clear that, even though in this painting the guitar is not blue, but brown, it is the pervasive blue of the rest of the painting, and the strength of the composition as a whole, which impressed Stevens and caused him to make this simple colour transposition. Picasso, moreover, is explicitly mentioned in the poem, and Stevens knew Christian Zervos's book on the early paintings of Picasso, in which there is a black and white reproduction of *The Old Guitar Player* which may have served to refresh Stevens's memory of the painting as he came to write his poem. (The term 'hoard of destructions' which Stevens, in the poem applies to Picasso's work, and came to associate with his reading of Zervos, does not originate in this book, which was the first volume of Zervos's monumental catalogue of Picasso's work, and the only volume that had appeared before the publication of 'The Man with the Blue Guitar', in 1937.)

> Would it be possible for you to write to the Kunsthalle at Bâle to procure
> from it a set of all the postcards containing reproductions of things in
> that museum, particularly the coloured ones, and send them to me.
> Perhaps you could procure at the same time a list of publications of
> the museum. I want postcards showing not only the objects on exhibition,
> but also the building, etc. (*L*, 530)

Correspondents as far away as Ceylon and Japan sent him small pieces of
sculpture and other interesting items. In this fashion Stevens surrounded
himself tirelessly with as many images of reality as he could find, trying as
much as possible to ignore reality itself. There are actually indications that
Stevens sometimes was unable to operate as a poet without having the
stimulus of a new painting to kindle his imagination. To Norman Holmes
Pearson, for instance, he wrote, in the year before his death:

> I have been pretty much at a standstill lately . . . However, yesterday
> a new picture came from France and the usual problem of where to
> hang it came with it. As I was thinking that over last evening, I thought
> that perhaps one of the things that has been in the way is that I have
> not been having a new picture often enough. (*L*, 829)

Perhaps Stevens was in some ways comparable to those people who can
reproduce a drawing of an object well enough, but who are incapable of
drawing that object directly from nature; people, in other words, who are
deficient in their ability or willingness to scrutinize and perceive concrete
reality, but who are capable of imitating the orderly schemata of concrete
reality produced by others. Stevens's progressive dissociation from the world
of immediate sensory experience, and his willing recourse to the works of
painters for his materials ('thinking about poetry is the same thing, say,
as thinking about painting', he believed), taught him to see the natural world
in terms of the schemata and visual articulations of the painters he studied,
rather than in terms of the elements of individuation and precise delineation
which he could have learned from the direct observation of reality. Thus
Stevens's vocabulary of experience became that of the art which fascinated
him. But while he recognized that painting was inevitably linked with reality,
he regarded poetry as a weapon 'against reality and against the fifth column
of reality that keeps whispering with the hard superiority of the sane that
reality is all we have, that it is that or nothing' (*L*, 600). Poetry could combat
the forces of the real with abstraction and metaphor. It represented for
Stevens a movement from reality into abstraction:

> While one thinks about poetry as one thinks about painting, the
> momentum toward abstraction exerts a greater force on the poet than
> on the painter. I imagine that the tendency of all thinking is toward
> the abstract and perhaps I am merely saying that the abstractions of
> the poet are abstracter than the abstractions of the painter. (*L*, 601–2)

This remark is of crucial importance, for it explains why Stevens's world,
for all its bright colour and lilting sound, is a world strangely without
substance. His poetry is all colour and music and form, and yet these
elements rarely come together to form a sense of real experience. The world
of Stevens's poetry is one in which ghostly mental shapes and verbal and
visual configurations, anaesthetized and stripped of concrete existence,
float together in an order devoid of human urgency and concern, devoid

also of the fears and crudities of human experience, an order expressly designed to interpose itself between man and reality, and thus to prevent him from experiencing the conflict and the torment as well as the potentially revolutionary shock of recognition inherent in his confrontation with the real. Stevens's poetry tries to supplant the certainties of orthodox, dogmatic, hieratic religion with the certainties of a religion of aesthetic dogma which urges the mind to succumb to the imagined pleasures and ideological safety of abstract theory, of pretty things and of words gathered for their sound, objects for their exclusiveness, or their exquisite colour, and thoughts for their intriguing lack of relevance to the question of what it means to live in a world of beauty, anger, fire and death.

It is not so much Stevens's notion of the interaction of the imagination and reality which created this artificiality, as his notion that poetry moves from reality to abstraction, that art starts in reality and should move from there into the mind. Had he been willing to recognize art as a movement of thought towards the apprehension of reality, his poetry would have had more substance. The often-repeated assertion that Stevens is a philosophic poet does not alter the fact of his responsibility towards reality and concrete experience. A poet's first concern must be to recall us to the material basis of experience by constructing his poems from those verbal signs which most closely correspond to the details of reality. Dante was a philosophical poet, and yet the world of his poetry is most brilliantly concrete when he wishes to convey the spiritual ramifications of his thought. The same is true of Milton, whose best work represents a clear attempt to illuminate the abstract by means of concrete materials. Blake's world is so persistently evocative of sensuous experience that it still has the power to frighten those who are reality-shy. The question is therefore not whether a 'poetry of thought' is possible, or whether or not poetry should have a philosophical focus. Great 'reflective' poetry exists. The only matter of real importance is whether a poet's work is truly effective as a tool of communication. The poets whose work has lasted have invariably shown a special ability to translate the elements of thought into 'objects' of experience, to communicate spiritual or philosophical concerns by means of material equivalences, that is, correspondent concrete 'events' taken from their observation of reality. But Stevens, using painting to escape from reality into abstraction, reversed the process which makes art a significant form of communication. He did not try to establish in his poetry equivalences between theory and real experience. He tried instead to decompose reality into an orderly abstraction, manageable in the mind and capable of continuous, effortless, re-arrangement as the occasion demanded. His poetry, moreover, consisted of patterns of abstraction built with verbal signs whose obscurity often made their relationship to sensuous experience deliberately tenuous. Stevens collected words as he collected postcards, as if they were knick-knacks, pleasing trifles to be put on a mantelpiece, not tools in the communication of real experience.

It is, I believe, highly inaccurate to assert, as Michel Benamou does, that Stevens was able to 'freshen' the effect of his poetry by continuously renewing his vocabulary. Benamou notes that Stevens used most words 'only once or twice' in any one of his books of poetry, and comments, 'since all we want is a new *sense* of things, renewing the words will do.'[6] But one of the clearest lessons of modern art is that it is not the accumulation of unfamiliar objects that gives us a new sense of things, but rather the unexpected

rearrangement of those objects which are most familiar. Stevens's fascination for 'new' words therefore actually helped to drive his poetry into abstraction, since the mind cannot visualize the unfamiliar, unless it be constructed out of familiar things.

Stevens, then, 'managed to shut out the face of the giant from his windows' as he had seen his fellow countrymen do when he was young—at least, he had managed as best he could. For notwithstanding his relentless attempts to maintain his ideals of order, his integration into the artificial stability of society, and his indulgence in a collector's connoisseurship of the objects of art rather than the materials of life, he could never completely forget that he was living a fiction, even if he considered that fiction 'supreme'. His clear intelligence continued to remind him that 'we keep coming back and coming back / To the real . . .' (CP, 471). Sometimes, especially towards the end of his life, when the self-deception seemed not so urgently necessary any more, Stevens allowed his youthful insights into the independent significance of man's organic and social environment to take the upper hand again. Many of the poems from Harmonium, his first collection, when he used painting not as a stepping-stone toward abstraction, but as a guide to the delineation of the real, when, as he once wrote to a correspondent, he 'liked the idea of images and images alone, or images and the music of verse together', will retain their evocative power, because they are suffused with the clear light of reality. The same is true of a number of Stevens's last poems, especially those in The Rock. In these he responded to his recognition that 'After the leaves have fallen, we return / To a plain sense of things. It is as if / We had come to an end of the imagination' (CP, 502). 'A fantastic effort' of dissimulation had failed, and now, at last, he heard again 'a scrawny cry from outside', which made him feel possessed of 'a new knowledge of reality' (CP, 534).

Yet Stevens never really succeeded in integrating what he considered the demands of society with his longing for a clear vision of reality. He wrote to Bernard Heringman, a few years before his death: 'Sometimes I believe most in the imagination for a long time and then, without reasoning about it, turn to reality and believe in that and that alone' (L, 710). Stevens's last poems show a certain resignation, as if, as Roy Harvey Pearce has remarked with great acuity, he has come to recognize that 'the dialectical compromise, although it is still wished for, is no longer conceivable. The poet will do one thing or the other. He will celebrate mind or celebrate things themselves, be either the poet of night or the poet of day, an old man or a young man. . . . He belongs to both sides of his universe, but never to both sides at once.'[7] Considering Stevens's depth of intelligence and talent, and the lasting beauty of his best poems, it is a great pity for poetry that, after the promise of Harmonium, he chose to be an old man most of his life, and dared to be young again only in his old age. In essence Stevens succumbed to the same hostility for the American environment which had crippled the work of so many earlier generations of American artists. In the nineteenth century many American artists had tried to ignore the 'indignities' of their crassly materialist environment by pretending that, through acts of sheer will-power and imagination, they could re-create the seemingly more poetic qualities of European experience. What Stevens did is not much different. Stevens, too, tried to escape America. As a collector, for instance, he consistently ignored the work of American painters, although there were now several who had developed a means of visual notation

capable of evoking the realities of their environment. Instead he bought works of European painters of little or no distinction. If he paid any attention to American painters at all, it was to show his disapproval, as of William Baziotes, a painter with an acute talent for the non-objective transliteration of organic form, whose paintings he called 'filthy things'. After a foray into New York to buy a number of expensive European art magazines, he remarked, 'one never realizes how completely we seem to belong to Europe until we attempt to get along without it' (*L*, 531). He went so far as to say 'French and English constitute a single language' (*OP*, 178).

For Stevens's contemporary and occasional acquaintance, William Carlos Williams, such a position was pure posturing. Williams, in fact, made a distinction that seems never to have occurred to Stevens: 'American poetry is not written in English but American.'[8] He recognized that 'if America or American is a stigma upon us it is because we have not yet been able to raise the place we inhabit to such an imaginative level that it shall have currency in the world of the mind.'[9] While Stevens was trying to discover whether his Dutch ancestry was pure enough to earn him a membership in the exclusive and snobbish Holland Society of New York, Williams, rejoicing in the fact that his parentage was hopelessly mixed, and unburdened by the strains of a strict upbringing, set out to discover how he could best express his immersion in all aspects of American life. Williams knew that 'the world of the artist is not gossamer but steel and plaster. The same in which men meet and work with pick and shovel, the same we go to war in.'[10] He wanted 'to evoke the sensual reality of our lives in relation to its time',[11] because to him it was self-evident that 'all art is of the senses',[12] and that 'art gives the concerns of man a tactile reality, it does not dissolve them'.[13]

Williams, before the Armory Show, had had as much difficulty as Stevens in finding a way to make the strained language of accepted poetic usage fit his ambition of creating an art that would be expressive of the American reality. And he, too, confronted with modern art, realized, as Stevens had, that these seemingly meaningless forms which the general public decried as a mockery of common sense, actually represented a deeply serious attempt to reassert the primacy of the real. As Stevens said, many years later,

> when people were painting cubist pictures, were they not attempting to get at not the invisible but the visible? They assumed that back of the peculiar reality that we see, there lay a more prismatic one of many facets. Apparently deviating from reality, they were trying to fix it.'
> (*L*, 601)

But whereas Stevens came to dislike these 'modernist perversions' of Picasso and Braque, Williams wholeheartedly followed their example, trying as best he could to apply the lessons of the painters to his poetry. Understanding, as Stevens had, that 'these men attach one to real things: closely, actually, without the interventions or excitements of metaphor', he quickly decided that 'what I put down of value will have this value: an escape from crude symbolism, the annihilation of strained associations'.[14] He therefore slowly developed a poetry which he tried to make as free from abstraction and metaphor as he could. In this pursuit he soon found himself studying and learning from exactly those American painters whose work Stevens scorned, painters like Charles Demuth (ill. 54), Marsden Hartley, Arthur Dove and Charles Sheeler (ill. 55), who, under the theoretical and artistic influence of the famous photographer Alfred Stieglitz, had begun to dissociate their

work from European forms, and who, in studying the endlessly varying facets of the American environment with precision and intensity, tried to create what would be the first truly 'American' art. In emulation of these painters and the theories propounded by Stieglitz, Williams explored his 'contact' with local reality, finding subjects for poetry in both the beautiful and the ugly, allowing the monstrous structures of corporate industrialism and the cacophonous disorder of metropolitan life to stand in immediate conjunction with the frail presence of, not exotic fruits and flowers, but chicory and daisies. He recognized also the unconscious choreography of order which man imposes on himself and his machines in the most unexpected places, as for instance in his early poem 'Overture to a Dance of Locomotives', where the influences of Cubism and Duchamp's orchestrations of motion meet with the geometrical analyses of metropolitan and industrial form of his friends Demuth and Sheeler:

> The rubbing feet
> of those coming to be carried quicken a
> grey pavement into soft light that rocks
> to and fro, under the domed ceiling,
> across and across from pale
> earthcolored walls of bare limestone.
>
> . . .
> A leaning pyramid of sunlight, narrowing
> out at a high window, moves by the clock;
> discordant hands straining out from
> a center: inevitable postures infinitely
> repeated—
> . . .
> Lights from the concrete
> ceiling hang crooked but—
> Poised horizontal
> on glittering parallels the dingy cylinders
> packed with a warm glow—inviting entry—
> pull against the hour. . . .

And when Williams turned to nature, it was not to meditate on an impressionistic 'Sea Surface Full of Clouds', it was to observe and record the 'miscellaneous weed / strands, stems, debris',[15] and to convey, in sharp verbal approximation of the painter's visual record, the aspects of man's relationship to nature which are otherwise impossible to articulate, by suspending forever in our minds the image of

> a mottle of green
> sands backward—
>
> amorphous waver-
> ing rocks—
>
> among which we see
>
> a severed cod—
> head between two
> green stones—lifting
> falling

Williams, then, in his best work, created a poetry free from metaphor, which limited itself to the conjunction and description of concrete objects, both organic and industrial, but always close to the American experience, a poetry which incorporated the austere beauties of New England landscapes as recorded by Marsden Hartley or John Marin (ill. 56), as well as the skyscrapers and factories of New York and the 'filthy Passaic' river, filled with industrial debris running through *Paterson*. Thus Williams made his poetry communicate, on the basis of visual and tactile configurations, the psychological structure of his response, as an American, to the details of his environment, without the interference of falsifying generalizations and inexact, myth-creating rationalizations which interfere with perception. Whenever he was successful in this difficult task, Williams created a poetry of astonishing immediacy and beauty.

Stevens is often called a hedonist poet. This is primarily due to the apparent gaiety and exotic sparkle of his language, and to the proliferation in his poems of natural objects and artefacts. These are the qualities which give his poetry its aura of realistic detail. But his colours and mangoes and sun are too often objects taken from art, not nature, decoys to disguise the artificiality of his stance. For all his presumed hedonism Stevens could not allow himself to dwell, like Williams, on something as 'vulgar' and real as a girl

> with big breasts
> under a blue sweater
>
> bare headed—
> crossing the street[16]

let alone find in a scene such as that something of value for poetry. Stevens shunned reality, because close observation of reality would threaten the moral order with which he had aligned himself by immersing it in the clear light of reason. His position was much too precarious to permit him to engage in such scrutiny. The rigid and consciously artificial idealism which he had built up to escape reality made it seem as if he were a hedonist, simply enjoying art for art's sake. But the absence of celebration in his poetry and the tenacious return to theorizing, show how desperately Stevens needed art, not for its own sake, but for his ideological equilibrium. We can trace the origins of this function for art in Stevens's life all the way back to that journal entry of 1899, when he wrote that art 'must be part of the system of the world', and when, anything but a hedonist, he decided that 'art all alone, detached, sensuous for the sake of sensuousness, not to perpetuate inspiration or thought, art that is mere art—seems to me to be the most arrant as it is the most inexcusable rubbish'. Stevens's art had to conform rigidly to the requirements of his idealism. That is why he preferred the quasi-religious metaphysical qualities of *The Old Guitar Player*, with its stylistic derivation from El Greco, to Picasso's later work. That is why the only American painter whom Stevens seems to have considered worthy of his attention, was Thomas Cole (although even Cole, with his rude attention to detail often 'shocks one's dreams'). That, finally, is why he chose to admire the weak, stylized post-impressionism of obscure French painters such as Yves Brayer, Cavaillès or Roland Oudot, or the so-called 'mystical realism' of Marcel Gromaire, whose wooden line and clumsy schematizations are mere parodies of the work of better painters. Stevens's

well-known statement that he 'had a taste for Braque and a purse for Bombois' (L, 545), is not entirely accurate: he needed Bombois and he feared Braque.

But where Stevens used the visual arts to escape from reality, Williams used the stylistic elements he took from painting as a welcome and efficient tool in the delineation of all aspects of sensuous experience. In their divergent responses to the possibilities opened up to them by modern painting, these poets were, in effect, choosing sides in the ongoing and crucial struggle in the United States between the traditional abstractionist idealism which has dominated American consciousness since the time of the first colonists, and an incipient demand for a positive humanism based on confidence in reason and its ability to deal with the immediate data of objective reality. Stevens's attempt to dissolve the real in the abstractions of the mind, so that the mind might then construct its own order, is representative of a dangerous American tendency to demand man's submission to a 'better world' of idealist metaphysics (Stevens's 'supreme fiction'), in which theory and practice have no relationship and reality too often becomes merely a tool to be manipulated as the mind sees fit. Williams's poetry, on the other hand, represents a significant, if limited and only partially viable, attempt to call the American consciousness back to the direct apprehension of reality and the immediate consequences of man's actions. It urges man to take stock of his environment and to recognize that as much as he tries to deny it, his humanity depends on his ability to respond to the challenge of analytic reason informed by the infinite ramifications of organic reality. In the United States the struggle between the modes of perception represented by the work of these two poets has only recently found expression beyond the bounds of literature and theory—but both Stevens and Williams knew that it was only a matter of time until it would. The confrontation was inevitable.

Notes

1 For Stevens, see Michel Benamou, 'Wallace Stevens: Some Relations Between Poetry and Painting', *Comparative Literature*, XI (winter 1959), 47–60, reprinted in Ashley Brown and Robert S. Haller, eds., *The Achievement of Wallace Stevens* (Philadelphia 1962), 232–48; and Robert Buttel, *Wallace Stevens: The Making of Harmonium* (Princeton 1967), especially pp. 148–68. For Williams, see Dijkstra, *The Hieroglyphics of a New Speech: Cubism, Stieglitz and the Early Poetry of William Carlos Williams* (Princeton 1969).

2 Quoted in Buttel, op. cit., p. 74.

3 Wallace Stevens, 'The Noble Rider and the Sound of Words', *The Necessary Angel: Essays on Reality and the Imagination* (NY 1965), p. 15.

4 Ivor Winters, 'Wallace Stevens, or the Hedonist's Progress; Postscript 1958', *Ivor Winters on Modern Poets* (New York 1959), p. 35.

5 Mrs Holly Stevens, the poet's daughter, informs me that the present whereabouts of this watercolour are unknown.

6 Michel Benamou, 'Wallace Stevens and the Symbolist Imagination', in Roy Harvey Pearce and J. Hillis Miller, eds., *The Act of the Mind: Essays on the Poetry of Wallace Stevens* (Baltimore 1965), p. 110.

7 Roy Harvey Pearce, 'The Last Lesson of the Master', in Pearce and Miller, op. cit., p. 129.

8 Williams, unpublished notes for a talk at Dartmouth College, Williams Collection of the Lockwood Memorial Library, State University of New York at Buffalo.

9 Unpublished notes for a talk at Briarcliff Junior College, Williams Collection, Lockwood Memorial Library, Buffalo.

10 This passage is from the manuscript version of Williams's introductory essay to the catalogue of the Charles Sheeler exhibition at the Museum of Modern Art in New York, in 1939. As reprinted in Williams, *Selected Essays* (New York 1954), p. 232, the relevant part of the essay reads: 'this world of the artist is not gauze but steel and plaster. It is the same men meet and talk and go to war in.'

11 'A Conception of Poetic Structure', unpublished manuscript, Lockwood Memorial Library, Buffalo.

12 Notes for a lecture at the Brooklyn Institute of Arts and Sciences, Lockwood Memorial Library, Buffalo.

13 'The American Spirit in Art', unpublished manuscript, Yale University Library, Williams Collection.

14 William Carlos Williams, *Spring and All* (Dijon 1923), p. 22.

15 'The Cod-Head', *Collected Earlier Poems* (New York 1951), pp. 333–4.

16 Williams, 'The Girl', *Collected Later Poems* (New York 1950), p. 123.

Index

DATE DUE